WHEN PANCAKES GO BAD

Optical Delusions with Adobe® Photoshop®

WHEN PANCAKES GO BAD

Optical Delusions with Adobe® Photoshop®

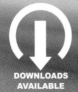
DOWNLOADS
AVAILABLE

Avi Muchnick and the Worth1000.com artists

SVP, Thomson Course Technology PTR: Andy Shafran

Publisher: Stacy L. Hiquet

Senior Marketing Manager: Sarah O'Donnell

Marketing Manager: Heather Hurley

Manager of Editorial Services: Heather Talbot

Associate Acquisitions Editor: Megan Belanger

Associate Marketing Managers: Kristin Eisenzopf and Jordan Casey

Developmental Editors: Lisa Bucki and Jeff Belanger

Project Editor: Jenny Davidson

Technical Reviewers: Lisa Bucki and Jeff Belanger

PTR Editorial Services Coordinator: Elizabeth Furbish

Interior Layout Tech: Bill Hartman

Cover Designer: Abby Scholz

Indexer: Sharon Shock

ISBN: 1-59200-524-1

Library of Congress Catalog Card Number: 2004107748

Printed in Canada

04 05 06 07 08 TC 10 9 8 7 6 5 4 3 2 1

THOMSON

COURSE TECHNOLOGY

Professional ■ Trade ■ Reference

Thomson Course Technology PTR, a division of Thomson Course Technology
25 Thomson Place ■ Boston, MA 02210 ■ http://www.courseptr.com

This book is dedicated to all my friends and family—especially my two leading ladies.

Erica, thanks for putting up with my ridiculously long hours and this cliché dedication.

Kayla, I can't wait for you to learn Photoshop.

Also, a special dedication to Mrs. Greenfield, my fifth-grade teacher, who was so enamored with my writing that she made me promise to dedicate my first published book to her. Somehow, I doubt that she meant a dedication in a picture book, but a promise is a promise, and them's the breaks.

Acknowledgments

A very special thanks go to the following people who went above and beyond in helping get this book ready:

My editors: Megan Belanger, Jeff Belanger, Lisa Bucki, Jenny Davidson, and everyone else at Course Technology who kept things moving speedily and efficiently.

My projects assistant: Lisa Schneider, who helped organize member submissions.

Worth1000 members who really went above and beyond all expectations in contributing so much material for this book: Alex Levin, Jeff Minkevics, Bob Schneider, Daniel Goodchild, Tracey Somo, Jeff Birtcher, Dorie Pigut, Renato Dornas de Oliveira Pereira, Jan Peterson, Kerry Brennan, Allison Huff, Dan Cohen, Anders Jensen, Chris McKenzie, Tom Ritchie, Megan Jackson, Robin Smith, Becky O'Bannon, Alex Feldman, Kris Aring, Doss Bradford, Gregg Stricke, Raymond Mclean, and Ian Capezzano.

All the Worth1000 members who submitted tutorials, edited images, and source images. Unfortunately, there are too many to list here, but you can find their names credited throughout the book by their work.

Worth1000 administrators who contributed material to this book or kept the website running smoothly during deadline crunch time: Kirby Gehman, Robert Whalen, Jack Cheng, Heather Flyte, Brooks Summerlin, Israel Derdik, Larry Rubinow, Cynthia Rhiley, and Lisa Schneider.

The following websites and website administrators for their assistance in providing source material and/or support for the Worth1000.com website and book: Drew Curtis of Fark.com, Colin Smith of PhotoshopCafe.com, Josh Boruff and Rich Kyanka of SomethingAwful.com, Brian Briggs of BBspot.com, Rob Manuel of B3ta.com, Denise Davert of Photospin.com, Péter Hamza of SXC.hu, Michael Connors of Morguefile.com, the folks at Google.com, ImageShack.us, bigphoto.com, and desktopcreatures.com, respectively.

The following software companies: Adobe, Extensis, and Wacom.

Lastly, I'd like to thank myself, without whom I wouldn't be here today.

About the Author

Avi Muchnick is the founder of Worth1000.com, a highly popular, Photoshop-based graphic design website that sponsors numerous Photoshop art contests, most of which feature humorous, spoof, and surreal images. Worth1000.com receives over 200,000 visitors a day and boasts more than 100,000 registered members. After graduating from Queens College in New York, Avi worked for a year as a graphic designer and became an expert in Photoshop. When he left to start law school, he simultaneously launched Worth1000.com, which became popular immediately. Worth1000.com was chosen as one of *PC Magazine*'s top 100 websites in their April 20, 2004 issue, and their images have been featured in *USA Today*, *Star* magazine, on CNN and *Good Morning America*, and on the cover of the *New York Post*. Avi currently resides on Long Island, New York.

Contents at a Glance

Contents

Contents

Contents

Contents

Introduction

A picture is worth a thousand words.

Truer words have never been spoken of Worth1000.com, the brainchild of Avi Muchnick. This contest site supports a talented and competitive community of artists whose goal is to create photo-realistic artwork and photographic "hoaxes." The large membership is the sole source of Worth1000.com's unique content, over 100,000 images in over 3,000 galleries.

Worth1000.com officially launched on January 1, 2002. The contests at Worth1000 required users to discover or create their own source material and contribute a unique interpretation of whatever theme the contest called for.

Some of the most popular themes over the course of Worth1000.com's tenure have been "Modern Renaissance" (inserting modern people or items into a Renaissance painting), "Six Degrees of Celebrities" (taking an image of a famous—or infamous—person and placing them outside of their normal timeline or circumstances), "Detouching" (users are to "de-touch" a celebrity photo and give the world a slightly slanted view of what's behind all that makeup), and "If people didn't rule" (how the world would look if one group of weird people—such as clowns, or even animals, ruled the world).

Images from some of the more popular contests have made their way into large publications such as the *New York Post*, the *Toronto Star*, the *LA Times*, the *National Enquirer*, and *Star* magazine. Images have been featured on *Good Morning America*, TechTV, and CNN. The BBC World News says, "Worth1000 is a visual feast..." and calls the images "breathtaking."

Every image of the site is imprinted with the Worth1000 logo. As the images fly from desktop to desktop, email to email, Worth1000.com's popularity grows. Worth1000 images probably contribute to half the bandwidth on most mail servers (aside from spam).

Worth1000.com doesn't stop at photo-editing competitions. The addition of photography, illustration, multimedia (3D renders and animation), and text contests in the spring of 2003 opened the floodgates of creativity. Soon photo-editing junkies were showing off their talents as photographers. Frequenters of the forums were delighting voters with their creative writing skills. Illustrators and animators, hidden amidst the Photoshop jungle, astounded the entire site.

Even after Worth1000.com's contests are over and the trophies have been awarded, these images continue to impress the over 200,000 visitors to Worth1000.com each day. The quality and realism of many images leave visitors with a sense of wonder, and many return again and again just to browse the galleries and see what the Worth1000.com community can come up with next.

But Worth1000 is also about learning and developing the skills to create such stunning images. This book is a natural progression from the site's tutorials and helpful forums. These pages are full of amusing and astounding images, many never before seen on Worth1000.com, and the artists explain some of the methods used in their creation. Whether you yearn to create photo-realistic images of your own, or just enjoy getting smile after smile as you flip through the gallery, this book shares the scope of Worth1000.com's humor and the depth of its talent.

But it doesn't stop here.

www.worth1000.com

Are you worthy?

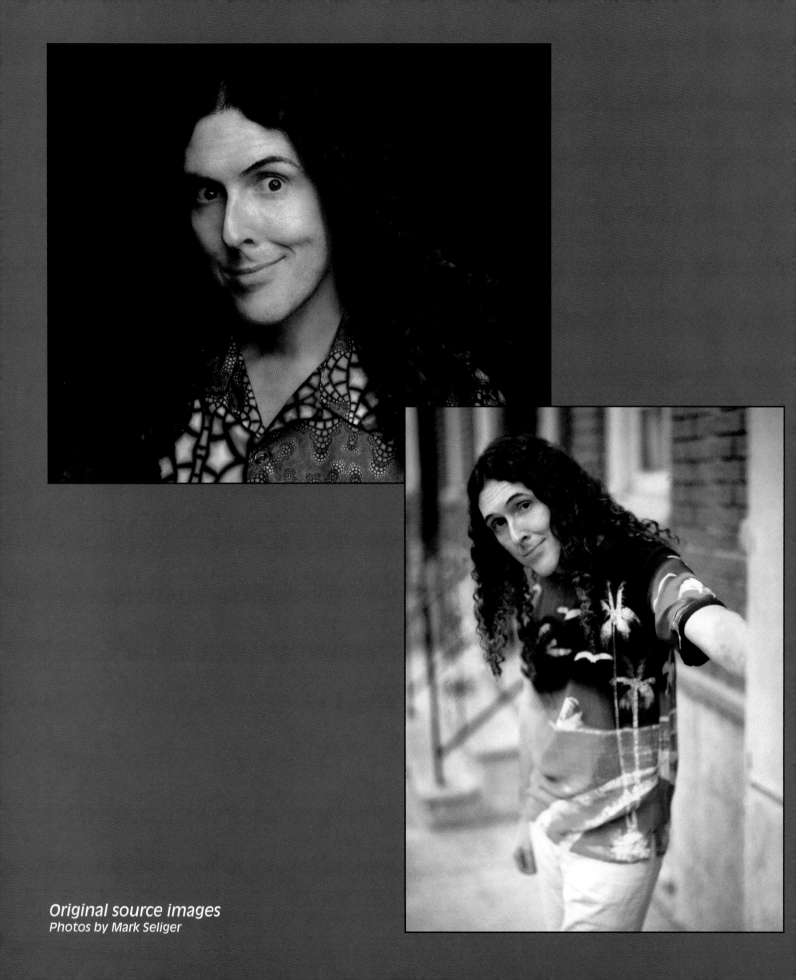

Original source images
Photos by Mark Seliger

1

Six Degrees of "Weird Al"

On Worth1000.com, we often have "Six Degrees of Anything" contests, where we take a random celebrity's image and tell people to parody it in any way they like. For our first chapter of our first book, we couldn't think of any more deserving subject than the King of Parody himself, "Weird Al" Yankovic. A special thanks to Al for being nice enough to allow us to have some fun with his image!

Wall Art Al
By Megan Pleuss
Source Images: Jeff Noble,
Jeffnoble.com, sxc.hu,
Mark Seliger

Old Al
By Derek Ramsey
Source Images: Photospin.com,
Mark Seliger

2

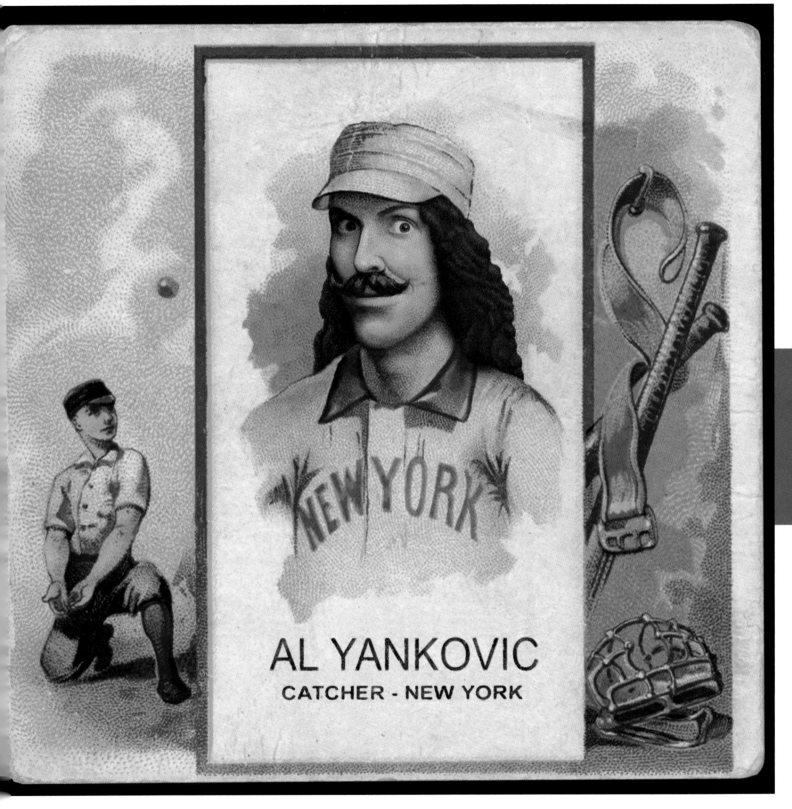

Baseball Card Al
By Bob Schneider
Source Images: Grantham Bain collection at the Library of Congress, Mark Seliger

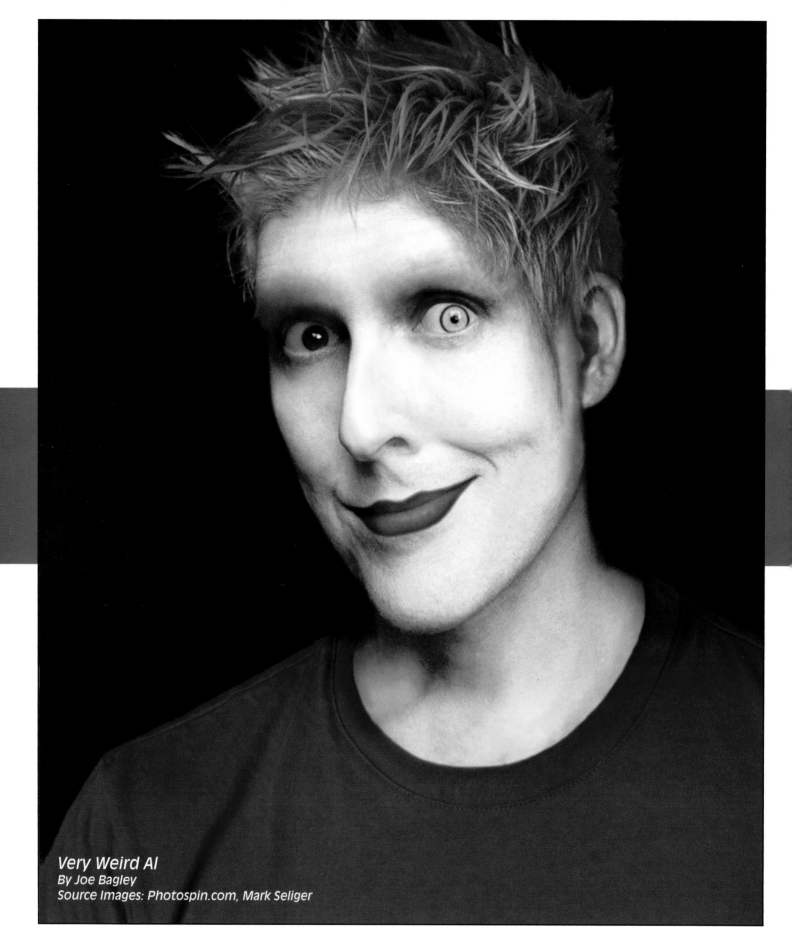

Very Weird Al
By Joe Bagley
Source Images: Photospin.com, Mark Seliger

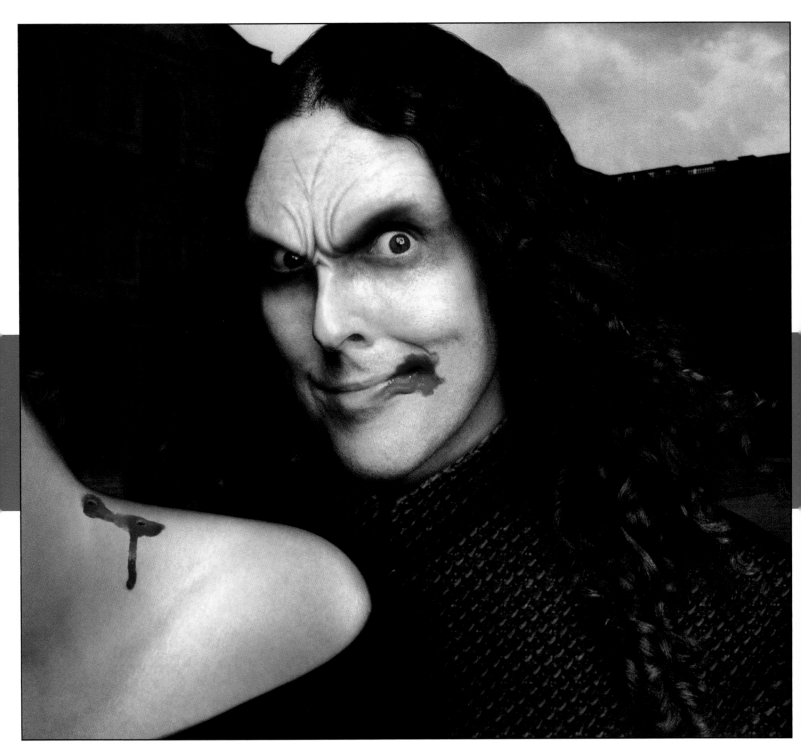

Weird Vlad Dracula
By Frits Bonjernoor
Source Images: Frits Bonjernoor, Mark Seliger

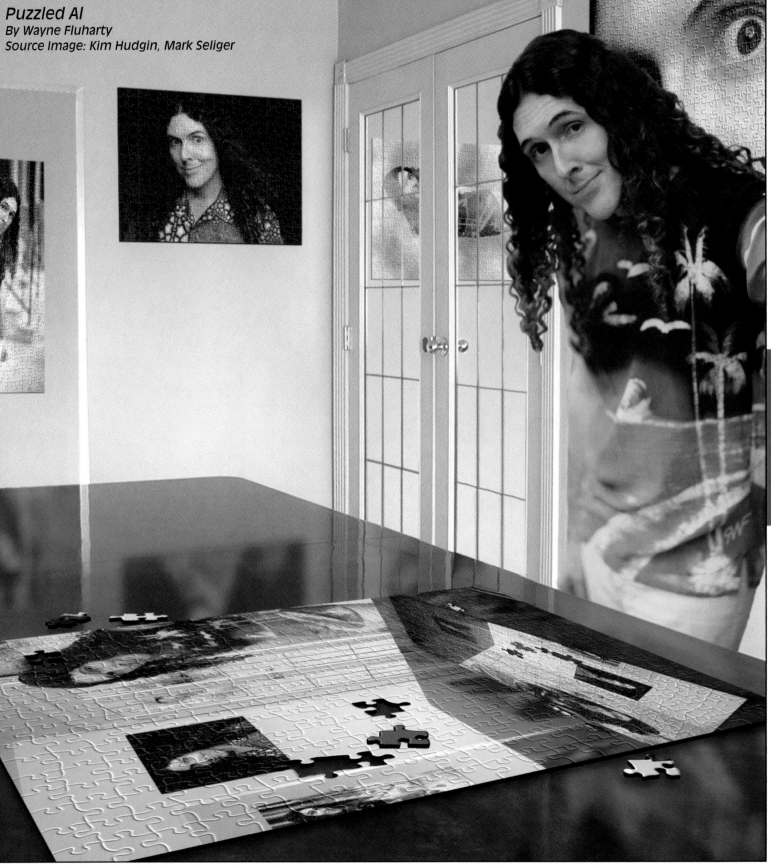

Puzzled Al
By Wayne Fluharty
Source Image: Kim Hudgin, Mark Seliger

7

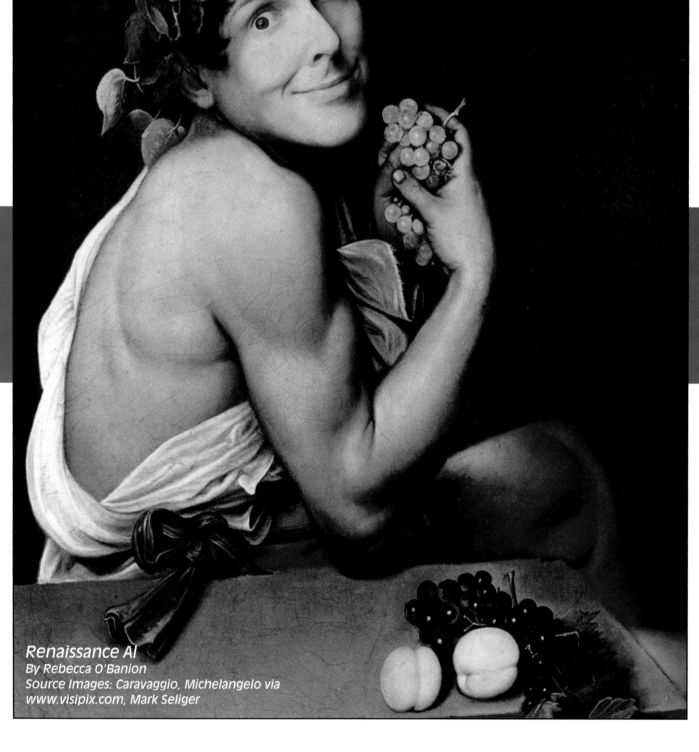

Renaissance AI
By Rebecca O'Banion
Source Images: Caravaggio, Michelangelo via
www.visipix.com, Mark Seliger

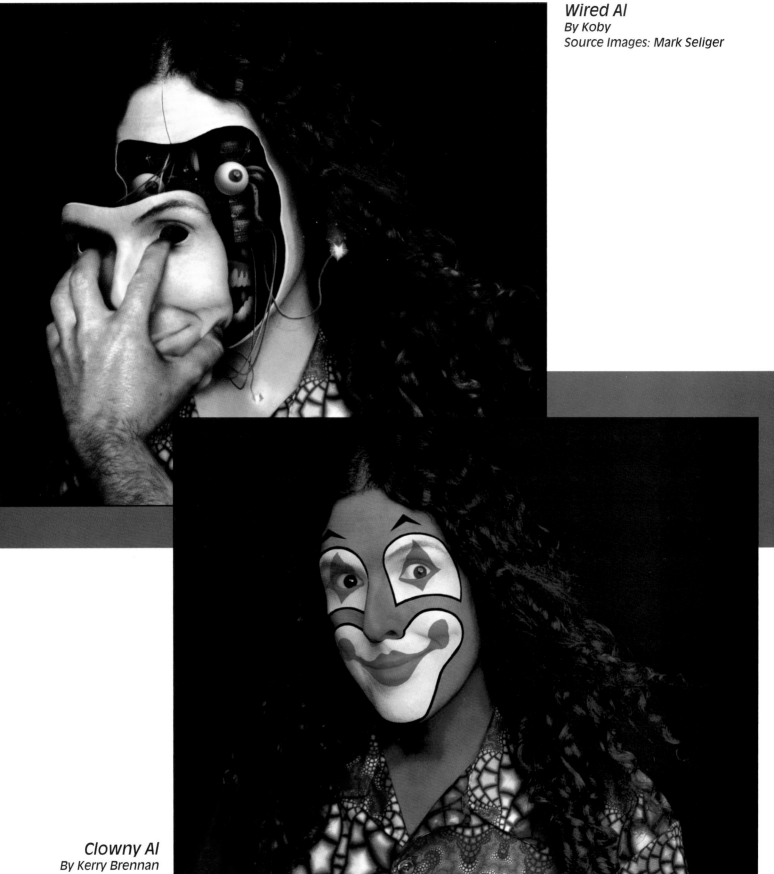

Clowny Al
By Kerry Brennan
Source Images: Mark Seliger

9

Weird Thumb
By Jeff Birtcher
Source Images: Jeff Birtcher,
Mark Seliger

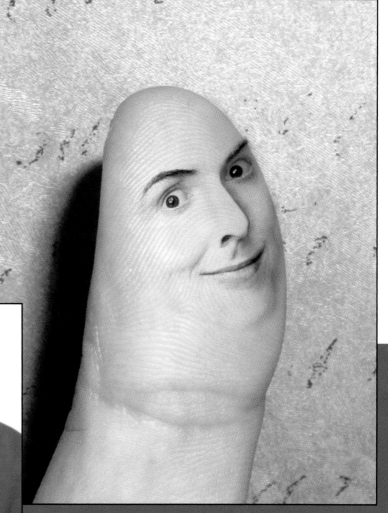

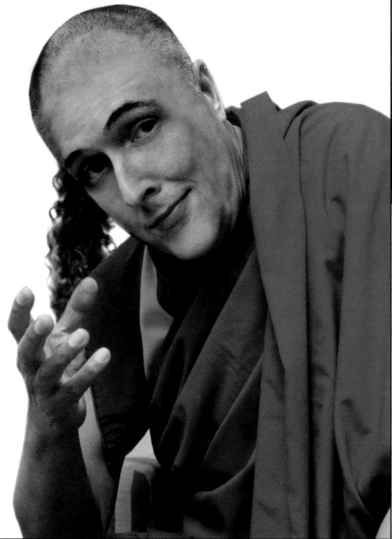

Dalai Allma
By Tracey Somo
Source Images: Tracey Somo,
Lemonlimestudio.com, Mark Seliger

10

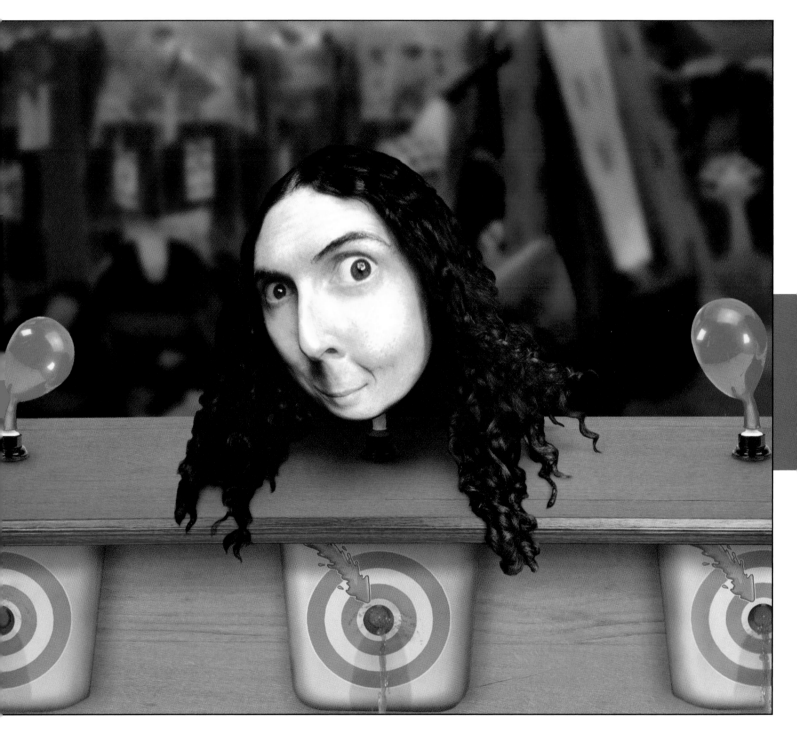

Carnival Al
By Andrew V. Gamet
Source Images: Clipart.com, Photos.com, Mark Seliger

Tutorials

A general note about organization

The first thing that I do before beginning work on photo manipulations is organize the images I will be working with (what I call my source images).

Here's a brief introduction of what I do to organize myself before working on an image:

1 I create a new image file by choosing File > New from the menu bar at the top of the Photoshop application window.

2 I select the dimensions and other features of the project I will be working with. I generally choose to work with a transparent background, as it makes for easier editing later on in the project. If I'm not sure of the total size, I usually just pick a size that I know will probably be larger than my project, as I can always make the image size smaller later. Similarly, if I choose a size that is too small, I can always make the project larger at any point as well.

3 I open up all the source images I intend to work with. I should now have a few image windows open within Photoshop. I can access these by going to File > Open and then browsing my computer for the files.

4 I move the new blank file I created away from the open files, so it is easily accessible.

5 I copy and paste the contents of all of the source files into my new Photoshop file. To do this I click on a source file, choose Select > All from the menu bar, and I should now see the marching ants selection line marquee bordering my entire image. Then I choose Edit > Copy from the menu bar. Lastly, I click onto any part of my new Photoshop file and click Edit > Paste from the menu bar. My source image should now be copied into my new file as a separate layer.

6 Then, I close my copied source image file and move onto the next source image, repeating Steps 5 and 6 until I am left with only my new file (now full of layers).

How I made Puzzled Al

If you are planning on using this tutorial, please note that I wrote it under the assumption that you have at least a rudimentary grasp on how the different tools and menu items work in Photoshop. This tutorial should be helpful to anyone with Photoshop 5.0 or greater.

Al Yankovic is a complex guy. To understand him, you need to put the puzzle pieces of his life together. An artist all the way, Al first chose to express himself musically through the accordion. He began playing this chick-magnet "axe" since the day before his seventh birthday. But his love of the instrument didn't stop there. He's been an accordion teacher and even an accordion repo-man (don't ask).

Getting started

In this tutorial, I will show you how I created the Puzzled Al image. Because this is the first tutorial in the book, you may find that it's a bit over-inclusive in listing the various steps used to create this image, but please note that the rest of the tutorials will assume you're beginning to grasp the fundamentals of Photoshop and don't need a guiding hand every step of the way.

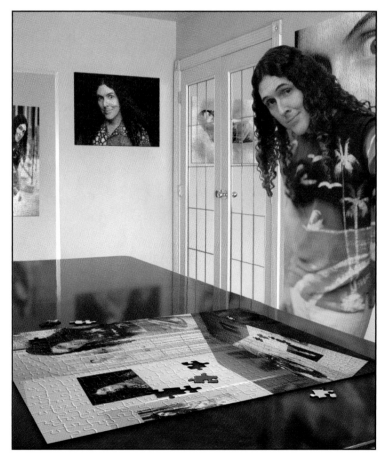

Editing "Weird Al"

For this project, I began with two source images in the form of the publicity stills of "Weird Al."

Because I figured that I eventually might need to adjust the colors and patterns in Al's pants and shirts, I wanted to save his pants and shirts as separate layers. To do this:

1 I used the Lasso tool on the Photoshop Toolbar to carefully select around Al's body and hair. Eventually, I had made a full selection around Al's entire body.

2 I copied and pasted this into a new layer (using the Edit > Copy / Edit > Paste method explained earlier) and then deleted the original layers.

3 Next, I made separate selections of Al's pants and shirts and put them onto their own layers too. You can see how I organized the layers in Figure 1.1.

Figure 1.1

To effectively select individual elements on a layer as described in Step 1, I zoomed in as closely as possible to the image so I could make sure that I only selected the pixels that I wanted. I zoomed in and out by choosing View > Zoom In or View > Zoom Out from the menu bar.

When I zoomed in on a digital image, it appeared to blur. I tried to keep my selection marquee as close to the edge of the blur as possible (see Figure 1.2). Although I did so, the copied selection (on its own layer) still appeared to have some unwanted pixels around the border.

Fortunately, Photoshop provides an easy fix for this type of situation. After I pasted a selection onto a new layer in the working image and chose Layer > Matting > Defringe from the menu bar, I typed the Width value (in pixels) in the Defringe dialog box and clicked OK to clean up around the edges of my layer. The higher the Width number I specified, the more of the border pixels were removed. In the case of this "Weird Al" image, I experimented by applying different matting widths and using Edit > Undo to retrieve my work until I was satisfied with the layer's appearance.

Figure 1.2

Adding a background

After I finished separating out parts of the pasted layers in the new Al image, I opened another source image of a room with a table (as shown in Figure 1.3) in a new window (again by choosing File > Open).

I then used the image as follows:

Figure 1.3

1 I noticed that the perspective of the room didn't really match the direction that Al was facing. In order to better match Al's direction, I flipped the image horizontally by choosing Image > Rotate Canvas > Flip Canvas Horizontal.

2 I then selected the entire image using Select > All.

3 I used Edit > Copy and Edit > Paste to copy and paste the image content into my new image file as a separate layer. The reason that I flipped the background image prior to moving it was because if I had flipped it after moving it, all of the other layers in the new Photoshop file would have been rotated also.

I also noticed that there were some items in the background image that I didn't really want as a part of my final version, so I edited them out using my Clone Stamp tool on the toolbox. I used the following steps to remove the reflection on the table, the dark area on the glass door, and the refrigerator in the back room.

4 First I selected around an area I wanted to remove using the Lasso tool.

5 Then I selected the Clone Stamp tool.

6 I specified an area that I wanted to clone by Alt+clicking on it in the image (Option+clicking it on the Mac).

7 Then I painted within my selection area using the Clone Stamp tool and voilà, no more unwanted elements! I had a bare room with a table to edit.

Next, I selected the table and copied it into its own layer. I then moved the Al layer in between the full background image layer and the table layer, so that Al appeared to be standing between the table and the wall, as shown in Figure 1.4. (To move a layer, click its layer thumbnail in the Layers palette and drag the layer to the desired location in the palette.)

Creating a reflection on the table

I used the following steps to add a reflection on the layer that has the table only:

1. I duplicated Al's layer (by right-clicking the layer in the Layers palette, clicking Duplicate Layer, typing a layer name, and pressing Enter/Return).

2. I moved this new layer above the table layer.

3. I chose Select > All from the menu bar.

4. I then went to Edit > Transform > Flip Vertical, which turned the new Al layer upside-down.

5. I chose Edit > Transform > Skew. I was now able to manipulate the handles on the bounding free transform box that surrounded the new Al layer. (See Figure 1.5.)

6. I zoomed out by choosing View > Zoom Out so that I could see some of the gray work area around the canvas. This enabled me to use all of the handles I needed to complete the skew.

7. I moved the left side of the image up so that the edges of Al lined up parallel with the table edge. I allowed for some overlap past the table edge since Al is not standing directly against the table. I tried to start right below the shirt so that the contrast of the white pants showed in the reflection.

8. Next, I started to blend the skewed layer into the tabletop. I changed the opacity for the layer to 50%. To do so, I made sure the layer was selected in the Layers palette. I clicked the arrow button beside the Opacity setting on the palette, dragged the slider to 50%, and clicked the arrow again.

Figure 1.4

Figure 1.5

9 I then chose Filter >Blur > Gaussian Blur from the menu bar. I changed the Radius setting in the Gaussian Blur dialog box to 10.0 and clicked OK. This gave the skewed AI a blur that mimics the natural reflection one might see in a table.

10 I slowly lowered the brightness on the layer to approximately –50 by choosing Image > Adjustments > Brightness / Contrast from the menu bar, until I felt that it matched the other layers.

11 Finally, I deleted any portions of the reflection that extended past the edge of the table. To do so, I first used Select > Deselect to remove the current selection. Then I selected the area to delete with the Lasso tool and pressed the Delete key.

Making the puzzle

Next, I needed to add the puzzle portion of the image. I decided to go with something simple for the back wall of the room, so I chose the other publicity image of AI that was provided, which didn't need any additional editing. I opened the image and wrote down the dimensions, found by choosing Image > Image Size. For the puzzles in the background, I decided that a 20 × 16 size puzzle would keep with the general image ratios and make the puzzle lines more visible from a distance.

I created the puzzle texture and applied it to this second AI image like this:

Figure 1.6

1 I opened the PUZZLE.PSD texture file that is supplied with Photoshop. This file is generally located in the Presets\Textures\ subfolder of the folder where Photoshop is installed. Unfortunately, this original image had the wrong number of pieces and does not allow for edge pieces, but that could be corrected. This image can be tiled. so I did the following to tile it: First, I enlarged the canvas by selecting Image > Canvas Size. I copied and pasted it onto itself until I had more than the number of pieces that were needed across and down. Then I zoomed out by selecting View > Zoom Out so I could see all of the layers' contents and moved all of the pieces into the correct position using the Move tool. Once this was done, I cropped the image to the selected number of pieces. Figure 1.6 shows how a 4 × 3 piece puzzle would be selected, but please note that I used a puzzle with more pieces when actually creating this effect.

2 Next I created the edge puzzle pieces, which need a straight outside edge, as in a real puzzle. Going around the entire edge, I chose the Lasso tool, selected the extraneous markings, and then deleted them by pressing Delete. For example, in Figure 1.7, all of the top edges have been cleaned up, and I've made a selection to clean up the middle right piece.

3 Once the edges were all cleaned up, and I had pretty side pieces for the puzzle, I resized the puzzle texture image to the size of the image that I would be using it on. (That is, the Al image that I had chosen to be puzzled.) I used the Image > Image Size command to resize the image.

Figure 1.7

4 Finally, I chose File > Save As and saved the texture under a new name (PuzzleTemp.PSD) in the same folder as the other textures.

5 I returned to the window of the file with the image I had chosen to be puzzled, and I chose Filter > Texture > Texturizer.

6 In the Texturizer dialog box, I clicked the round palette button to the right of the Texture drop-down list and clicked Load Texture in the menu that appeared.

7 In the Load Texture dialog box, I clicked the new PuzzleTemp.PSD texture that I just created and clicked Open.

8 Back in the Texturizer dialog box, I made sure that the Scaling was set to 100%. Since this particular puzzle would be located on the back wall, I increased the Relief setting to be fairly deep (10 or 11) so that the details could be seen easily. I also thought about what direction the light would be coming from with respect to the puzzle's position on the wall, and I chose the desired light direction from the Light drop-down list.

9 Finally, I clicked OK to apply the Texturizer settings. Now this picture was ready to be pasted into my scene.

10 I used Edit > Select All to choose the texturized puzzle image.

11 I then used Edit > Copy and Edit > Paste to paste the puzzle image into the main Puzzled Al image.

12 Finally, I selected the new puzzle image layer in the Layers palette and used the Move tool from the toolbox to move the puzzle image to the desired location on the back wall of the scene.

I used the process just described to prepare and place each of the other puzzle pictures on the walls. For variety, I created a close-up of Al's eyes for one picture, changed the color of his shirt in a couple of the pictures, and also made a simple cloud background (by selecting Filter > Render > Clouds) in the last one.

As I added each new picture into the scene, I made sure to also add a corresponding table reflection. I used the same technique that I applied earlier to Al's reflection (described in the section called "Creating a reflection in the table") to the pictures to create each reflection. The natural reflection of the door's window frames on the table made good markers to help position each picture reflection.

Finishing up

Now that everything except the puzzle on the table was done, I merged all of the existing layers together into a single layer by selecting Layer > Merge Visible. I first blurred the edges of the content on some layers by selecting around the borders using my Lasso tool and then using the Blur tool from the toolbox to lightly blend in any hard images that didn't appear to flow with the picture. Figure 1.8 shows an example.

Figure 1.8

I duplicated the resulting merged layer twice, leaving three different copies of the same layer in my image file. One duplicate I used for puzzling, and the other was added to the puzzle layer to add to the illusion.

Using the following steps, I completed the image:

1. I texturized one of the layers using my puzzle texture, exactly as I had done it earlier.

2. I removed a few pieces of the puzzle and placed them on the table. I zoomed in to better view a piece that I wanted to cut out and used the Lasso tool to select it (see Figure 1.9).

3. I cut (Edit > Cut) and pasted (Edit > Paste) this piece onto a new layer, using the method discussed earlier in this tutorial.

Figure 1.9

4 Then I performed a Free Transform (Edit > Free Transform) on the puzzle piece, rotated it, and repositioned it on the table, to the side of where I wanted to ultimately place the puzzle itself.

5 I repeated steps 2 through 4 and removed and placed additional puzzle pieces.

6 I returned to the puzzle layer, selected it, and made it appear rougher by selecting Filter > Noise > Add Noise from the menu bar.

7 I performed a Free Transform (Edit > Free Transform) on the puzzle and skewed it so that it appeared to be lying on the table.

8 Finally, I duplicated the finished puzzle layer. I then adjusted the brightness and contrast (Image > Adjustments > Brightness/Contrast) of the duplicated layer to make it black.

9 I moved this black puzzle layer underneath the other puzzle layer by dragging the black puzzle layer on the Layers palette. I used the Move tool to position the black puzzle layer on the image a tiny bit down and to the left so that it appeared to become a shadow for the other puzzle layer.

10 I then used the Opacity control on the Layers palette to lower the opacity on this shadow layer to about 50% and then applied a blur to it by selecting Filter > Blur > Blur More from the menu bar.

As the puzzle pieces of Al watching Al, watching Al, come together, we start to learn more about the man behind the accordion.

Credits

Author: Wayne "Flu" Fluharty
Source Images: Kim Hudgin, Mark Seliger

How I made Weird Vlad Dracula

Al's first album, *"Weird Al" Yankovic*, came out in April of 1983 and featured songs like "I Love Rocky Road," a parody of Joan Jett's "I Love Rock N' Roll" and "Another One Rides the Bus," a take-off of Queen's "Another One Bites the Dust." Wailing accordions and hilarious lyrics quickly propelled Al to fame. But is there a dark side to the rise? Could Al secretly be a vampire when he's not making us laugh?

Getting started

This tutorial assumes that you have an advanced grasp on how to use Photoshop. Skills you will need to know to understand this tutorial include masking, using displacement maps with textures, and the basics of working with layers.

When I saw one of the source images of "Weird Al" Yankovic, I was reminded of the Romanian prince Vlad Tepes (otherwise known as Vlad Dracul), who is widely credited as being Bram Stoker's inspiration in his vampire novel, *Dracula*. So with that in mind, I decided to turn Al into a vampire, using Figure 1.10 (shown here with a few guidelines displayed) as a starting point.

Figure 1.10

1 The quest for additional source images began. I wanted an ominous background, a freshly bitten neck of a woman, and of course, BLOOD!

My wife agreed to let me use her neck for this gruesome portrait. The lighting wasn't really ideal, but I would fix that later.

2 Then I went in search of blood. I contemplated robbing the nearest blood bank, but I figured they probably didn't allow inmates to use Photoshop in jail, and I needed to complete my image. So, I settled on making a substitute from red acrylic paint mixed with black ink. When the mixture was acceptable, I dabbed some on my mouth first and tried to assume the right position, so I could blend it in realistically.

3 Then, blotches of "blood" on my left arm were blended onto my wife's neck.

4 For the ominous background, I decided to use a vacation picture that my wife took when we were in Paris many years ago. Figure 1.11 below shows the additional source images that I combined with the original "Weird Al" source image.

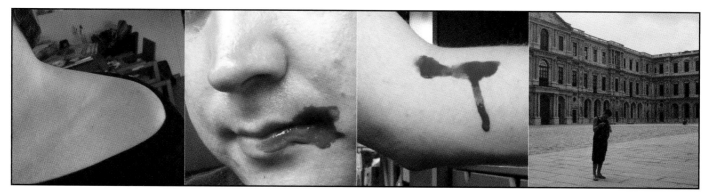

Figure 1.11

Love bites

1 I copied the image of my wife's neck into a layer and used the Lasso tool to select her neck and shoulder only.

2 I then hid the background by selecting Layer > Add Layer Mask > Reveal Selection from the menu bar. This also placed Photoshop in Quick Mask mode.

3 I then painted any remaining bits of the background with a black paintbrush to eliminate them fully and then exited Quick Mask mode by clicking the Edit in Standard Mode button on the toolbox. The background had now been removed from the image.

4 I clicked on the layer thumbnail in the Layers palette and edited my wife by adjusting her skin tone. To do this, I used the Polygonal Lasso tool to select her neck, selected Image > Adjustments and sequentially selected Levels, Color Balance, and Hue / Saturation.

5 I changed the settings for each color control until the tone of my wife's skin matched up perfectly with Al's.

6 Then I used the Burn and Dodge tools from the toolbox to darken and highlight certain parts of her neck, to better match the tone of the image.

7 Lastly, I positioned her on top and to the side of Al, so that he was in perfect striking distance of her neck (see Figure 1.12).

8 Then it was time to get bloody. In the images of me with fake blood on my mouth and arm, I selected the bloody areas with the Lasso tool, copied each selection into the main Al image as new layers, used Edit > Transform > Scale to resize the copied bits to match Al, and used the Move tool to move them into position. I also used Edit > Transform > Rotate to better align the image.

9 Finally, I again entered Quick Mask mode to remove the unwanted background from each of the pasted layers (such as any skin shown around the blood copied from my arm).

Figure 1.12

10 I selected a portion of my wife's neck and copied it into a new layer. I positioned it under the blood layer and used the Burn tool (with a small brush size of 13 or 19 pixels, shadows and/or midtones set to 100%) to create two neat bite marks.

11 I then changed the blood layer's blending mode to Darken on the Layers palette so the holes showed through.

12 Over the blood layer, I created a new layer to paint some highlights on the edges of the holes using the Paintbrush tool.

Good dental hygiene

Combining Al's mouth with my bloody source image was really just a matter of simple matching and blending.

1 Using the same masking method I used to change my bloody arm into my wife's neck, I removed all unwanted pieces of my mouth and positioned the resulting layer of bloody lips over Al's mouth (see Figure 1.13). Because our mouths were making similar expressions, it was extremely easy to match them up.

2 I used a bit of opacity with the brush while cleaning up the mask in order to achieve a more blended effect.

Figure 1.13

Beauty queen

Then it was time to create vampire features.

Figure 1.14

1. First, I copied Al's forehead onto a new layer and made it longer by using the Free Transform tool.

2. I then used the Liquify tool from the Filter menu to sculpt it a bit better into the desired form.

3. The eyebrows were removed with the Clone Stamp tool, and then I added shadows and redness to Al's face with the Burn tool.

4. After I created some deep wrinkles and lines in his forehead using the Burn and Dodge tools, I could see that he was really starting to look moody (see Figure 1.14).

Fashion to die for

In keeping with the whole vampire cliché, I decided to give him a very stylish, regal coat. To accomplish this effect:

1. I selected the shape of his coat using the Lasso tool from the toolbox.

2. I copied the coat selection and pasted it onto its own layer so I could better manipulate it.

3. I created a new file to create a pattern by selecting Edit > Define Pattern. I then painted the simple chain link pattern I made using the Paintbrush tool.

4. Finally, I colorized and added depth to the pattern with the Bevel and Emboss and Color Overlay layer styles (see Figure 1.15). (I clicked the layer thumbnail in the Layers palette, clicked the Palette menu button, and then clicked Blending Options to open the Layer Style dialog box.)

Figure 1.15

5 In order to accurately mimic the curve of a natural pattern on Al's collar and arm, I used Image > Liquify and used the Bloat tool to give the pattern a more curved three-dimensional look, according to the general shape of the coat.

6 I then did some minor retouching by darkening and lightening with the Burn and Dodge tools, and I created a mask on the coat layer so I could erase the areas that were covering Al's hair and chin. With those parts erased, the coat really looked like it was natural (see Figure 1.16).

Figure 1.16

Gothic finishings

My final touch was the addition of an ominous Gothic background.

1 I used the photograph taken during a vacation in Paris.

2 The image was copied into a new layer and again I used a layer mask to reveal Al and his lunch beneath (see Figure 1.17).

3 Finally, I darkened the original image by adjusting the sky levels, color hue, and contrast.

4 As a final touch, I painted in some hairs and moderately desaturated most of Al's skin color.

Figure 1.17

Fame has its dark side, clearly. Though you probably don't have to worry too much about Al hunting you down and drinking your blood. He's been a vegetarian since 1992.

Credits

Author: Frits "furitsu" Bonjernoor
Source Images: Frits Bonjernoor, Mark Seliger

How I made Clowny Al

In February of 1984, Al forever cemented his name in song parody history when he released "Eat It," a parody of Michael Jackson's über-hit "Beat It." The video that followed made Al a visual staple on MTV. The 1980s were great to Yankovic; he released a string of hit records and even a movie called *UHF* that went on to become a cult classic. It was in the '80s that Al boldly answered the age-old musical question, "Can there be rock n' roll polka?"

This tutorial assumes that you have a basic grasp on how to use Photoshop.

1 First I added a new layer to my project and labeled it "Outline." I then used the Paintbrush tool to map out the makeup on my clown, shown in Figure 1.18.

Figure 1.18

2 Then I switched back to the Al background layer by clicking the layer thumbnail in the Layers palette. Using the Lasso tool, I selected the area inside the black makeup lines. I toggled between Quick Mask and Standard editing modes via the buttons on the toolbox and perfected the selection. I also masked the eyeballs and returned to Standard mode, where I was left with my desired selection (see Figure 1.19).

3 I changed the color of my selection by choosing Layer > New Adjustment Layer > Hue/Saturation from the menu bar. After entering a layer name and checking Group with Previous Layer in the New Layer dialog box, I clicked OK. Please note that in earlier versions of Photoshop (5 and under), it might say Use Previous Layer to Create Clipping Mask instead.

Figure 1.19

4 I checked Colorize in the Hue/Saturation dialog box when it opened next. I also adjusted the Hue, Saturation, and Lightness sliders until I found a good white tone, and then clicked OK (see Figure 1.20).

5 I then lowered the layer's opacity to about 75% to allow more details to show through. Once I applied my white tone, I noticed some jagged masking edges around the eyes. I activated my hue/saturation adjustment layer and clicked on the mask thumbnail beside it in the Layers palette. I then used a soft brush to smooth the transitions before proceeding.

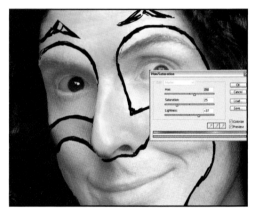

Figure 1.20

6 I repeated the process presented in Steps 2 through 5 to paint the blue areas (shown in Figure 1.21) and, once again, to color the hair. Unlike with the white coloring, I did not have to adjust the opacity or duplicate the layers when working with color (in this case, blue). One layer each at 100% did the trick nicely.

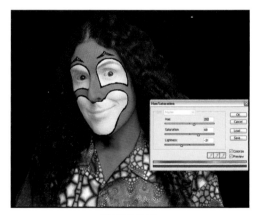

Figure 1.21

7 I added a new Hue/Saturation adjustment layer by choosing Layer > New Adjustment Layer > Hue/Saturation. After entering a layer name, clicking Group with Previous Layer, and clicking OK in the New Layer dialog box, I then clicked Colorize in the Hue/Saturation dialog box and dragged the sliders to tint the selections to deep purple for the eye makeup (see Figure 1.22). I then dragged this layer above the white layer.

8 I clicked on the mask thumbnail for the new purple lip/eye makeup adjustment layer in the Layers palette to activate the mask. I then used the paint bucket to fill the mask with black paint. Using a small paint brush and white paint, I drew in his lips and eyes. The tint began to show through. I hid my white layers while I worked on this to make it easier to see what I was doing (see Figure 1.23).

9 Next, I wanted to bring back some of the contrast that got lost with the adjustment layers, especially in the shadows in the white areas. Using the Lasso tool from the toolbox, I selected the entire face and neck on the background layer. I selected Layer > New Adjustment Layer > Levels. In the New Layer dialog box, I typed a layer name, clicked Group with Previous Layer, and clicked OK. In the Levels dialog box, I adjusted the sliders until the contrast looked great, and then I clicked OK. I placed this layer above all other adjustment layers (see Figure 1.24). Since some areas needed the levels adjustment more than others, I did need to edit the mask with a soft brush to achieve an even look throughout the face, especially on the nose.

10 And now for the finishing touches. I used the black outlines to hide the seams between the blue and white makeup. I simply used the Paintbrush tool from the toolbox to clean up the black outlines. I also brightened up the eyeballs because they looked a little bloodshot next to the white makeup. Finally, I cleaned up any remaining jagged masking edges I could find.

KISS has their trademark makeup. Maybe if Al wanted to go in a similar glam-parody-rock direction, he might look like this.

Credits

Author: Kerry Brennan
Source Image: Mark Seliger

Figure 1.22

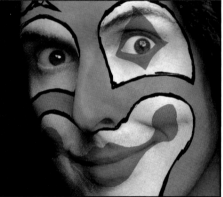

Figure 1.23

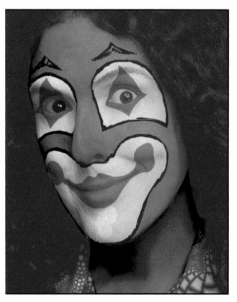

Figure 1.24

How I made Punk Al

In the 1990s, music was changing fast - it was getting a harder punk edge. And Al was changing with it. Now that Al had become a musical icon, many groups, including Nirvana, have been quoted as saying they knew that they had "made it" when "Weird Al" did a parody of one of their songs. Al moshed and kicked his way into the '90s with his song "Smells Like Nirvana," a parody of Nirvana's biggest single, "Smells Like Teen Spirit." If the punk scene of the 1970s ever becomes en vogue again, we want Al to be ready, complete with mohawk and piercings.

Getting started

This tutorial assumes that you have an advanced grasp on how to use Photoshop. Skills you will need to know to understand this tutorial include masking and airbrushing.

Finding good source images is very important for ensuring a good finished product. Matching the lighting direction and perspective are critical to believability. In making Punk Al, I found several source pictures that contained items I wanted to include in the image.

A new hairdo

1. The first element I found was the mohawk. I copied the picture of the man with the mohawk into a new layer in my image and scaled it to roughly match the size of Al's head.

2. I erased the general area around the mohawk so it would be easier to work with, as shown in Figure 1.25.

3. To match the size of the mohawk to Weird Al's head, I then enlarged the mohawk slightly.

4. Once it was properly sized, I expanded the mohawk's width to better match the direction of Al's head.

5. Then I created a mask on the mohawk layer and hid the rest of the unwanted background.

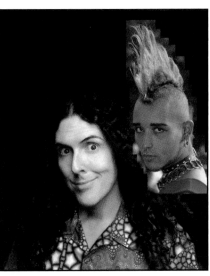

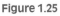
Figure 1.25

6 I used a small soft-edged brush to hide the background that was in the mohawk image. It was important to zoom in close so I could remove the background but still leave the small hairs that stuck out intact.

7 Once all of the background was removed, I needed the blue background of the original "Weird Al" photo to show through. At this point, while still in Masking mode, I switched to the Brush tool in the toolbox, turned on its airbrush feature in the options bar, and changed the Flow setting of the brush to about 4 percent. I used various sizes of soft-edged brushes to allow the blue background to show through anywhere the mohawk didn't cover. By using the small soft-edged Paintbrush with airbrush capabilities turned on at a very low pressure, it allowed me to remove the old background without removing the hair, as shown in Figure 1.26.

8 I also added a small patch of blue hair to the front of Al's head to make the alignment of the head and the hair match up better. Once the hair was complete, I turned my attention to the various piercings that I was going to apply to Al.

Figure 1.26

Heavy metal

Images of metal tend to show the direction of the light source, so the source images for such a small part of the image were still very important.

1 I placed and sized the nose ring, eyebrow ring, and lip ring onto Al's face, making sure to mask out any place they would go through the skin.

2 I then created a new layer and used it to simulate shadows. I painted it with a small soft-edged brush, set as an airbrush with a low flow. By doing this on a separate layer, I was able to experiment with opacity to get the darkness and thickness of shadows that I wanted (like the example in Figure 1.27), without affecting the rest of the image. It's important to note that shadows and highlights add a level of realism to any image manipulation and therefore should never be overlooked.

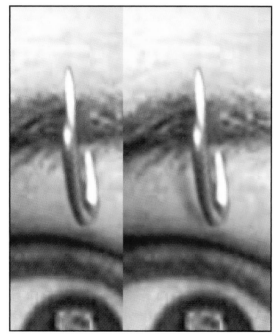

Figure 1.27

3. Finally I added the chain collar. Using a layer mask on the Al layer, I erased only the skin that covered the links. Because the original image of the collar did not match the shape and curvature of Al's neck, it had to be split into two pieces.

4. Once all the masking was done, I duplicated the collar layer and laid out the two collars so that the curvature matched the neck better. I found a place where a ring from each collar overlapped almost exactly.

5. Then, in the layer mask of each image, I removed the part of the collar I didn't want to show.

6. To make the collar fit just right, I did a little bit of cloning using the Clone Stamp tool from the toolbox.

To survive in the music business for 10 minutes, you need to tap into something that speaks to a lot of people. To survive for more than 20 years, you need to be able to evolve on the fly. With Photoshop, we can give Al a new look everyday, if need be.

Credits

Author: Alex R. Feldman
Source Images: Photospin.com, Mark Seliger

How I made Carnival Al

Through the late 1990s and into the new millennium, Al showed his soul and demonstrated how even suburban white guys can "keep it real." Al rapped his way through Coolio's "Gangsta's Paradise," turning it into his own "Amish Paradise." He turned Puff Daddy's "All About the Benjamins" into the PC satire "All About the Pentiums," yet he never put down his accordion (except to shower and sleep). Staying true to his roots, he still belts out polkas on his albums. Classics like "The Alternative Polka," "Polka Power!," and "Angry White Boy Polka" are sure to be heard at an Oktoberfest or county fair near you.

Getting started

This tutorial assumes that you have a basic grasp on how to use Photoshop.

Composite images can be tricky, since you are basically trying to re-create what you see in your mind. In this example, source images of waste-paper baskets, clip-art targets, wheels, and a butcher knife needed to become the target boxes. The other objects also need to be created using separate source images. For this reason, composite images take a serious amount of time and patience.

The targets

Using my only image of the carnival water-shooter game and my childhood memories at the carnival, I remembered that the game's target boxes were made of plastic, normally had a decal of some sort, and had a bright orange button in the center which was hung by a metal bar. The goal was to re-create these items using everyday objects. I realized that a waste basket was plastic and the right shape.

1. I added the decals images, which were the easiest. I found two decals images (one a target and one a water arrow) and merged them into one decal.

2. I moved the decal layer over the basket layer and trimmed the decal to fit.

3. To make the decal appear to actually be a part of the basket, I lowered its layer opacity to 95%, which allowed a slight bit of the basket's hue and its curves' shadows to come through just slightly (see Figure 1.28).

Figure 1.28

4 Next, I created a hole in the basket using the Elliptical Marquee tool on the toolbox. I made an oval selection over the basket layer and chose Edit > Copy from the menu bar.

5 I pasted the copied material into its own layer and lowered the contrast and brightness so it was slightly darker than the basket layer.

6 I then duplicated this new layer and made it slightly darker than the previous layer.

Figure 1.29

7 By moving each of these new layers a little bit under each other, I created what looked like a hole in the plastic, with progressive shadowing on the rim, as shown in Figure 1.29.

8 To emphasize the yet-to-be-added orange button in the center of the hole I just created, I added a small, rectangle rod of metal texture taken from an image of a knife.

9 I chose a source image of a tire and selected the center of a hubcap to use as the button. After copying my selection into a new layer in my image file, I resized and distorted it slightly, angling it down to make it look as though it was being depressed.

Figure 1.30

10 I then changed its color to a bright orange by selecting Image > Adjustments > Hue / Saturation from the menu bar, as shown in Figure 1.30.

11 I merged all of my layers together by selecting Layer > Merge Visible from the menu bar. I then added some shadowing to the completed target using the Burn tool in the toolbox (see Figure 1.31).

Figure 1.31

The water

Water is difficult to work with because too much color or sharpness can make water look cartoonish and too little can make it look like fog or smoke. The carnival game required a stream of water, but for realism and this specific angle, I also needed to add general water droplets here and there. Plus I needed to make it appear to be moving.

1 To make the lower portion of the target look wet, I used the Polygonal Lasso tool to select and copy a portion of the target.

2 I copied and pasted this selection into its own layer, using Edit > Copy and Edit > Paste from the menu bar.

3 I then selected Image > Adjustments > Brightness / Contrast and increased the contrast and decreased the brightness of this layer. The resulting effect makes that portion of the target look damp.

4 I then used the Eraser tool with a soft brush to manually blur the edges in order to blend them into the image.

5 Using a source image of a sprinkler, I used my Lasso tool to select part of the water stream. I then copied and pasted it into its own layer.

6 Using the Layers palette, I decreased the opacity on this stream layer to 50%.

7 I used the Smudge tool to manually smudge the stream, giving it a slight blur and direction to make it appear to be moving.

8 I then modified the layer's hue and saturation by choosing Image > Adjustments > Hue / Saturation from the menu bar.

9 To complete the effect, I added water droplets by using the Clone Stamp tool to select an area of the water stream.

10 I then selected a tiny soft brush and painted little water droplets around the edges (see Figure 1.32).

Figure 1.32

The table

I chose two source images of wooden boards to use as the countertop and the base of the table.

1. I selected and copied them into a new layer in my composite image and then changed the hue of the boards to a blue color, in keeping with the carnival theme, by selecting them and then choosing Image > Adjustments > Hue / Saturation.

2. I then positioned the target layer between the countertop layer and the base layer.

3. Using the Burn tool, I added some shadowing for depth.

4. Finally, I duplicated the target layer and moved it to either side of the original target. Choosing Edit > Free Transform from the menu bar, I skewed and distorted both duplicate targets so that they had left and right perspectives, respectively, as shown in Figure 1.33. This made this table more like the actual carnival game, with multiple targets for multiple players.

Figure 1.33

Balloons

1. I used a source image of a lightbulb to simulate the nozzle where my balloon would attach to the table. I simply selected the base of the lightbulb from the source image and then copied and pasted it into a new layer in the composite image.

2. Then I duplicated the new layer twice and moved each copy so I could add a nozzle for each target (see Figure 1.34).

Figure 1.34

3 I then merged a source image of a balloon with a source image of a condom (ahem). The contrast between the sources needed to be adjusted slightly; otherwise, the two shapes merged nicely together.

4 I duplicated the finished balloon layer once and moved each of the balloons over an end nozzle. I then changed the hue of each balloon and skewed them in different directions to make them look different. I applied finishing touches by giving them slight shadows using the Burn tool from the toolbox (see Figure 1.35).

Figure 1.35

Attaching Al

1 First I used the Lasso tool from toolbox to select Al's head from his publicity source image.

2 I then copied and pasted his head into the project and moved its layer to the top.

3 I removed Al's face, using the Eraser tool in the toolbox, leaving only his hair.

4 I added shadowing to the hair and the table to make the two seem more realistic (see Figure 1.36).

5 Next, I went back to my source image of Al and recopied his head into my image file on a new layer.

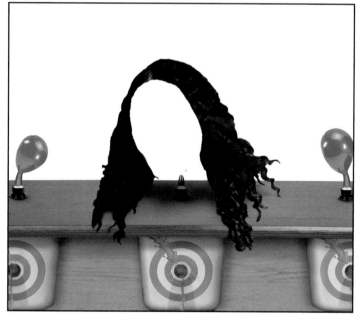

Figure 1.36

6 I then chose Filter > Distort > Spherize and his face layer became circular. This would be the base of the "Alloon," as I called it.

7 I then simulated shadows to the table beneath Al's head using the Burn tool from the toolbox.

8 Finally, I connected Al's head to the nozzle by using my Polygonal Lasso tool to select a small rectangle sampling of Al's skin. I then copied this into a new layer and pasted it beneath his face.

9 I maneuvered this new layer into position between his head and the nozzle.

10 To give the image some finishing touches I chose Filter > Liquify from the menu bar and enlarged and distorted Al's left eye and cheek (see Figure 1.37).

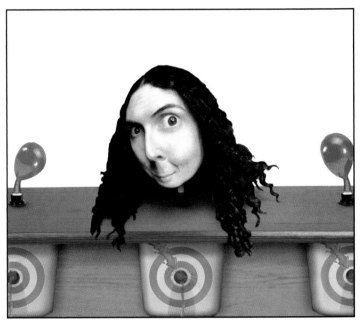

Figure 1.37

Background

In this last step, I blended three different source images of carnival prizes together to create the booth background. It didn't matter what source image I used, though; I was really just looking for bold colors and shapes. I selected Filter > Blur > Gaussian Blur from the menu bar and then used my Burn tool to give this layer some shadow depth.

After more than two decades of lampooning pop princesses, gangsta' rappers, rock legends, and country moguls, you just never know where Al will pop up next.

Credits

Author: Andrew V. Gamet
Source Images: Clipart.com, Photos.com, Mark Seliger

2

Scary and Funny Signs

O ne thing we at Worth1000.com try to do is improve society. We realize that signs just aren't so effective at getting people to stop and listen. When's the last time you ever really came to a complete stop at a stop sign? When's the last time you went ahead and parked in a "No Parking" zone because you "would only be there for a second?"

Maybe if signs were a little bit more like we envisioned them, people would actually follow the rules.

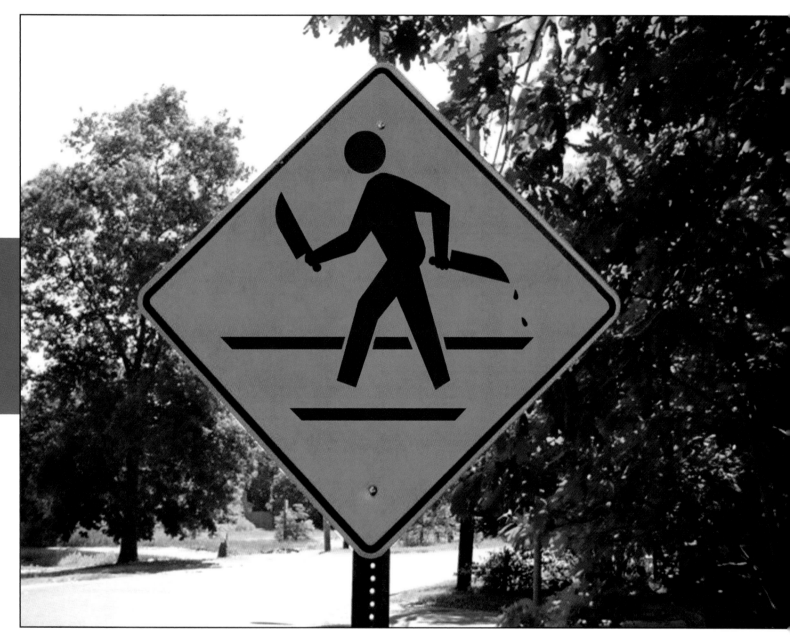

Serial Killer Crossing
By Kerry Brennan
Source Images: Kerry Brennan

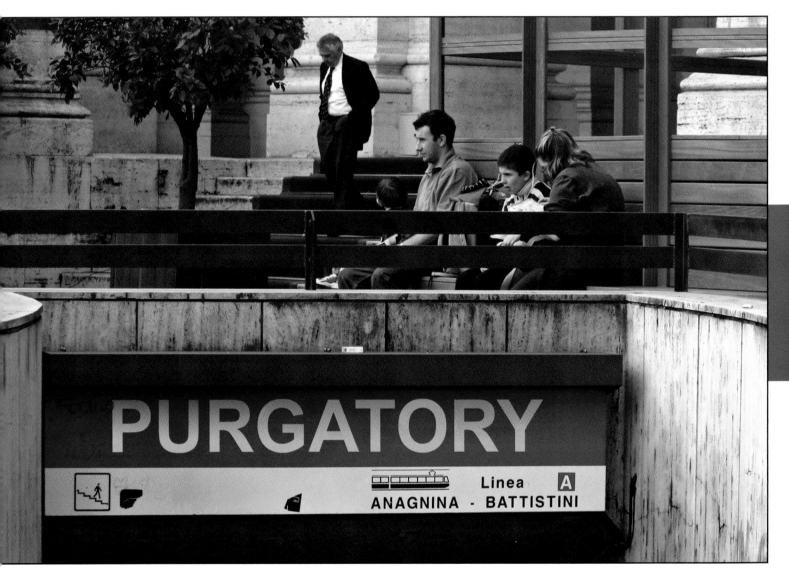

Purgatory, This Way
By Kerry Brennan
Source Images: Bonifacio Pontonio Design

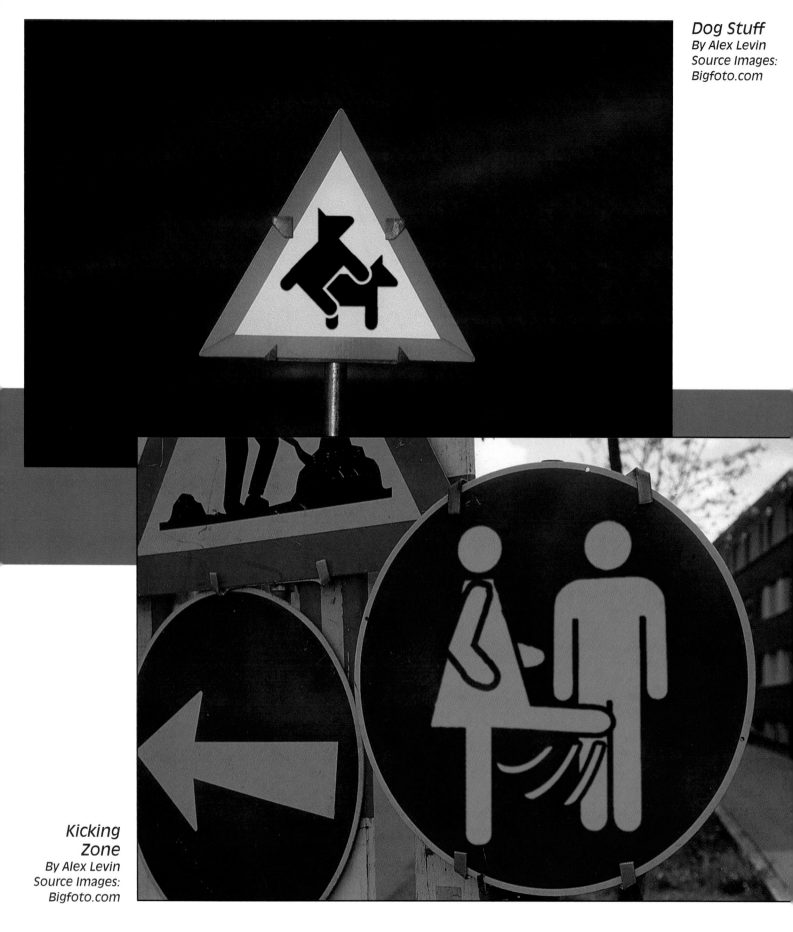

42

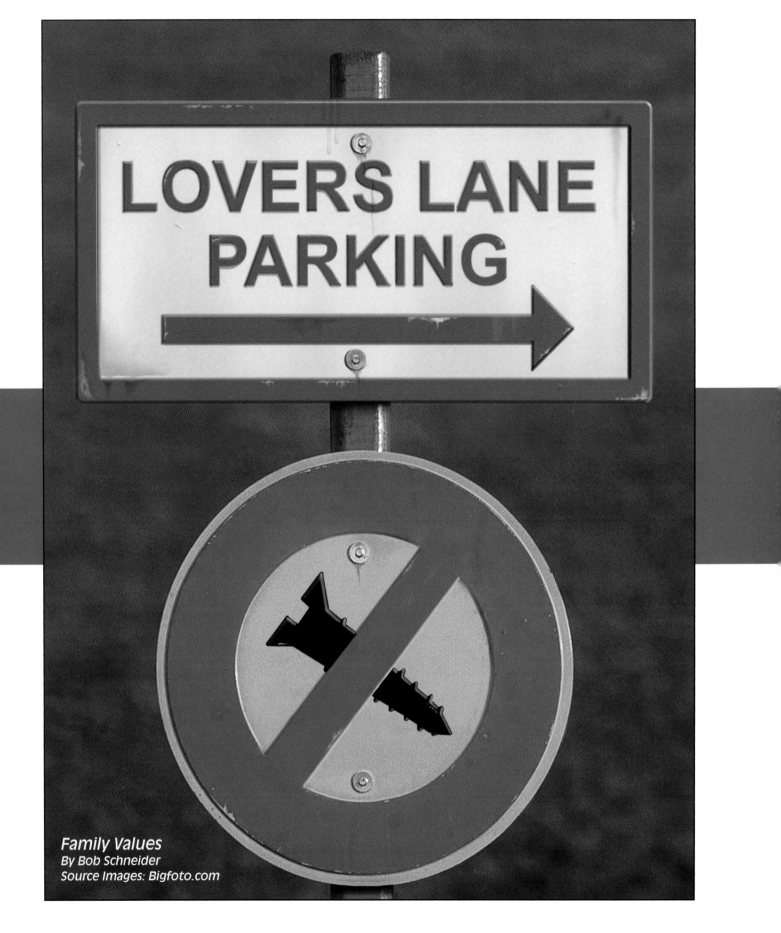

Family Values
By Bob Schneider
Source Images: Bigfoto.com

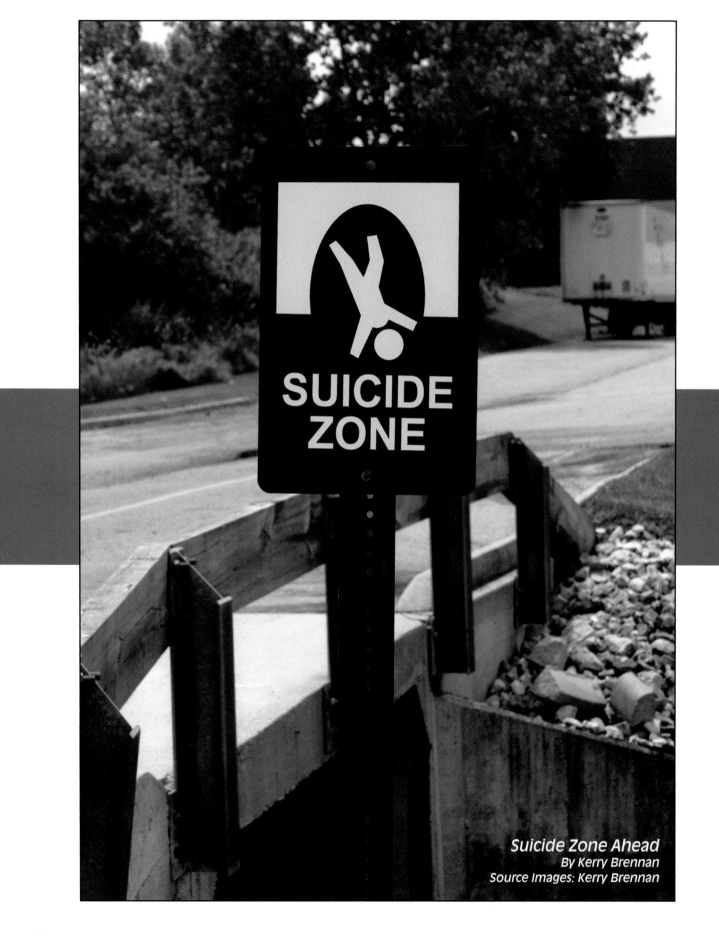

Suicide Zone Ahead
By Kerry Brennan
Source Images: Kerry Brennan

Snail Crossing
By Derek Ramsey
Source Images: Photospin.com

Fish Fast Food Area
By Agustin M. Martin
Source Images: Bigfoto.com

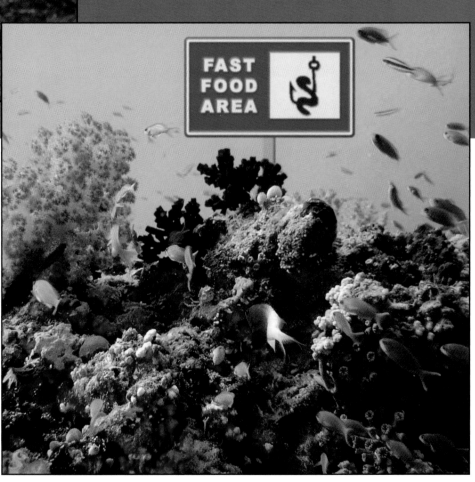

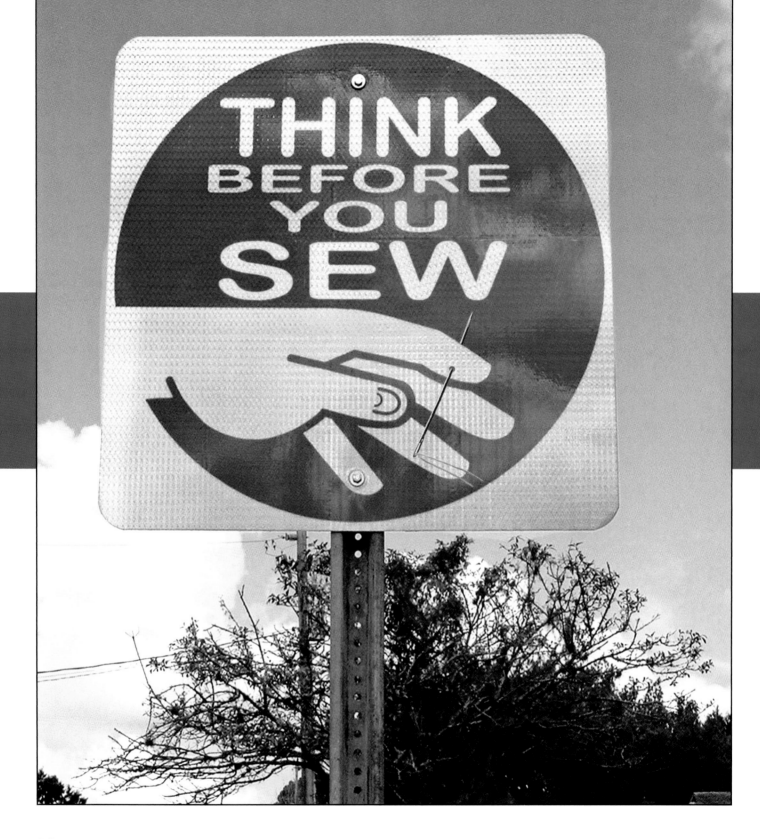

Stomp Ahead
By Jeff Birtcher
Source Images: Jeff Birtcher

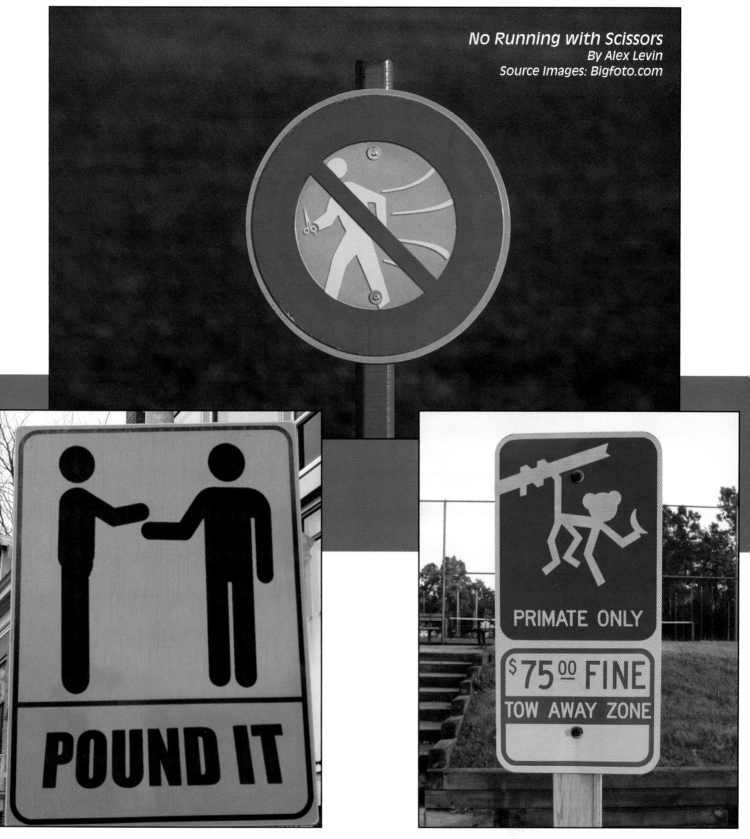

Pound It
By Alex Levin
Source Images: Imageafter.com

Primate Parking Only
By Axwear
Source Images: Axwear

Pedestrian Open Season
By Chris McKenzie
Source Images: Chris McKenzie

49

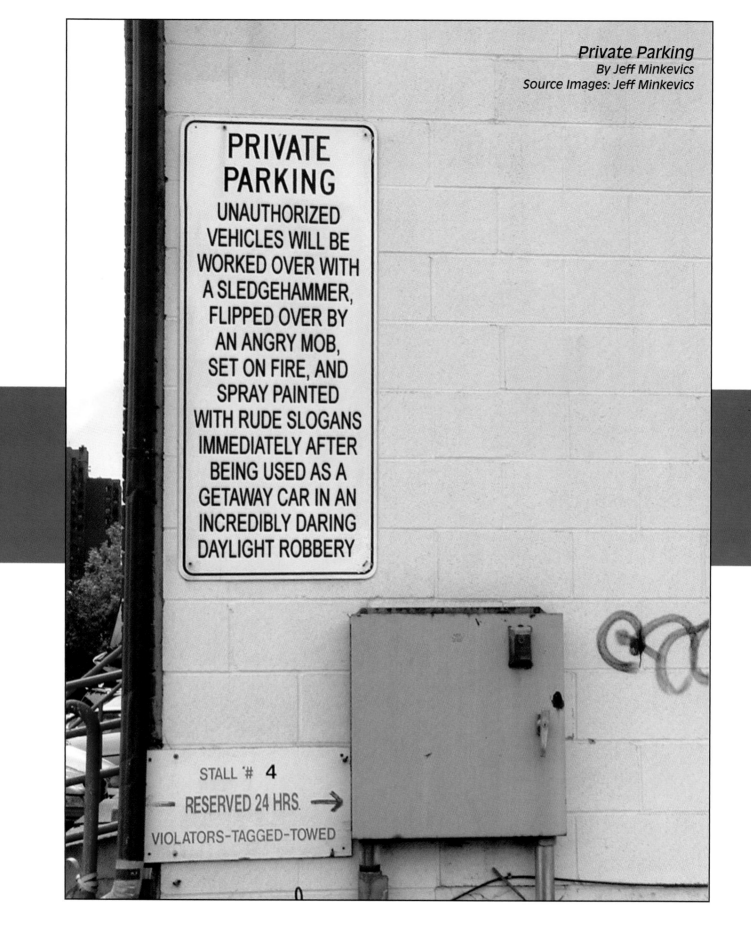

Private Parking
By Jeff Minkevics
Source Images: Jeff Minkevics

PRIVATE
PARKING
UNAUTHORIZED
VEHICLES WILL BE
WORKED OVER WITH
A SLEDGEHAMMER,
FLIPPED OVER BY
AN ANGRY MOB,
SET ON FIRE, AND
SPRAY PAINTED
WITH RUDE SLOGANS
IMMEDIATELY AFTER
BEING USED AS A
GETAWAY CAR IN AN
INCREDIBLY DARING
DAYLIGHT ROBBERY

STALL # 4
← RESERVED 24 HRS. →
VIOLATORS-TAGGED-TOWED

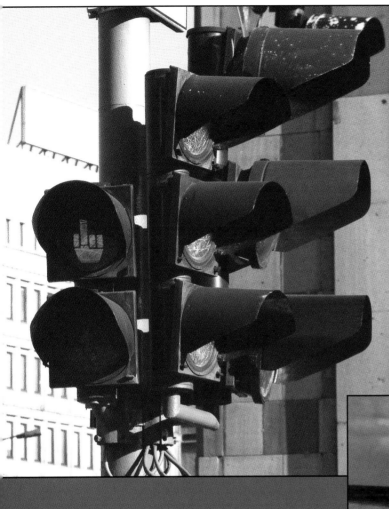

Seriously, No Walking
By Marcin Dziedzic
Source Images: Marcin Dziedzic

Topless Photos Only
By Christel Bohnen
Source Images: Christel Bohnen

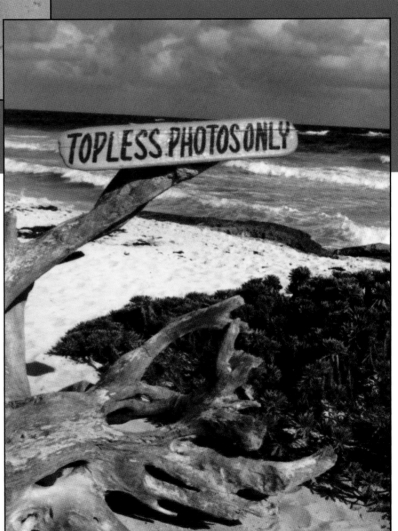

Tutorials

How I made Private Parking

Sometimes signs have a meaning that is generally understood by all. The stop sign certainly comes to mind. The vast majority of us understand that it's not a good idea to blow through a stop sign (unless of course there are no police around, then it's just an efficient use of time to speed through). But Private Parking signs are different. People see "Private Parking" and instantly try to guess the intent of the person who put the sign up. "Sure, it says Private Parking," an oblivious driver might say, "but I'm not really parking, just resting my car here so I can run across the street to the deli to pick up my lunch and do some scratch-off tickets." In our litigious society, you'd think someone would have fixed the humble Private Parking sign by now. Fortunately, we have a prototype ready.

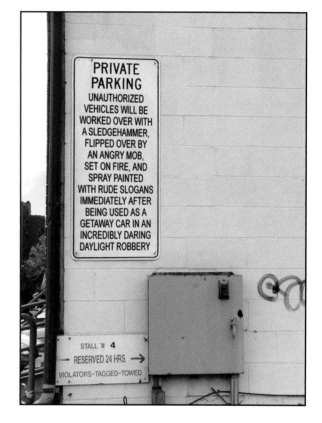

This tutorial assumes that you have a basic grasp on how to use Photoshop, but it provides clear steps so that even less-experienced users can follow along.

First, I selected a source image to work with (see Figure 2.1):

Figure 2.1

From there, I used the following steps to create the image:

1. I removed the sign text in order to make it virtually blank, except for the words **Private Parking**, which I wanted to keep.

2. Working on the newly created layer, I used the Clone Stamp tool from the toolbox to sample a white portion of the sign background. Then I carefully cloned that white portion directly onto the black letters on the sign, to eliminate the unwanted sign text (see Figure 2.2).

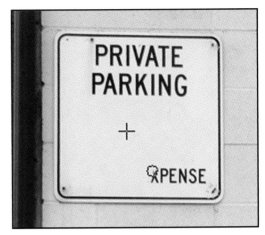

Figure 2.2

3. Once all of the letters were removed from the sign, I changed its shape to accommodate the massive amount of text I had planned for this sign—text that would leave nothing to the imagination of the potential offender. To do this, I copied and pasted the bottom of the sign (from the layer where I removed the text from the sign copy) into its own layer. I reselected the layer holding the blank sign, selected the middle of the sign, and copied and pasted it to its own layer, as well.

4. I then selected the layer holding the middle of the sign by clicking its layer thumbnail in the Layers palette. I stretched the layer holding the middle of the sign by selecting Edit > Free Transform from the menu bar, dragging the vertical handles to the size that I wanted, and clicking Commit.

5. Then I selected the layer holding the bottom of the sign and used the Move tool to move the bottom of the sign to match up with the stretched middle sign layer.

Figure 2.3

6. I used Edit > Transform > Distort as needed on the sign layers to line the edges of the sign, as well as the sign with the bricks. I clicked Commit to finish each change (see Figure 2.3).

7 I then merged all of the layers together into one single layer by selecting Layer > Merge Visible from the menu bar. I was left with a large, blank sign just waiting for some horrid description of what would happen to the poor unfortunate sap who parked there without permission (see Figure 2.4).

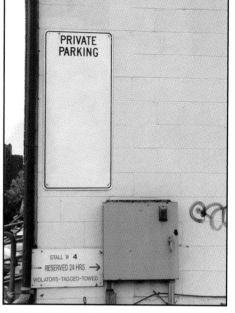

Figure 2.4

Adding the text was relatively easy to do. All I had to do was compare the size and shape of the different fonts I was using against what actually appeared on the original sign. In this particular case, I chose to use an Arial font, as it is one of the most commonly used fonts for signs. Here's how I added the text to the enlarged sign:

8 Using the Horizontal Type tool from the toolbox, I typed the same text that appeared on the original sign and played around with the different text options (font size, space between letters, width/height proportions) until I had almost perfectly matched up my words to those of the original sign. (I simply dragged the text directly over the words I was copying to better see how they compared). Once I felt they were similar enough, I erased my sample text and typed out my very stiff warning, before clicking Commit (see Figure 2.5).

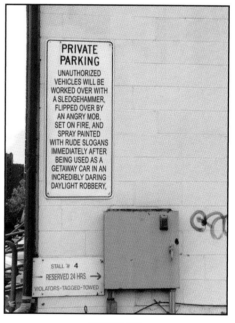

Figure 2.5

9 I noticed that the font was a bit square and did not quite conform to the boundaries and tilt of the sign. This was easily solved by rasterizing the text layer by choosing Layer > Rasterize > Type from the menu bar. That command converted my type layer into a picture of the type, meaning I could no longer edit it as text. However, now I could distort it easily and make it fit better within the sign. I selected Edit > Transform > Distort from the menu bar and positioned the corner handles on the bounding box to line up with the proportions of the sign, clicking Commit to finish (see Figure 2.6).

10 I then saved the finished sign image.

With the new text, sledgehammer, angry mob, spray paint, and potential robbers in place, we're now free to leave our coveted parking spot knowing it will be there when we get back. Inefficient, but highly effective.

Credits

Author: Jeff Minkevics
Source Images: Jeff Minkevics

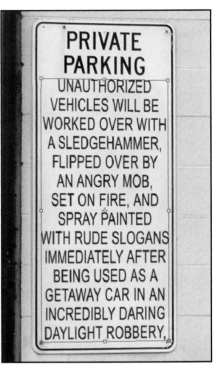

Figure 2.6

How I made Fish Fast Food Area

They call fishing a sport. Ha! Let's give the fish at least a fighting chance and warn them of what may be coming. To the cunning fish, this will be a dining area. To the slow-witted, this will be their last swim and first introduction to dry land. With a three-second memory span, the fish will most likely pay close attention to this sign for quite a long time. "Fast food area. Wow!" one fish may say. "Fast food area. Wow!" that same fish might say three seconds later. "Fast food area. Wow!"

Getting started

This tutorial assumes that you have a basic grasp on how to use Photoshop.

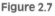

First, I selected an underwater image scene. I looked for something with fish, coral, or other submarine life and settled on Figure 2.7.

1. I then located a free area in the watery blue background of the image, which seemed like the perfect place to put my sign—a place where fish would surely read it. I got particularly lucky with this image because some of the fishes were facing the place where I intended to put my sign, and that eventually made the image funnier. I prepared this background layer for the placement of my sign by using the Clone Stamp tool to erase the swimming fish that appeared behind my sign. I then had a clear area in which to add my sign.

Figure 2.7

2. Next, I selected the Rounded Rectangle tool from the toolbox, clicked the Paths button in the options bar, and used the tool to create a path in the basic shape of the sign (see Figure 2.8).

Figure 2.8

3 I then selected Layer > New > Layer from the menu bar, typed a layer name, and clicked OK. The new layer was added above the layer with the rectangle path on it.

4 I clicked on this new layer in the Layers palette to select it. Then I went to the Paths palette and selected the rectangle work path. I clicked on the round arrow palette menu button at the top right of the Paths palette, chose Make Selection, and clicked OK. I then had a selection marquee in the shape of my rectangle path.

5 Switching back to the Layers palette and the new layer I created, I used the Fill tool from the toolbox and filled the selection up with a dark blue. I temporarily hid the background layer that held my original rectangle path by clicking the eye icon beside that layer on the Layers palette.

6 Then, I created the white and black bounding borders around the sign by using the same process as described above, only I created a slightly larger rectangle each time. For convenience, I placed them all into their own layers and moved them beneath the blue sign layer. They now appeared to the eye as a single layer.

7 In the Layers palette, I selected the bottom layer that comprised the outermost black border of the sign and selected Layer > Layer Style > Bevel and Emboss from the menu bar shown in Figure 2.9. I specified settings for a large outer bevel that would give the sign edges a feeling of depth and clicked OK.

Figure 2.9

Fish gotta...read?

1 To add the text, I selected the Horizontal Type tool from the toolbox and typed **Fast Food Area** in a bold white font in a new layer. I made sure to drag the new type layer to the top of the list in the Layers palette. I went back to the Layers palette and selected the layer to which I had previously applied the bevel and emboss. I then chose Layer > Layer Style > Copy Layer Style from the menu bar. Then I selected my Fast Food Area type layer in the Layers palette and chose Layer > Layer Style > Paste Layer Style from the menu bar. The same bevel settings instantly were applied to the wording of my sign, giving it the same feeling of depth and being underwater that the sign border had. You can see the results in Figure 2.10.

Figure 2.10

2 Then I created the symbol for the sign. First, I created a white square in a new layer. This served as the backdrop for the symbol. I gave it the same beveled edges as I did the lettering and the sign edges to better blend it with the sign. Then I created a new layer and began drawing a path in the shape of a worm on a hook with the Pen tool. The hook is there to give fair warning to the local fish—we are trying to make this "sport," after all.

3 Again, I created a new layer, and it was added above the layer with the worm path on it. I clicked on this new layer to select it. I went to the Paths palette and selected the worm work path. I clicked on the Palette menu button at the top right of the Paths palette, chose Make Selection, and clicked OK. I now had a selection marquee in the shape of my worm path.

4 Switching back to the Layers palette and the new layer I created, I used the Fill tool from the toolbox to fill the worm selection with a black color. Since I would no longer need it, I hid the layer that held my worm path by clicking the Layer Visibility (eye) icon beside that layer on the Layers palette.

5 Then, I moved the black worm over the white area of the sign. I applied the same Bevel layer style to this worm layer.

6 The last addition to the sign was the post that held it up. To create this, I again used the rounded rectangle path and created a gray beveled rectangle using the same steps I used to create the sign itself. The only difference is that I used a much softer bevel on the post, in order to give it a rounder metallic feel. I then moved the signpost layer below all the other sign layers in the Layers palette, so that it appeared to be behind the sign. Next I used the Move tool to properly position it in the bottom-center of the sign.

Finishing touches

The sign was nearly done, so it was now time to merge it.

1 First I made sure that all of the layers that comprised the sign were visible by checking that the Layer Visibility (eye) icon was displayed.

2 I then clicked the Layer Visibility icon for any displayed layer that wasn't part of the sign.

3 Finally, I selected Layer > Merge Visible from the menu bar. All of the sign layers were merged into one, and I was able to work on the entire sign to give it a better underwater feel.

Because the sign was in the background of the image, and underwater, I decided to give it a slight blur and a blue tint.

4 To achieve the blur, I chose Filter > Blur > Gaussian Blur from the menu bar and created a blur that was less than 1 pixel in radius.

5 To give it the blue tint, I lowered the sign layer's opacity to 90% from the Opacity slider on top of the Layers palette. This added a bit of the background water color to the sign, which added to the effect of the sign being underwater (see Figure 2.11).

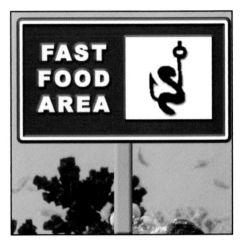

6 The final step was blending the sign with the background image. Using the Eraser tool from the toolbox, I carefully erased the parts of the sign post that blocked part of the fauna that was supposed to be in front of it.

7 I then redisplayed the background layer by clicking to redisplay its Layer Visibility (eye) icon in the Layers palette.

Figure 2.11

We know what you're thinking... how do you know fish can read? Duh... they learn in schools. *Editorial note: sorry.*

Credits

Author: Agustin M. Martin
Source Images: www.bigfoto.com

How I made Pedestrian Open Season

We all know how embarrassing it can be when you get caught hunting pedestrians out of season. We have signs to tell us speed limits, weight limits, where you can turn and can't, and which direction to go. Finally, a sign to make it clear how many pedestrians you're allowed to bag and when. We always wondered why our boss always gets in before 8:30 and works until at least an hour past sunset…

Getting started

I primarily used the Clone Stamp tool and Healing Brush tool (found in Photoshop 7 and above), along with the Type tool and Shape tool. This tutorial is for intermediate users. It assumes that you have a basic understanding of how Photoshop works; that is, you know the difference between active and inactive layers (and how to make a layer active or inactive) and how to create new layers and copy existing layers.

1. After opening the source image, selecting the Background layer content, and copying it into a new layer, I zoomed in close to the image by selecting View > Zoom In from the menu bar.

2. Working on the layer copy, I used the Clone Stamp tool to clone out the sign text in the white areas. First I selected a white area of the sign to copy, and then I carefully painted over the black lettering of the sign. I was left with the empty sign shown in Figure 2.12.

3. Next, I selected the Healing Brush tool and chose a small brush size. After looking closely at my newly erased sign, I could see that the white area was not one solid color; it had some color noise associated with it. I chose a section that had a lot of noise and selected it with the Healing Brush tool.

4. Then I clicked the less noisy areas where I had cloned and painted. The Healing Brush blended in the noise throughout the white sign, removing all evidence of using the Clone Stamp tool.

Figure 2.12

5 I then removed the stick figure from the image, in order to add him and adjust him for use as part of my finished image. To do this, I duplicated the stick figure into his own layer and used the Clone Stamp tool (and Healing Brush) to remove him from the original sign.

6 I selected the Magic Wand tool from the toolbox, gave it a tolerance of 100, and clicked within the stick figure's body. I then used Shift + click to add the head, bouncing ball, and road line to the selection. There was now a selection in his shape.

7 I chose Edit > Copy and Edit > Paste from the menu bar and the selection of the stick figure was added to a new layer. I wasn't ready to work with him just yet, so I hid the stick figure layer by clicking the Layer Visibility (eye) icon next to the new layer on the Layers palette and then selected the original sign layer to resume work on it.

8 Using the Clone Stamp and Healing Brush tools (and the same methods described earlier), I removed all traces of the stick figure from the sign. I had a clean canvas (as shown in Figure 2.13) to use and abuse to my heart's content.

Figure 2.13

Target practice

1 I then created my sniper crosshatch. I created a new layer by selecting Layer > New > Layer from the menu bar, typing a layer name, and clicking OK.

2 I then used the Elliptical Marquee tool from the toolbox to create a circle selection. To match the circle with the rest of the sign, I chose the Eyedropper tool from the toolbox and used it to select a black line from the sign. With the selected black color as the foreground color on the toolbox, I selected Edit > Stroke from the menu bar, specified a stroke width of 4 pixels in the Stroke dialog box, and clicked OK. The selection now displayed a black circle behind it.

3 To further add realism, I selected Filter > Noise > Add Noise from the menu bar, specified 4% amount of noise, and clicked OK. This made the circle look less drawn and more like a real photograph. I then chose Select > Deselect to remove the selection marquee from the circle.

4 To make the center line of the target, I clicked on the layer with all the sign content in the Layers palette and then used my Rectangular Marquee tool to select the black line that cuts down the middle of the white area of the sign.

5 I then chose Edit > Copy and Edit > Paste from the menu bar and pasted this duplicate line into a new layer. I used the Move tool to move it up into position on the circle.

6 To stretch it to the right size, I selected Edit > Free Transform from the menu bar, stretched it out to span the entire circle, and clicked the Commit button to apply the change.

7 I then repeated the process to make the little horizontal crosshatch lines that go down the length of the vertical scope line. To turn the first crosshatch sideways, I again chose Edit > Free Transform, used the mouse to rotate the piece horizontally, and clicked the Commit button (see Figure 2.14).

Figure 2.14

8 Duplicating the crosshatch layer was easy. After clicking the layer thumbnail in the Layers palette, I chose Layer > Duplicate Layer from the menu bar to make as many new copies as needed and then used the Move tool to move the pieces into the desired position (see Figure 2.15).

9 To better work with my developing scope lines, I hid all of the other layers by clicking the Layer Visibility icons next to them. I then chose Layer > Merge Visible from the menu bar and now had one layer to work with.

10 I wanted to make some room for my stick figure/boss... err, I mean target, so I decided to clear some of the area in the middle. Using the Elliptical Marquee tool, I made a selection in the center of the developing target and deleted it.

11 Then I duplicated the target into a new layer by choosing Layer > Duplicate Layer from the menu bar. Finally I rotated this new layer horizontally to create the horizontal bar on my sniper's crosshatch, by choosing Edit > Transform > Rotate 90° CCW.

Figure 2.15

12 It was then time to bring back my target stick figure. I made that layer visible again by clicking the Layer Visibility icon next to it in the Layers palette so the eye icon reappeared.

13 Then I chose Edit > Free Transform, stretched him to an appropriate size, and clicked the Commit button (see Figure 2.16).

Figure 2.16

Adding the text

Finally, it was time to add the sign text.

1 I chose the Horizontal Type tool from the toolbox and selected an Arial (20pt and bold) font, which seemed to match the original text that appeared on the unedited sign. I typed **MAX LIMIT** into the white area of the sign and clicked the Commit button (see Figure 2.17).

2 I noticed that the words **MAX LIMIT** appeared a little too sharp for the sign. To fix this, I selected the type layer in the Layers palette. I chose Filter > Blur > Gaussian Blur from the menu bar, clicked OK when prompted to rasterize the text, set the blur Radius relatively low (1.3 pixels), and clicked OK.

3 Finally I chose Filter > Noise > Add Noise from the menu bar, specified an appropriate Amount of noise, and clicked OK.

Figure 2.17

I added the rest of the wording to the image using the same technique I applied to the words "MAX LIMIT" and was finished!

I recognize that 30 may be quite a low number for some people's taste, but a society without rules just isn't a society, now is it? Now, if only my boss would leave early.

Credits

Author: Chris McKenzie
Source Images: Chris McKenzie

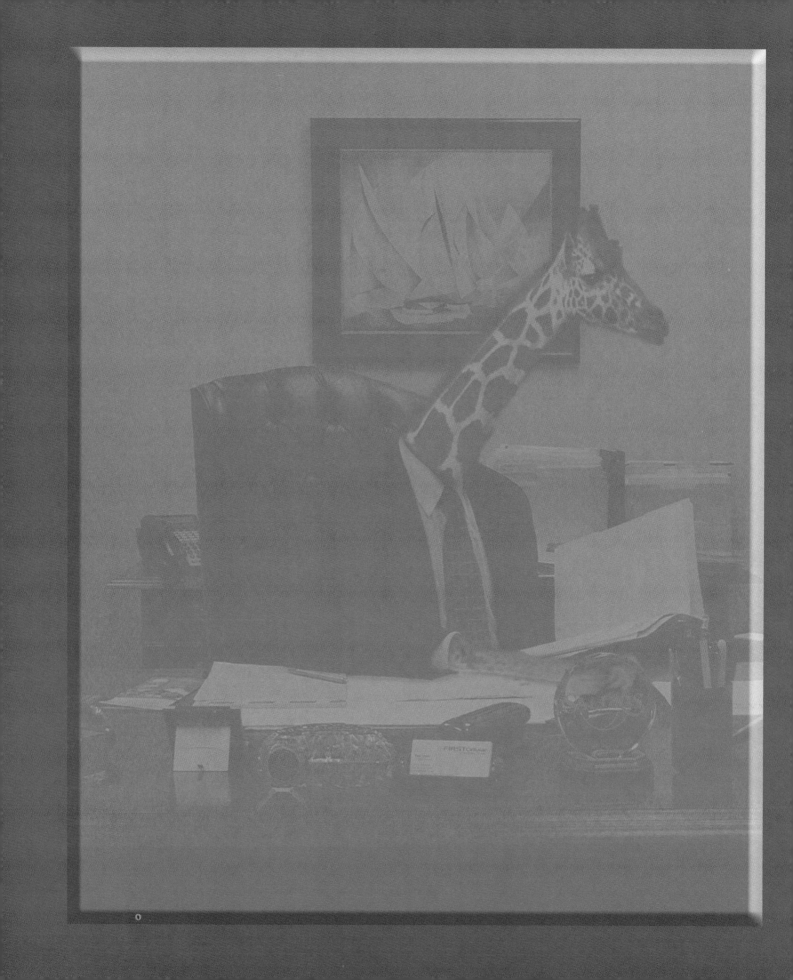

CHAPTER 3

Animal Antics

Oh, those wacky, crazy animals. Whether it's eating grass, moving around, or sleeping, they never fail to amuse us with their zany antics. At Worth1000.com, we have several competitions focused on making animals a little more exciting: We have competitions to genetically crossbreed them with other animals, objects, and technology; competitions to make them more human-like; competitions to depict them as the truly evil, mischievous beasts that they really are. Hmmm…hopefully no one from PETA gets a hold of this book.

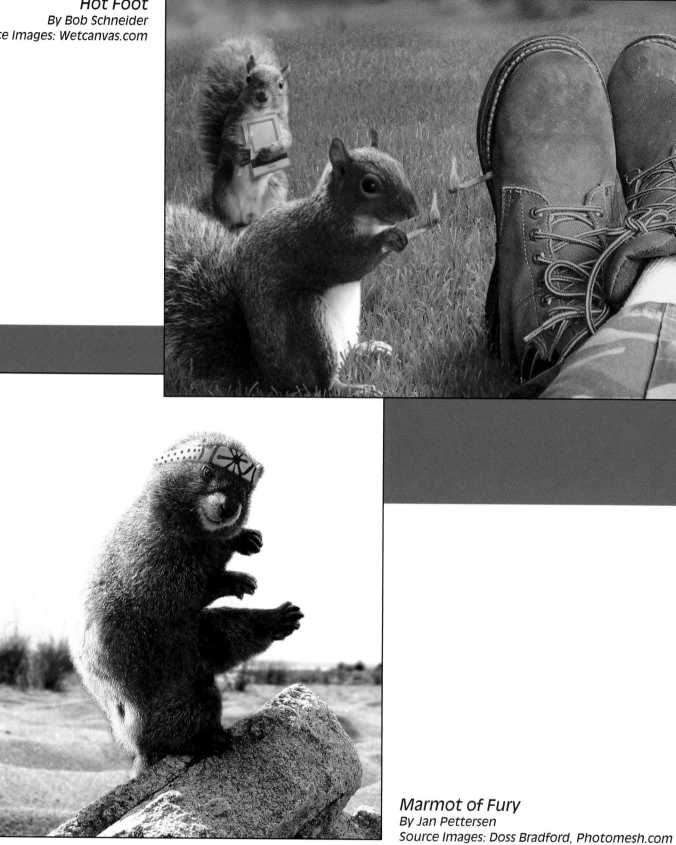

Hot Foot
By Bob Schneider
Source Images: Wetcanvas.com

Marmot of Fury
By Jan Pettersen
Source Images: Doss Bradford, Photomesh.com

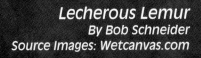

Lecherous Lemur
By Bob Schneider
Source Images: Wetcanvas.com

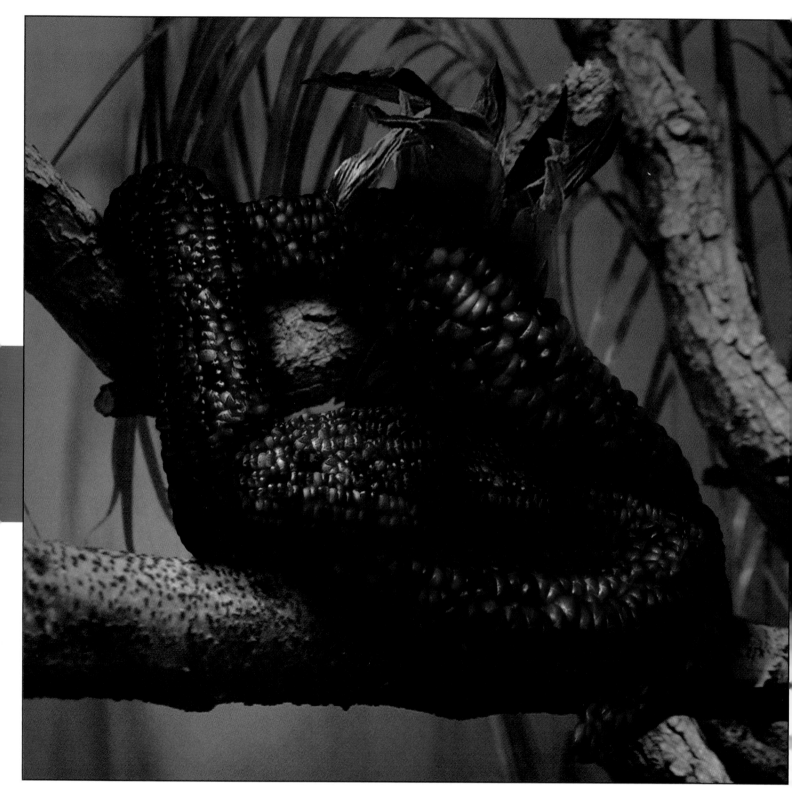

Corned Viper
By Allison Huff
Source Images: Wetcanvas.com

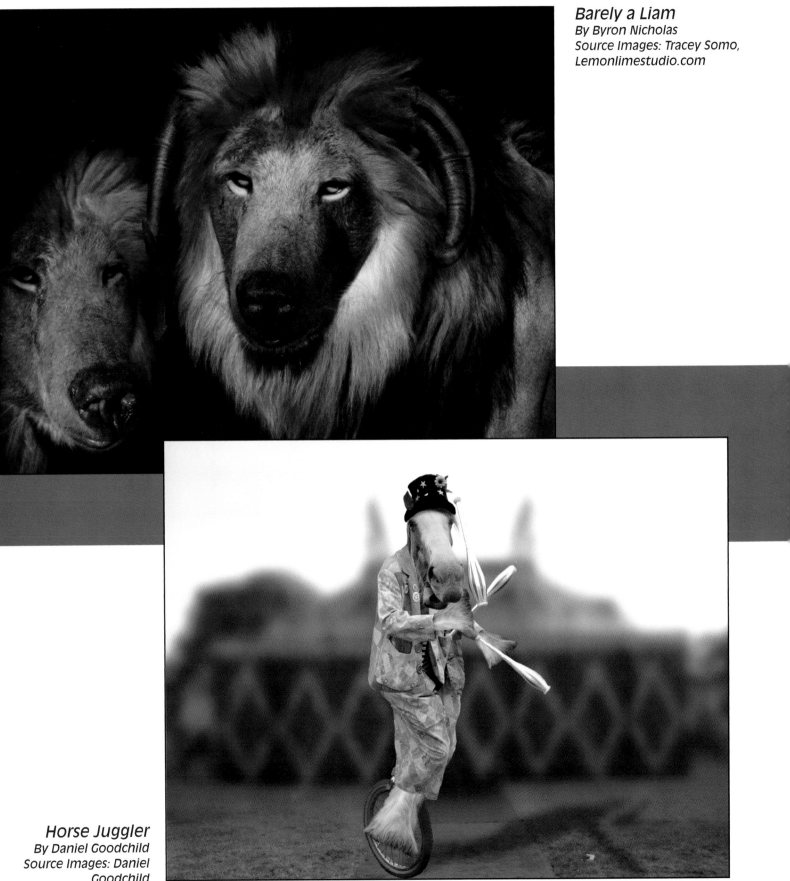

Barely a Liam
By Byron Nicholas
Source Images: Tracey Somo,
Lemonlimestudio.com

Horse Juggler
By Daniel Goodchild
Source Images: Daniel
Goodchild

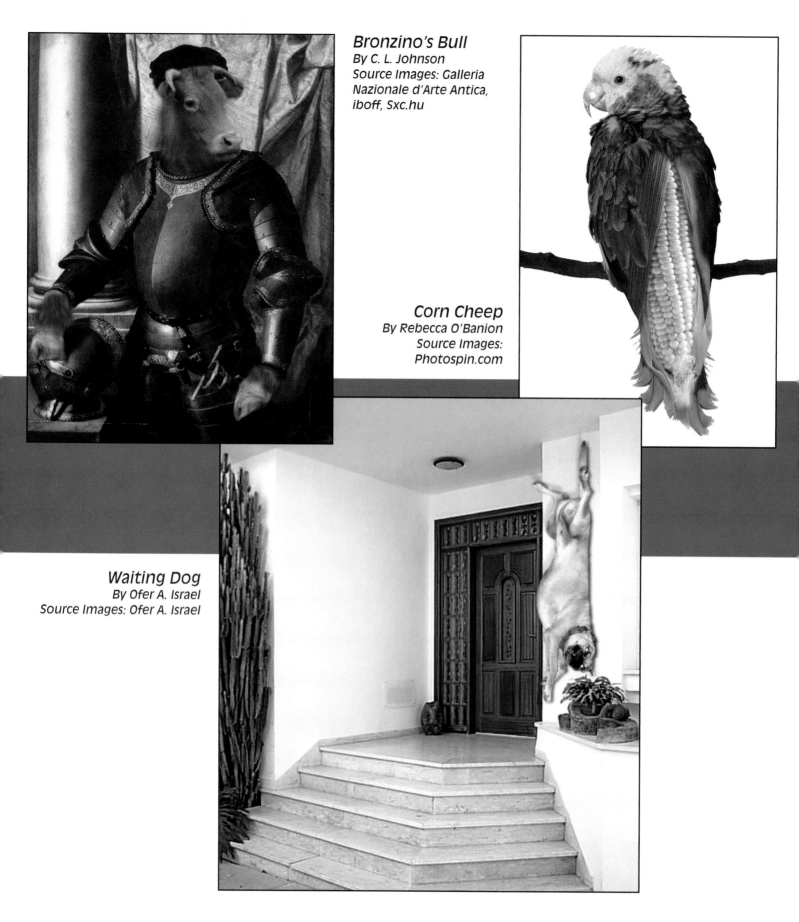

Bronzino's Bull
By C. L. Johnson
Source Images: Galleria
Nazionale d'Arte Antica,
iboff, Sxc.hu

Corn Cheep
By Rebecca O'Banion
Source Images:
Photospin.com

Waiting Dog
By Ofer A. Israel
Source Images: Ofer A. Israel

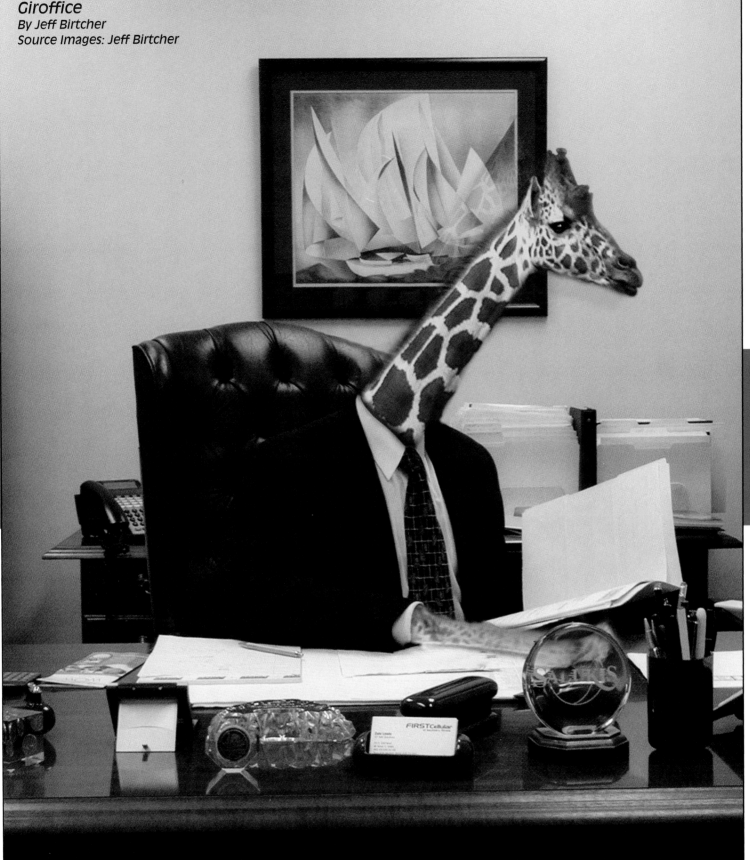

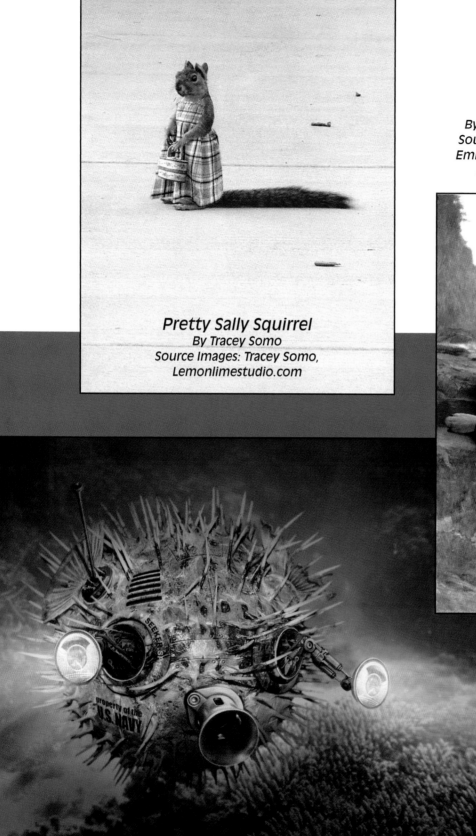

Pretty Sally Squirrel
By Tracey Somo
Source Images: Tracey Somo,
Lemonlimestudio.com

Friendship
By Renato Dornas de Oliveira Pereira
Source Images: Artrenewal.org, Sxc.hu,
Emma, Ibon san Martin, Jennifer Tuttle,
Joern Straten, Robbie McDowall

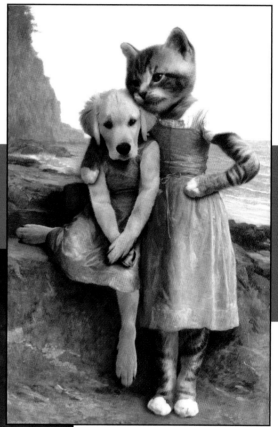

Techno Puffer
By Kris Aring
Source Images: Franca
Cibecchini, Mathew Hillier,
Mark Rutkiewicz, Paul Fris,
Sxc.hu

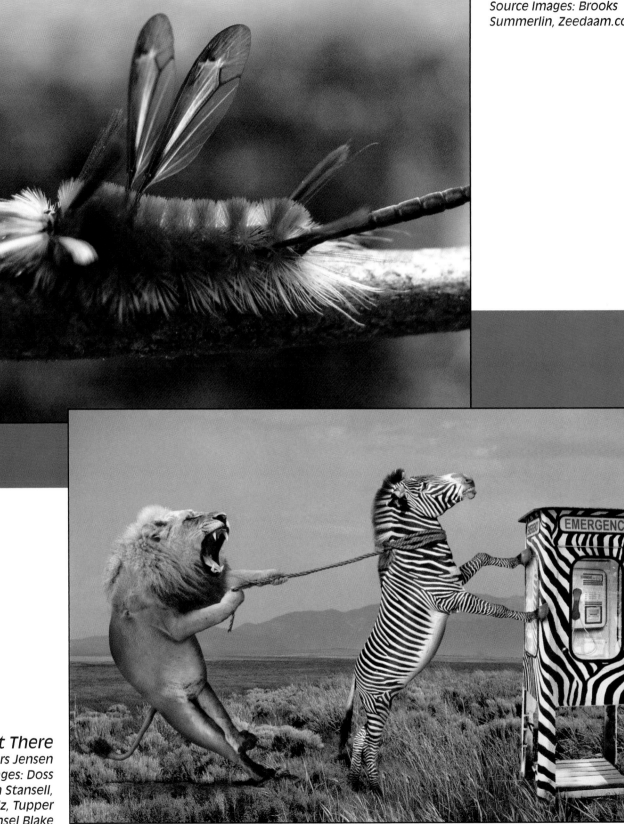

Dragonpillar
By Brooks Summerlin
Source Images: Brooks
Summerlin, Zeedaam.com

Almost There
By Anders Jensen
Source Images: Doss
Bradford, Ken Stansell,
Gary M. Stolz, Tupper
Ansel Blake

Tutorials

How I made Corned Viper

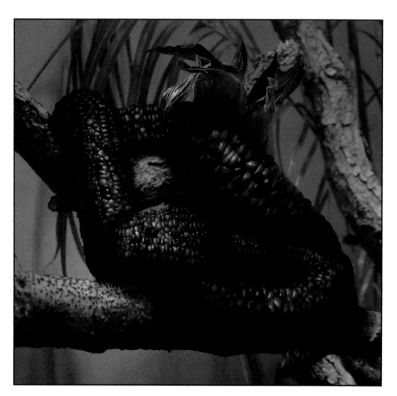

The debate on agricultural cloning will wage on for years to come. Any idea that can help engineer crops to grow in tougher environs to help get food to hungry people is a good idea. Any idea that crosses said food with an animal that could potentially run away from (or maybe even attack) said hungry people is probably a very bad idea. The Corned Viper is a result of government investment in agricultural sciences, imagination, and genetic engineering spinning violently out of control.

Getting started

This tutorial assumes that you have a basic grasp on how to use Photoshop.

To begin this project, I used two source images: one of an ear of corn and one of a viper in a tree.

1. I started my project by placing my source image of a viper in a tree into a new image file in Photoshop. To do this, I chose Select > All, Edit > Copy, File > New, and clicked OK to accept the file dimensions specified in the New dialog box. Then I chose Edit > Paste. This created the new image file in exactly the same size as the original.

2. I clicked the layer with the viper in the tree in the Layers palette and chose Layer > Duplicate Layer from the menu bar. I typed a layer name in the As text box and then clicked OK.

3. Then I chose the Eraser tool from the toolbox and erased everything but the viper on the new layer. I wasn't concerned with precision: I simply wanted to block out the areas of the corn kernels I would be converting into snake scales later on.

4. I then opened my source image of an ear of corn and used the Lasso tool on the toolbox to select a general portion of the ear of corn. The exact dimensions didn't matter: I just needed a random chunk of the corn with a lot of kernels showing. I copied the selection by choosing Edit > Copy from the menu bar and pasted it into my project image as a new layer using Edit > Paste from the menu bar. I repeated this step several times until I had a few different pieces of corn in different sizes to work with.

5 To make it easier to work with the corn layers, I renamed them according to how they looked. To rename each layer, I right-clicked the layer name in the Layers palette, clicked Layer Properties, typed a new Name in the Layer Properties dialog box, and clicked OK. I used the Eraser tool to remove any pieces of unwanted corn or background on each corn layer.

6 Still working in my project image file, I created a new layer. I chose Layer > New > Layer from the menu bar, typed **cloning 1** as the layer Name in the New Layer dialog box, and clicked OK. In the Layers palette, I dragged the cloning 1 layer above the layer that held my viper. This eventually became the main layer that I copied the corn kernels onto in the same shape as the viper.

Merging the two

1 Just to get a start, I changed the angle of the corn on each of the corn layers to see which ones would be more suited for which areas of the viper. Most snakes have a light underbelly, so I opted to use the red-orange corn for the top areas of the body and the yellow-multicolored corn for the belly areas. This may not make for the most camouflaged viper in the world, but sacrifices must be made in the name of science. (To rotate the corn on each layer, I first hid any piece of corn I wasn't working on by clicking the Layer Visibility icon by the unwanted layers on the Layers palette, and then I made sure the corn layer I was working on was visible and active. I chose Edit > Free Transform, dragged near the border to rotate the corn, and clicked Commit.)

2 Then, I moved on to work with the largest section of the snake: its right, upper back. I turned off the visibility for all other corn layers by clicking the Layer Visibility (eye) icon beside each on the Layers palettes, hiding everything except the layer I needed to work with (the largest red-orange piece). I chose Edit > Free Transform from the menu bar; dragged handles with the mouse to adjust the perspective, skew, and rotation of the corn piece; and when it reached the shape of the snake's back, I clicked Commit (see Figure 3.1).

3 I chose the Clone Stamp tool from the toolbox and selected the middle of my visible corn layer as the source. I then selected my empty cloning 1 layer and painted this cloned corn into it using a large, hard-edged brush at 100% opacity and flow. When this was completed, I went back to my corn layer to again transform and rotate it slightly by using Edit > Free Transform from the menu bar.

Figure 3.1

4 I continued to create new layers using cloned pieces of corn and rotated/transformed them all as needed, until I was left with the general shape of the snake. When I was done, I merged all of the corn-snake layers together by first hiding any layer that wasn't part of my cloned corn and then choosing Layers > Merge Visible (see Figure 3.2).

5 Next, I removed the excess corn kernels around the shape of the snake using the Eraser tool and generally cleaned up the mess so I had a well-defined snake shape to work with. I moved the viper layer above all of the cloned layers for better visibility while outlining.

Figure 3.2

6 I then dropped the Opacity slider on the Layers palette to 50% to make it easier to view the translucent viper layer while I edited the corn, allowing me to see which kernels needed to be removed (see Figure 3.3).

Figure 3.3

7 I roughly followed the shape of the snake but erased along the edges of the defined kernels. This made the outlining shape of the snake more defined and finished in appearance (see Figure 3.4).

Figure 3.4

8 I wanted to add the corn husk to the image, so I looked over the source images of the ears of corn and chose the husk that I felt would blend in the nicest. I chose the Lasso tool from the menu bar and selected an area of the husk, then copied it into my corn viper project image file by selecting Edit > Copy from the source image and Edit > Paste in the project image file. I positioned the pasted husk layer behind the viper and cleaned it up by using the Eraser tool from the toolbox (see Figure 3.5).

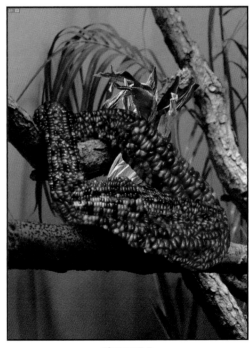

Figure 3.5

Adding shadows

1. Beginning with the upper section of the snake, I began to add in some shadowing. After clicking the Brush tool in the toolbox, I used the options bar to choose a soft size 40 paintbrush.

2. I set the Paintbrush mode to Multiply and changed the opacity setting to 20%. I also used the toolbox to specify a dark brown foreground color to paint with.

3. I then made a couple of light sweeps in the areas that I wanted to have the strongest shadowing. I followed up by using the same paintbrush, setting the mode to Color Burn with an opacity of 5%, over most of the same areas. This further darkened the areas, and it brought out a bit more of the color and definition of the kernels in those areas, as well (see Figure 3.6).

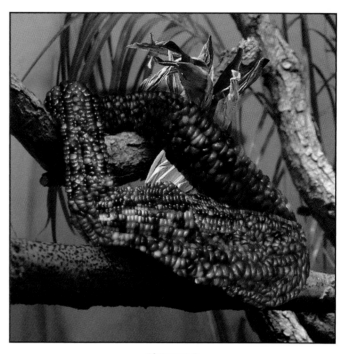

Figure 3.6

4. I tackled each of the remaining layers holding the sections of the corn snake in the same way, taking into account the way each piece twisted and turned as well as the way that the light affected it (see Figure 3.7). Sometimes it took a few trials to see what really looked best for a particular section.

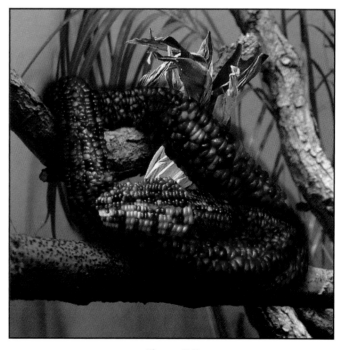

Figure 3.7

Now that the main body was pretty well shaded, it was time to tackle the face.

5 I dropped the opacity of the cloned corn layer by using the Opacity slider on the Layers palette, so that I could see the original viper layer beneath.

6 I used the Eraser tool to erase a space for the viper's eye to peek through the kernels. Once that was done, I returned the layer to 100% opacity and began to add in some shading in the same manner as all of the other sections (see Figure 3.8).

7 To add in the shadows, I used the Paintbrush tool set at low opacities and alternated between Multiply and Color Burn modes, just as I did for all of the layers that made up the entire snake. Always keeping in mind the relationship of the husk to the way that the snake's body rested against it, I applied shading where the darker and lighter shadows would fall in a natural way.

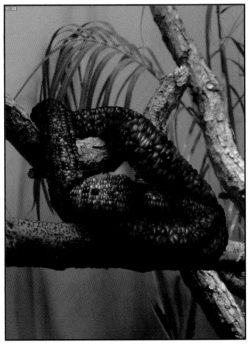

Figure 3.8

8 I then used the Lasso tool to select the small portion of the husk that would appear to hang over the top of the snake. I copied the tip into a new layer and positioned it above the snake layers, so it now appeared to hang over the snake (see Figure 3.9).

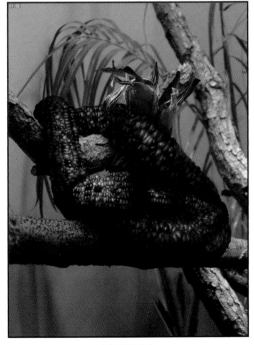

Figure 3.9

9 Looking over the image, one thing that caught my eye was the shadowing of the tree branches beneath the snake. To fix this, I used the Brush tool (again with both the Multiply and Color Burn modes) to apply shades of deep blue-gray and light black to the areas that needed further shadowing. I also added just a bit more shadowing to the edges of the snake that were near the areas that I was darkening (see Figure 3.10).

Figure 3.10

10 Finally, I added in the snake's tail to the cloned corn layer by using the Clone Stamp tool to clone parts of the snake's body. I continued using the Clone Stamp tool to paint in the tail until I was happy with the general shape. I then used the Eraser tool to erase any unwanted parts of the tail (see Figure 3.11).

Figure 3.11

Finishing touches

With all of these things done, I felt it was time to move on to the few, finishing touches.

I really did not like the brightness of the background against the snake's skin. I felt that muting it slightly would compliment the snake a little better.

Figure 3.12

1. I selected the background layer of the tree and viper, adjusted the brightness and saturation by choosing Image > Adjustments > Hue/Saturation from the menu bar, dragged the sliders until the tone appeared as I wanted it to, and finally clicked OK.

2. Next, to add a bit of lighting, I chose a very large (350 pixel), soft brush shape for the Brush tool, set the mode to Soft Light and the opacity to 8%, and chose a pale beige foreground color. I then made a couple of sweeps on the area of the branch that was just in front of the snake. As you can see in Figure 3.12, this also helped to justify the noticeable brightness of the snake's head in the process.

Our incredible, edible viper is now ready for prime time. Hopefully this snake won't spend too much time basking in the hot sun. We'll save the Popcorn Viper for the sequel.

Credits

Author: Allison Huff
Source Images: Wetcanvas.com

How I made Pretty Sally Squirrel

Squirrels work hard, and their work is never done. After a long day of hiding nuts and dodging traffic, a squirrel likes nothing more than to get gussied up in her finest dress and promenade down the sidewalk, intent on catching the eye of that certain guy squirrel, but hopefully not the eye of any dogs. But Pretty Sally Squirrel is ready for anything—inside her handbag is a bottle of her favorite perfume, *l'essence d'rodent stinké*, and a can of mace.

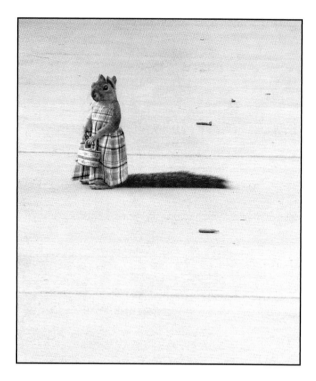

Getting started

This tutorial assumes that you have a basic grasp on how to use Photoshop.

My first step was to find a great source image to work with. I looked through my library of animal photographs I've taken over the last year and found the squirrel image shown in Figure 3.13—it's very simple, and the squirrel is just so darn cute. Even better, it has a plain background, which is great for cutting the squirrel out easily.

People have told me that this squirrel looks like it was posing for me. It does look rather pretty, so I decided to dress it up as a pretty girl squirrel.

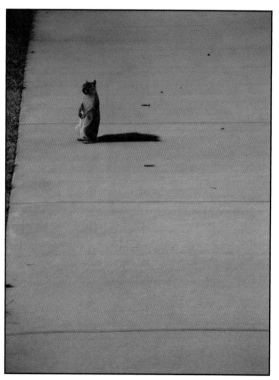

Figure 3.13

1. The image was very dark, so I added a level adjustment layer to brighten it up by selecting Layer > New Adjustment Layer > Levels from the menu bar.

2. After naming the layer and clicking OK to go to the Levels dialog box, I dragged the right Input Levels histogram slider to the left, to the point where the dark graph drops off at the right. I then clicked OK to finish creating the layer. As you can see in Figure 3.14, that brightened up the image enough to work with. (Also, because I made a new adjustment layer rather than applying my changes to the background layer, I could always fine-tune the levels at a later time.)

Figure 3.14

Dress-up

1. At that point I needed a pretty dress to put on the squirrel. My daughter was wearing a pretty dress, so I decided to make her my other source. I took her outside and shot a picture of her in the dress. I made sure to put her in the shade to help match the lighting of the squirrel shot as closely as I could. I had her stand in the same position as the squirrel but put her arms out of the way so I wouldn't have to edit them out (see Figure 3.15). Sometimes the lazy approach is the best way to create an image!

2. With the dress image in place and added to my project as a new layer (by copying the source image and pasting it into the project image file), I created a quick mask by clicking the Edit in Quick Mask button from the toolbox and used a hard brush at 100% opacity to carefully paint the red mask over my daughter (see Figure 3.16).

Figure 3.16

3. After exiting Quick Mask mode, the inverse of what I painted was selected, so I chose Select > Inverse from the menu bar to select only the dress. I then copied this selection of dress into its own new layer by choosing Edit > Copy and Edit > Paste from the menu bar.

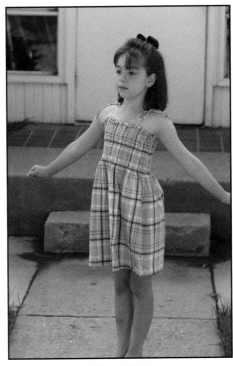

Figure 3.15

4 I then removed the extraneous edges from the dress in the new layer by hiding all other layers, zooming in close to the image using View > Zoom In from the menu bar, again entering Quick Mask mode, and finally using a hard-edged black Brush tool to erase the edges next to the dress (see Figure 3.17).

Figure 3.17

5 Once I was up to working on the frilly area and the straps at the top of the dress, I switched to the Polygonal Lasso tool and selected the area outside of the dress. I filled in the selection with black (as I was still on the mask)—see Figure 3.18.

Figure 3.18

6 I then exited Quick Mask mode, inverted the selection by choosing Select > Invert and pressing Delete. I then resized and distorted the dress to match the size and shape of the squirrel by selecting Edit > Transform > Scale and Edit > Transform > Distort from the menu bar (clicking Commit after finishing my changes with each command)—see Figure 3.19.

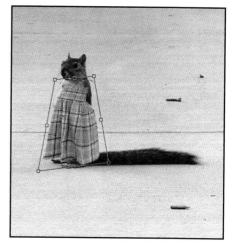

Figure 3.19

7 I then applied a quick mask to the dress layer and used a soft-edged brush to erase around the edges of the dress to make it look a little cleaner. I also erased the parts of the dress where the squirrel's arms were, so that they showed through (see Figure 3.20). Then I exited Quick Mask mode and chose Layer > Add Layer Mask > Reveal Selection.

8 The dress looked too bright to match the squirrel image, so I adjusted the hue and saturation of the dress to better match by selecting Image > Adjustments > Hue/Saturation from the menu bar. I brought the darks up with another levels adjustment layer (using the technique discussed in step 1 of this tutorial).

9 The colors were better, but the resolution and picture quality were still too high. I duplicated the dress layer by clicking the layer thumbnail in the Layers palette, choosing Layer > Duplicate Layer from the menu bar, typing a layer name, and clicking OK. I then matched the dress to the original squirrel image by choosing Filter > Noise > Add Noise, specifying a noise amount, and clicking OK. Then I chose Filter > Blur > Gaussian Blur from the menu bar, specified a blur Radius until the tone matched appropriately, and clicked OK. Finally, I applied a quick mask and painted with 50% black on some of the folds of the skirt, so that some of the blur faded a little (into the original dress layer), and the image was sharper on the folds.

10 I merged the dress layers together (by selecting the top one in the Layers palette and choosing Layer > Merge Down) so that they could now be worked on together, applying the layer masks as I did so. I again entered Quick Mask mode and used a soft mid-opacity brush to gently mask over the edges of the dress so that it appeared to blend in with the background better. Then I exited Quick Mask mode and selected Layer > Add Layer Mask > Reveal Selection.

11 I went back to the dress by clicking on the dress thumbnail in the Layers palette and used the Burn tool on midtones at 18% to burn in shadows on the side of the dress and the right side of the chest. I deepened the shadows in the folds and under the arms. I also applied the Burn tool to the spaghetti straps, especially on the right side where the shadow was.

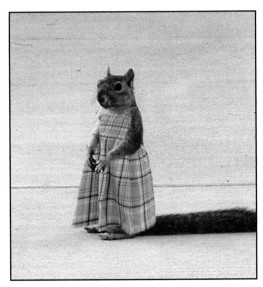

Figure 3.20

12 I zoomed in and out of the picture, examining it to see how well the dress matched at this point. I noticed that behind the squirrel's arm on the right side, there was some fur where the dress should have been. Rather than build just a little bit of dress there, I used the Clone Stamp tool to copy the sidewalk over that area (see Figure 3.21).

Finishing touches

She was definitely getting pretty cute! I added a straw purse and a bow using the same techniques discussed earlier in this tutorial. I also added some white highlights on the bow to help separate it from her ears (see Figure 3.22).

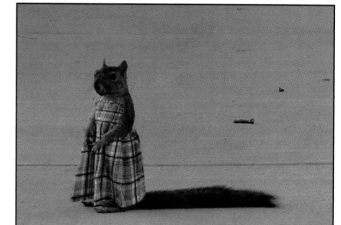

Figure 3.21

1 For finishing touches, I merged all the layers by choosing Layers > Merge Visible from the menu bar.

2 I then used the Rectangular Marquee tool from the toolbox to select the main area around the squirrel. I chose Edit > Transform > Rotate, rotated it so that the lines of the sidewalk were perfectly horizontal, and clicked Commit.

3 Finally, I reselected the area around the squirrel which would make up the focus of my image and cropped it by selecting Image > Crop from the menu bar. I played with the image levels by going to Image > Adjustments > Levels, dragged the sliders until I felt it was warmer in tone, and then clicked OK.

4 Finally, I applied a very slight Noise filter and Gaussian Blur filter (using the same technique discussed in step 9), just to smooth things out.

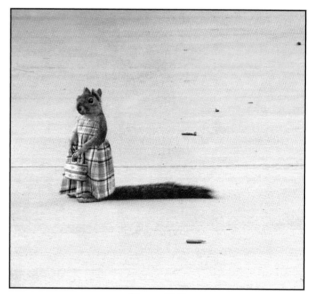

Figure 3.22

Pretty Sally is now ready for her close-up, though hopefully not with your car tire.

Credits

Author: Tracey Somo
Source Images: Tracey Somo, Lemonlimestudio.com

How I made Barely a Liam

The ancient Greeks brought us myths of Zeus, Medusa, Euro Disney, and the chimera, a fire-breathing monster made up of three different animals. The Greeks brought us the myths; Photoshop brings us the reality.

In my case, I merged a bear, ram, and a lion to form the chimera.

Getting started

This tutorial assumes that you have a basic grasp on how to use Photoshop.

I used the source images shown in Figures 3.23, 3.24, 3.25, and 3.26.

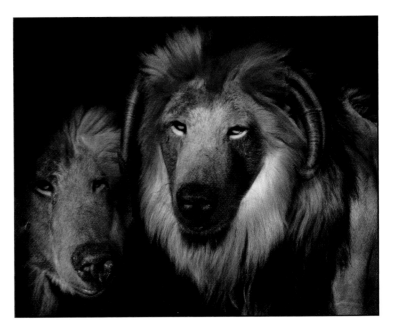

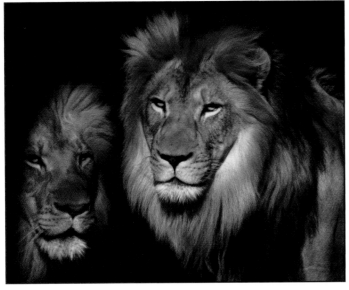

Figure 3.23

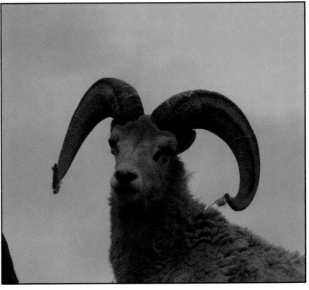

Figure 3.24

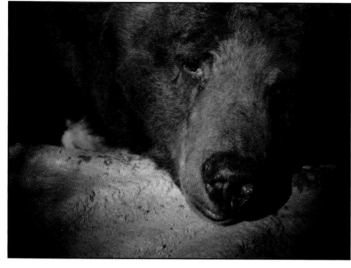

<div align="center">Figure 3.25</div>

<div align="center">Figure 3.26</div>

The two lions made up the body and the head of the chimera, the bear made up the face, and the ram horns were used as the horns. I copied each of these images from its source image file and pasted it into a new layer in my project image file shown in Figure 3.27.

1 I started with the lion image and the two bear faces. I used the Move tool to overlay the left bear's face on the lion's face. I lowered the bear layer's opacity to about 65% using the Opacity slider on the Layers palette.

2 I then positioned and rotated the bear's face by first using Select >All on the bear layer.

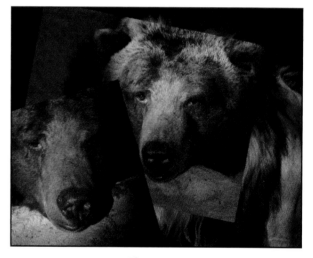

<div align="center">Figure 3.27</div>

3 Then I chose Edit > Transform > Rotate from the menu bar, dragged a handle to get the rotation I wanted, and clicked Commit (see Figure 3.28). I used the left eyes as a guide when matching up the faces of the lion and the bear.

Figure 3.28

4 I then applied a quick mask to the lion's face by selecting the Edit in Quick Mask button on the toolbox. I used a medium-sized soft brush to mask out everything except the muzzle (see Figure 3.29). I exited Quick Mask mode and chose Layer > Add Layer Mask > Reveal Selection.

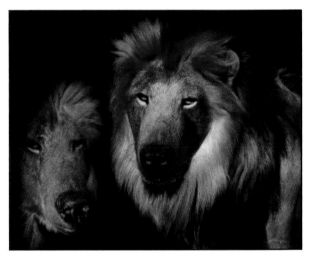

Figure 3.29

5 Next I took the ram horns layer and masked out everything except the horns, using the same technique described earlier in this tutorial. I then positioned them over the right lion's head. Note how this mask looks in the Layers palette in Figure 3.30.

6 To position the horns a little closer to the front of the lion's head, I selected the Rectangle Marquee tool from the toolbox and selected the horns. I then chose Edit > Copy and Edit > Paste from the menu bar and copied one horn into a new layer. I then repeated this for the other horn.

7 I then had two identical layers, each with a right horn and a left horn. I moved them both until they were positioned closer to the face.

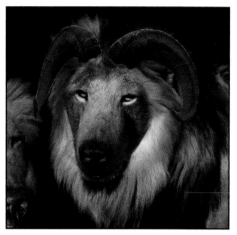

Figure 3.30

8 Then I masked out part of the horns on the top horn layer so it looked like it was coming out of the lion's head and through its hair.

9 Finally, I merged the two horn layers together by selecting the top horns layer's thumbnail in the Layers palette to activate it and then chose Layer > Merge Down. My chimera was beginning to take shape (see Figure 3.31). Call me crazy, but I wonder if this thing might make a good pet for grandma. She's alone now, you know.

10 I added a small shadow behind the horns to make the horns pop out of the image a bit more. I did this by first duplicating the horn layer by clicking it in the Layers palette, choosing Layer > Duplicate Layer, typing a layer name, and clicking OK.

Figure 3.31

11 I then selected the bottom horn layer in the Layers palette by clicking its thumbnail. I selected Image > Adjustments > Brightness / Contrast from the menu bar and moved the sliders until the layer was completely black, and clicked OK.

12 I then applied a slight blur by choosing Filter > Blur > Gaussian Blur from the menu bar, specifying a 4-pixel blur Radius, and clicking OK.

13 Finally, I lowered the layer opacity to 32% by using the Opacity slider on the Layers palette. You can see the before and after results in Figures 3.32 and 3.33.

Figure 3.32 Figure 3.33

14 Finally, I added some more pop to the horns by duplicating the horn layer twice more (again, using the Layer > Duplicate Layer command).

15 I then set the first duplicate's blending mode to Linear Dodge using the drop-down menu on the Layers palette and set its opacity to 67% using the Opacity slider. I then set the second duplicate's blending mode to Color Dodge at 100% opacity. Finally, I used the Burn tool from the toolbox to modify the horn's edges so that they blended into the darkness of the lion (see Figure 3.34). I also used the Dodge tool (also from the toolbox) to bring out the horn's highlights (see Figure 3.35).

Figure 3.34 Figure 3.35

If you ever find yourself ringleader in a circus with a chimera, I double-dare you to stick your head in its mouth. Very few ancient Greek mythology scholars know this fact, but the chimera has surprisingly minty-fresh breath.

Credits

Author: Byron Nicholas
Source Images: Tracey Somo, Lemonlimestudio.com

How I made Horse Juggler

Not all horses are content with grazing in an open pasture their whole lives. Some horses dream of big entertainment careers like a juggling act in the circus. There's good news and bad news for a horse with such lofty aspirations. The good news is, there's always factory work to fall back on if the circus gig fails. The bad news is, it's the glue factory.

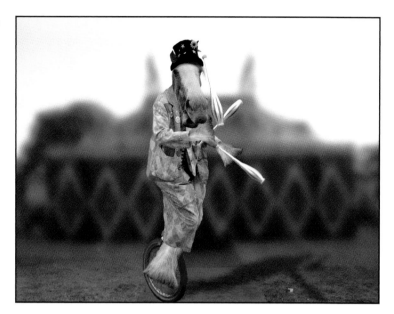

Getting started

As you can see in Figure 3.36, this is an exercise in cutting, pasting, masking, and finally tweaking a few points to give our horse juggler the finishing touches. This tutorial assumes you have a basic grasp on how to use Photoshop.

1. To begin, I made very rough cutouts of the component parts from their original images, then pasted them onto the background image and renamed each layer by double-clicking the layer name and typing in a description ("clown bottom," for example).

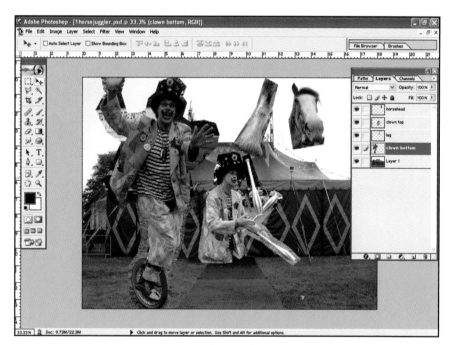

Figure 3.36

You'll notice that the top and bottom half of the clown are from separate sources. In real life, it's typically not a good idea to cut a clown in half, but in Photoshop, it's just fine. Although my good friend Julian (from www.circusunlimited.com) is quite capable of unicycling and juggling at the same time, I just didn't catch him doing both at the same time that day!

2 Then, I gave each new layer a layer mask. I selected the layer in the Layers palette, then selected the Add Layer Mask icon at the bottom-left of the Layers palette.

3 I knew I didn't need the top half of the clown on the unicycle, so I drew a marquee around the area I didn't want and filled it with black (Alt + Delete did this quickly)—see Figure 3.37.

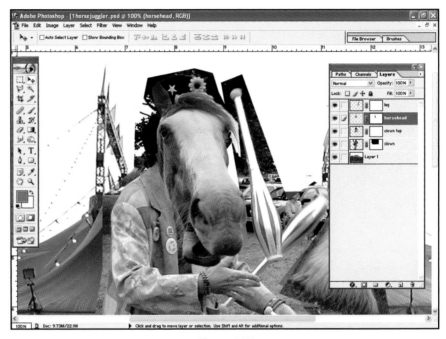

Figure 3.37

4 Next, I moved the horse head layer into position over the upper torso of the clown and masked the head to fit in with his jacket (see Figure 3.38). I used the smallest soft brush available to do this.

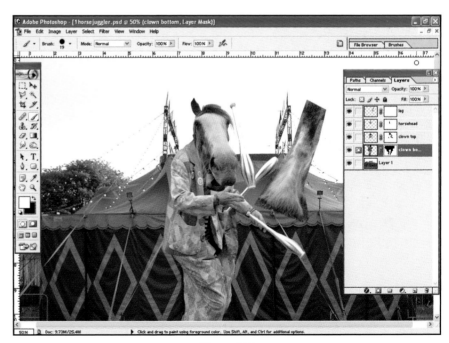

Figure 3.38

5 While I was masking, I finished off masking together both the juggling and unicycling halves of the clown (see Figure 3.39). It was time-consuming doing it right, but I zoomed in close and made it worthwhile. Nothing is worse than a juggling horse clown that looks thrown together.

6 For the hands, I used the same piece of hoof for each. I couldn't tell a right hoof from a left hoof, and I'm hoping no one else will either! But then, it would probably take a special kind of ambidextrous horse to juggle anyway.

7 I duplicated the layer twice by dragging the layer onto the New Layer icon in the bottom-right of the Layers palette.

8 I rotated and scaled to find the right orientation and size for the hoof/hands and masked out accordingly (see Figure 3.40). (A good tip for masking: Start with black foreground and white background and hit D when you go too far and mask an area you didn't mean to. Swap foreground and background colors by hitting X. Replace and hit X again to swap them once more.)

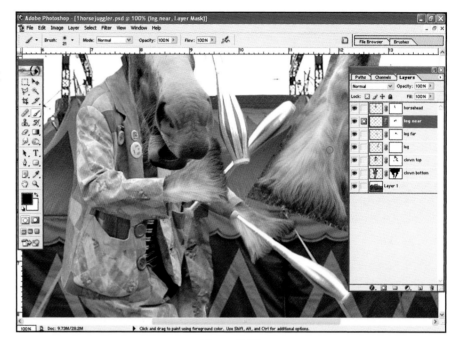

Figure 3.39

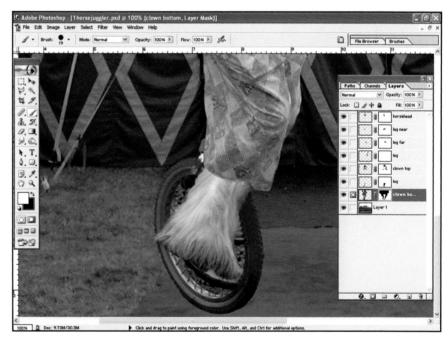

Figure 3.40

9. For the foot, I wanted to see more of the hoof because one can never show enough hoof in our modern "sex sells" society. Taking the Clone tool, I raised his trouser hem slightly. Finally, I moved the last remaining hoof into place and masked accordingly (see Figure 3.41).

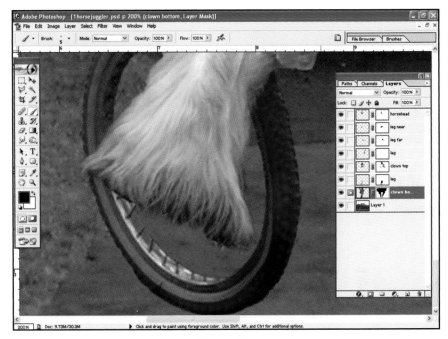

Figure 3.41

10. Now, there was some remaining foot there, so I masked that too. Unfortunately, I had to take the wheel spokes out with it, because I simply didn't have the interest in meticulously masking around them (see Figure 3.42). But I couldn't have a horse clown juggling on a unicycle without spokes—no one would believe something so ludicrous could exist! Imagine a unicycle with no spokes. Ha!

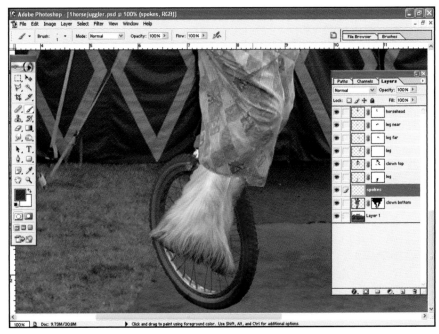

Figure 3.42

To solve the spoke issue, I cheated.

11 I added a new layer by clicking on the arrow in the upper-right corner of the Layers palette and selecting New Layer. On the new layer, I drew a few straight lines where the spokes should be with the Paintbrush tool, using the smallest hard brush possible. After I drew the solid lines, I added a touch of blur by selecting Filter > Blur to make my hand-drawn spokes look like they were part of the unicycle (see Figure 3.43).

12 What would a horse be without his top hat? I selected the top half of the clown, dragged a marquee around the head area, right-clicked, and selected Layer Via Copy.

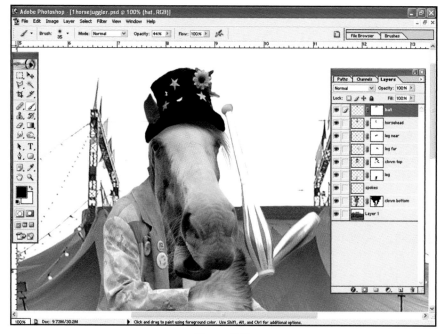

Figure 3.43

13 Then I renamed the layer (of course) and dragged the layer above the horse head layer.

14 While masking, I left a little hole for his ear (for the cute factor).

15 The look was a little hard-edged, so I selected the horse head layer and then selected a large, soft brush. Next, I lowered the opacity to 50% and drew some shadow under the brim of the hat over the horse's forehead.

Adding shadows

For the entire figure's shadow, here's the way I did it—possibly not the best way, or even the easiest way, but hay, (get it?) it works for me.

1. I merged together all of the clown component layers by choosing Layer > Merge Down. Next, I selected all (by choosing Select > All), and copied it (using Edit > Copy) to load it into the clipboard. Then I stepped backwards a bit. I undid those three steps (Edit > Undo three times) and pasted the figure from my clipboard, giving me a "whole" person to work with. I dragged this new layer to the bottom of the clown layers pile and Ctrl + clicked the layer to select the area (see Figure 3.44).

Figure 3.44

2. I loaded a dark gray into the foreground color palette and filled the clown figure shape. Although you can't see it, there's now a hard-edged shadow behind the clown.

3. Using Edit > Transform > Distort, I dragged the corners around until I found a good shadow position. I then lowered the opacity of the shadow layer to around 50%.

4 Finally, I selected a Marquee tool, then Ctrl + clicked the layer again to select it. Then, I right-clicked and chose Select Inverse. I right-clicked again and selected Feather (I chose 7 pixels). Next, I hit Delete a few times until the blur around the edge looked right (see Figure 3.45).

You'll notice that the background in the finished picture fades out of focus. (We can't have anything distract us from the star of our show, now can we?) This was an easy effect to achieve.

5 I duplicated the background layer and chose Filter > Blur > Gaussian Blur until it was blurred to where I wanted it (in this case, 21 pixels).

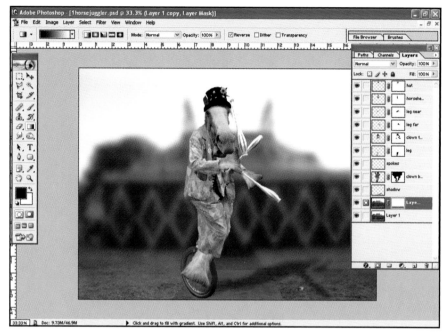

Figure 3.45

6 I added a layer mask by selecting the layer within the Layers palette and clicking the Add Layer Mask button on the bottom of the palette.

7 I selected the Gradient tool, which launched the gradient options bar at the top. I chose a simple black-and-white foreground to background gradient. Making sure the layer mask was selected, I held the Shift key (to force a vertical line), then clicked at the furthest point on the blue path and dragged to the bottom of the screen. This reveals a gradient of "in focus" background underneath.

Our horse is now ready for the big time at the big top!

Credits

Author: Daniel Goodchild
Source Images: Circusunlimited.com
Model: Julian C. Mount

How I made Marmot of Fury

The marmot is a charismatic rodent found only in the northern hemisphere. Groundhogs, prairie dogs, and other large ground squirrels are all members of this species. I needed to know just how much wood would a marmot chuck if a marmot was a deadly martial artist!

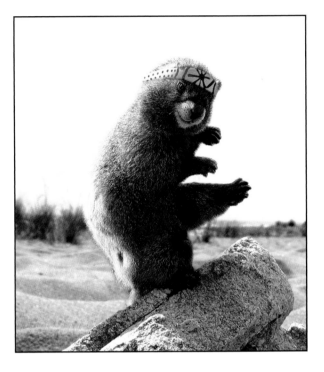

Getting started

This tutorial assumes you're at an intermediate level with Photoshop and know how to perform actions such as removing a detailed object from one image and inserting it into another.

1. I found this deceivingly cute and cuddly picture of a marmot in non-attack mode in a pleasant woodland scene (see Figure 3.46). By choosing Layer > New > Layer, I created a new layer in the Layers palette to paste the beach view with a practically white sky—where only the marmot masters train.

2. Using the Lasso tool in the marmot layer, I masked out the rock the marmot was sitting on and placed it onto the beach layer to act as the martial arts stage.

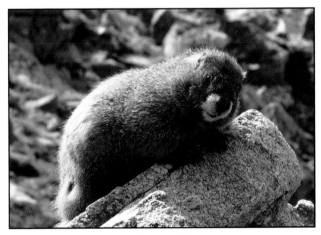

Figure 3.46

3 Using the Clone tool, I removed the marmot's claws that hung over the edge of the rock. I cloned the already-shadowy area to account for the shadow that would be cast by the standing creature.

4 To give myself more room to put the marmot in a vertical pose, I made the canvas size twice as tall by choosing Image > Canvas Size and doubling the height and selecting the bottom-middle anchor arrow (see Figure 3.47).

Figure 3.47

Poised for attack

A marmot in attack mode is obviously going to be in a different pose than our subdued original (though I heard a rumor that seconds after the photographer clicked this picture, the marmot struck him with Jet Li-like force. The final photo is probably the last thing the unfortunate photographer remembers seeing before the paws of fury flew).

1 I copied the marmot base layer several times by dragging the layer onto the Create a New Layer icon in the bottom-right of the Layers palette (to the left of the garbage can icon). I needed the multiple copies of the various layers to deconstruct the creature and rebuild him in his final pose.

2 In my first copied layer, I roughly circled the body with the Lasso tool and chose the Add Layer Mask icon in the bottom-left of the Layers palette. I repeated the step for each body part—the head, the claws, and so on.

3 I selected the layer that contained the body. I chose Edit > Transform > Rotate, and I used the Arrow tool to rotate the soon-to-be fierce creature into a more vertical position on the rock (see Figure 3.48).

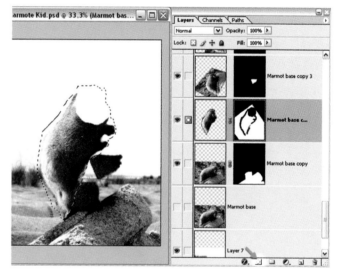

Figure 3.48

4 On some layers, like his left leg, I used Edit > Free Transform to better match the texture of the fur (see Figure 3.49).

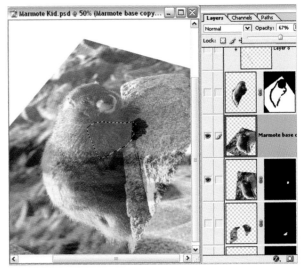

Figure 3.49

5 I left his head at the same angle and size as our original because it fit well on the vertical body—the creature's eyes tell the whole story at this angle: *You're about to get a butt-whoopin'* (see Figure 3.50). The roundness of the marmot's head made it relatively easy to place back on his new body.

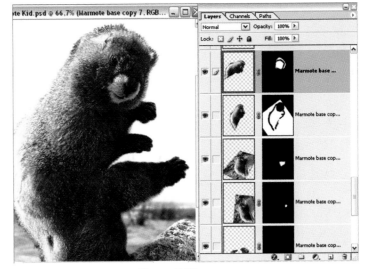

Figure 3.50

6 With the body part layers all separate, fine-tuning the masking was easy. I added new layers, using the body part layers as clipping masks (see Figure 3.51). This way I could clone, paint, and edit in the clean-up layers without distorting other parts of the image.

7 I copied the head layer and chose Filter > Liquify to turn up the corners of his mouth into an ironically cute smile. I used the same effect on his eye to give him a look that says: *I'm happy to be whoopin' your butt*. I then masked this layer, keeping only the eye and mouth in order to reduce the blurriness.

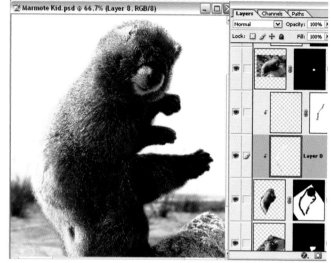

Figure 3.51

8 By choosing Layer > New > Layer, I added another layer so I could hand-paint in whiskers using the Brush tool (see Figure 3.52).

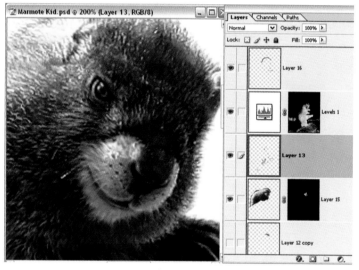

Figure 3.52

9 I drew the headband onto our marmot of fury and used the Clone tool to place small tufts of hair over the headband to make it look like it's really wrapped around the creature's head (see Figure 3.53).

Somewhere in the background a gong bangs, and with a twitch or two of his nose, our marmot is ready to strike.

Credits

Author: Jan Pettersen
Source Images: Doss Bradford, Photomesh.com

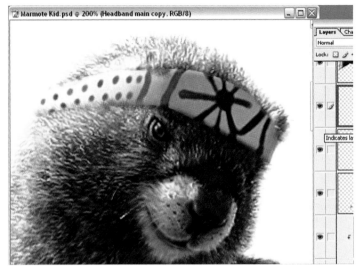

Figure 3.53

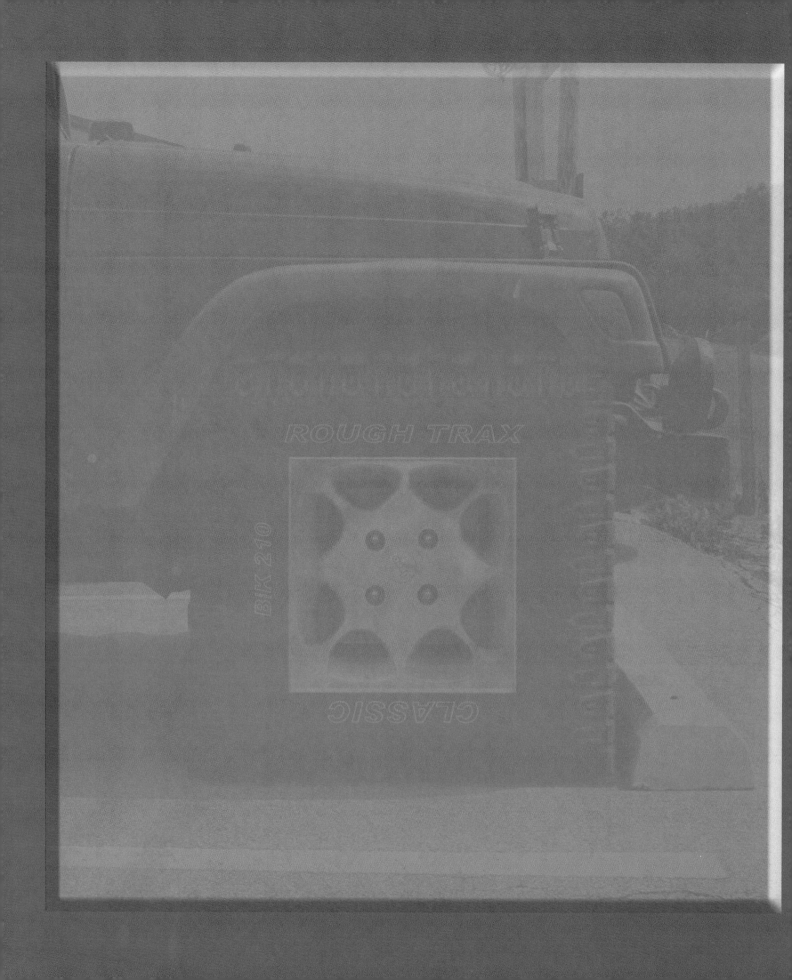

Rejected Products

With every brilliant product on the market, there are always countless prototypes that came before it. Or sometimes there are just products that made it to the market that flat-out bombed and nobody understands why. At Worth1000.com, we strive to showcase these early experiments and market failures.

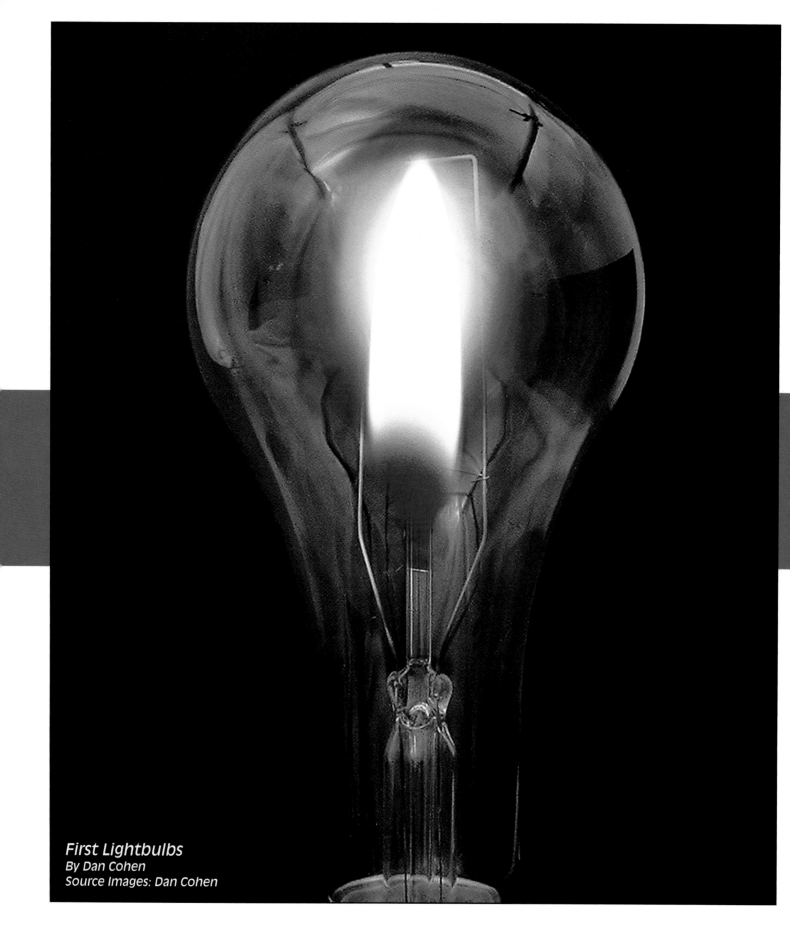

First Lightbulbs
By Dan Cohen
Source Images: Dan Cohen

![Mama Soybean's bottle]

Mama Soybean's

Organic
Products
from Nature's
Kitchen

all natural dressings
Dirt Flavor
made with 100% organic mud

All Natural Ingredients
By Dorie Pigut
Source Images: Tracey Somo, Lemonlimestudio.com

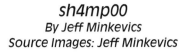

sh4mp00
By Jeff Minkevics
Source Images: Jeff Minkevics

NEW HAIR HAXORIZING FORMULA!
4 L33T HAIR WHIT FLAVAH

Does your hair lack flavah? Is it teh sux? We puts
together a buncha stuff 4 U that'll fix your sad-ass
hair probs!!!11 Our hair h4x0rizing formula is made
in really cool sup3r-secret labs by guys with lots an'
lots of chemicals!!!11 Chyxors will think U R a god!

Lots o nutrients 'n other kewl plant stuff is all over
this stuff! Like flowers and tree bark and weeds 'n
stuff like that! (no, not THAT weed..LOL!)

Directions:

hair = hair + wet
<wash> hair = hair + champoo

lather [muss around, 2 min.]
hair = hair + wet until hair = hair - champoo

x = x+1 if x=2 then next else <wash>

if hair = clean then end else repeat.

Where does the screwdriver go?
By James Osborne
Source Images: Michael Connors, Morguefile.com

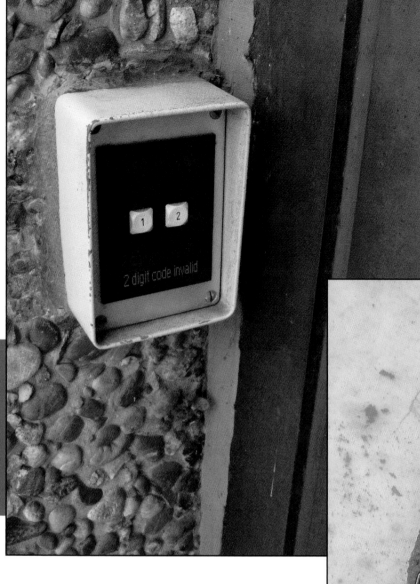

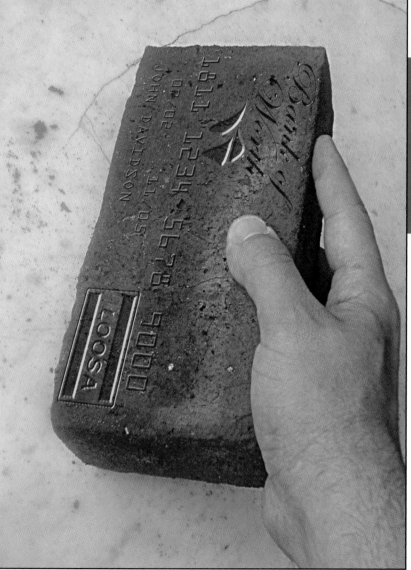

Code Invalid
By Alex R. Feldman
Source Images: Christian Becker,
Morguefile.com

2 digit code invalid

Credit Brick
By Daniel Goodchild
Source Images: Daniel Goodchild

For the artist who likes to relax while he works...
By Dan Cohen
Source Images: Dan Cohen

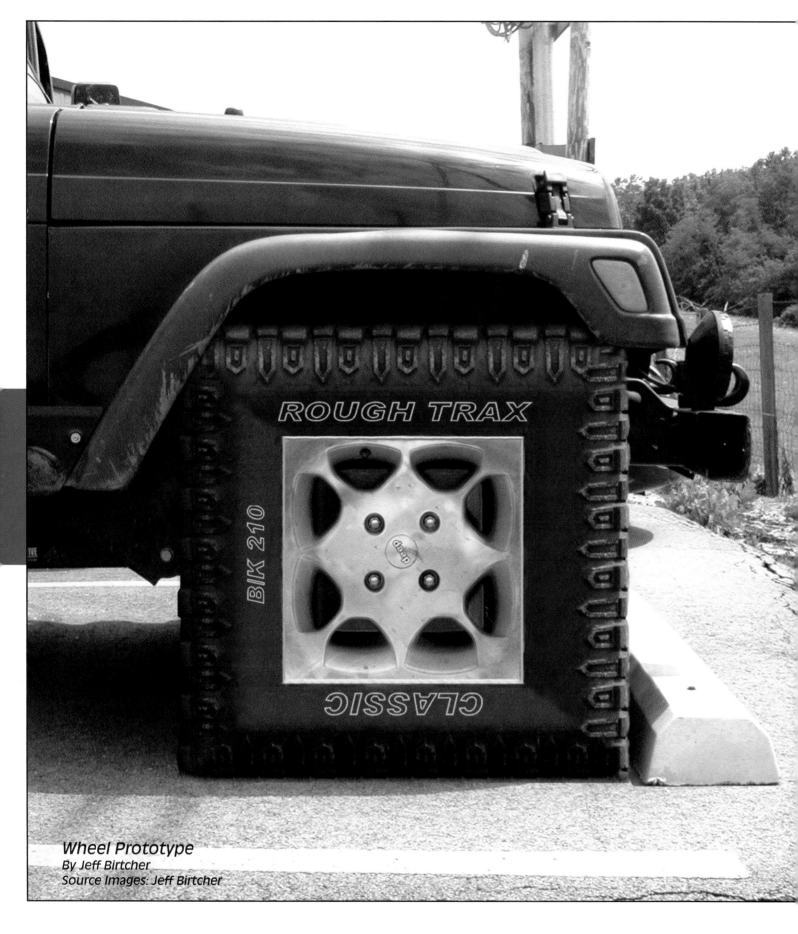

Wheel Prototype
By Jeff Birtcher
Source Images: Jeff Birtcher

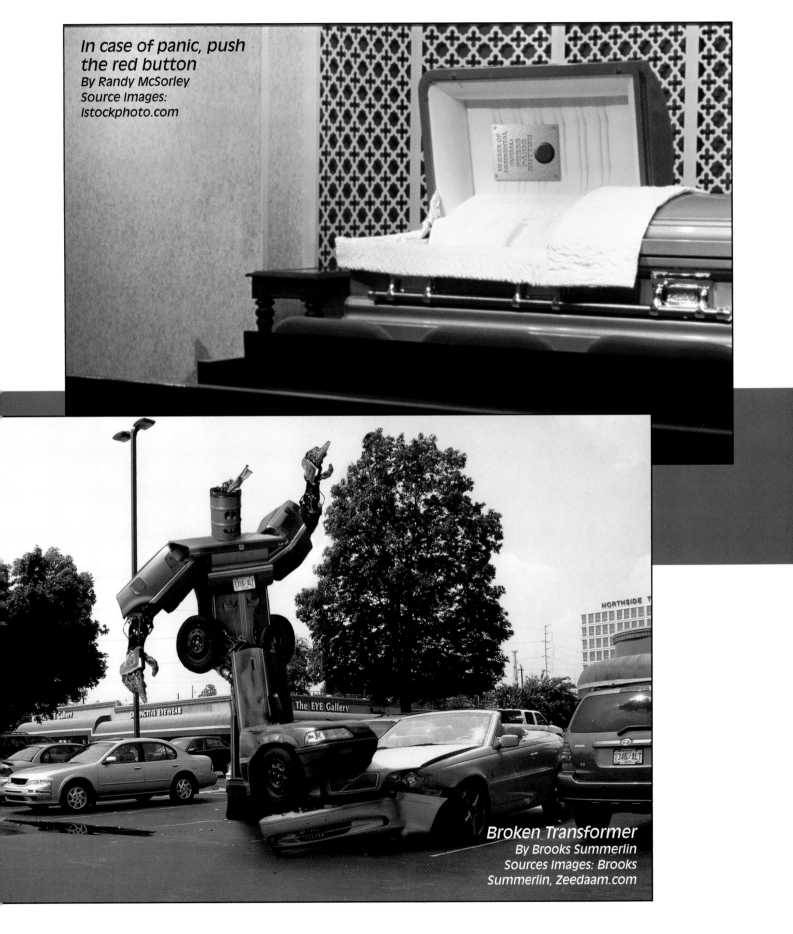

In case of panic, push the red button
By Randy McSorley
Source Images:
Istockphoto.com

IN CASE OF ACCIDENTAL BURIAL PRESS PANIC BUTTON

Broken Transformer
By Brooks Summerlin
Sources Images: Brooks
Summerlin, Zeedaam.com

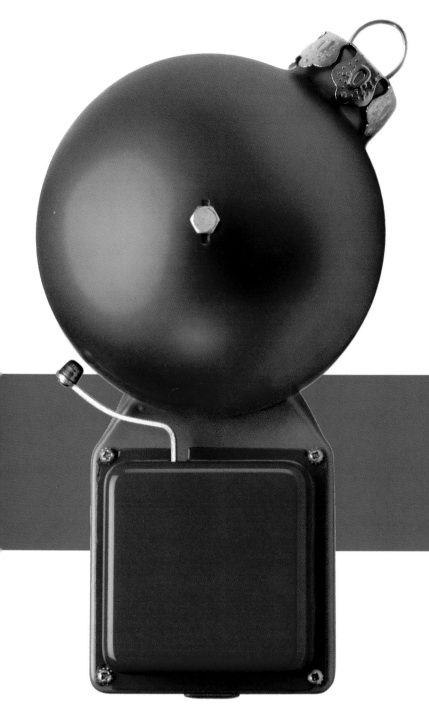

Christmas Bell
By Kirby Gehman
Source Images: Johanna Goodyear, Sxc.hu, Photospin.com

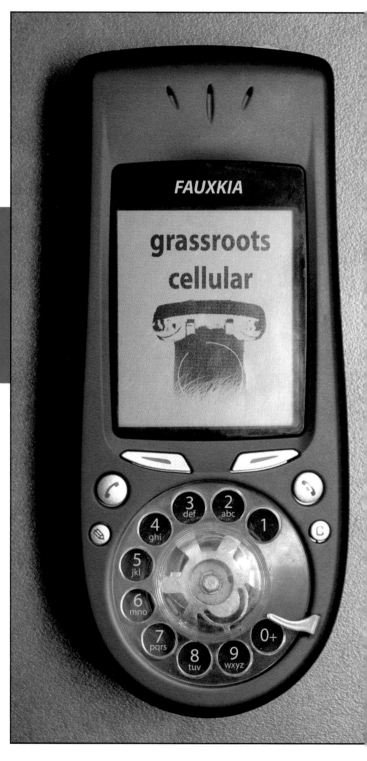

Rotocell
By Jeff Birtcher
Source Images: Jeff Birtcher

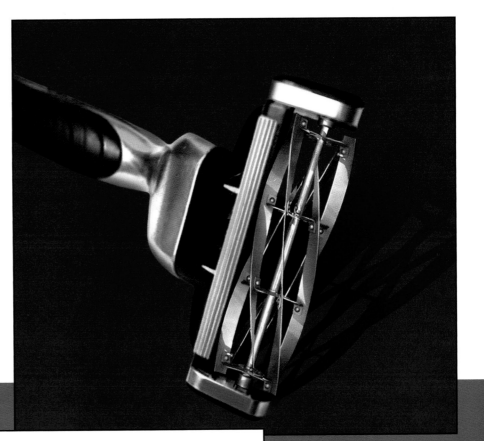

Lawnshaver
By Robert Schneider
Source Images: Melissa Norquist,
Jenn Borton, Sxc.hu,

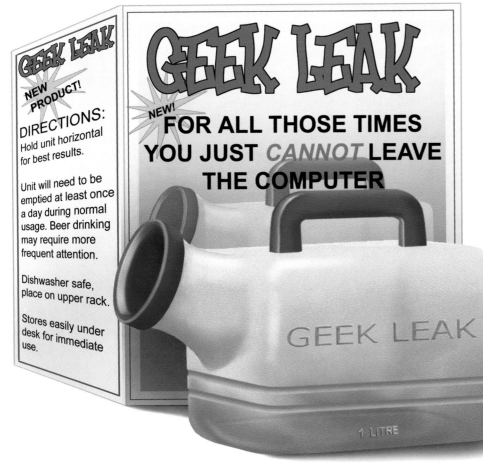

GEEK LEAK

NEW PRODUCT!

DIRECTIONS:
Hold unit horizontal for best results.

Unit will need to be emptied at least once a day during normal usage. Beer drinking may require more frequent attention.

Dishwasher safe, place on upper rack.

Stores easily under desk for immediate use.

GEEK LEAK

NEW!
FOR ALL THOSE TIMES YOU JUST *CANNOT* LEAVE THE COMPUTER

GEEK LEAK

1 LITRE

Geek Leak
By Robert Schneider
Source Images: Robert Schneider

Tutorials

How I made Code Invalid

Do you know how many possible numerical options there are
with a 10-digit security code pad on a door? Well, do you? If we
multiply by the square root, then add the variables, it comes out
to... a whole lot! I bet you didn't realize Photoshop could turn a
near-infinite door code keypad into a rather easily-guessed door
code. If only all hackers had it this easy!

Getting started

While not all Photoshop projects are technically complicated, the
idea behind them can make or break them. For this Chop ("Chop"
is an insider's term used to describe a photo edited with a photo-
editing program), I chose a more simple method to get my idea
across.

Often when creating an image manipulation, it is helpful to use
only the elements that are already in the image (see Figure 4.1)
rather than looking to other images for items to add. That way,
the lighting, contrast, and saturation are already at the correct
levels.

Figure 4.1

Zero through 9, +, and – are way too many digits for today's short attention spans. So we're going to cut down the choices.

1 First, I duplicated the background layer and turned off the visibility to it. That way I had something to fall back on, as well as cut and paste out of, later in the process.

2 I then used the Clone tool to completely remove the buttons from the face of the keypad using a small, soft brush (as to leave no hard edges). I sampled from various areas and changed frequently so the newly cloned area didn't look exactly like the area I was sampling from. I was half-tempted to leave it like this (see Figure 4.2). What could make security easier to remember than just a blank pad? Users could simply mash their hands on the black pad to open the door. But I figured in today's heightened state of national security, perhaps a key code would still be best.

Figure 4.2

3 Once the keys were removed, I went back to my duplicated background layer and selected two keys to copy and paste back into the image. I didn't use the 1 and 2 keys as it might appear, because their perspective didn't match the center of the pad as well as keys located closer to the center of the keypad.

4 With the new keys in place, again I went back to my duplicated background image, used the Marquee tool, and selected Edit > Copy to copy the 1 off of the 1 key in the image. Next, I went to Edit > Paste to paste the 1 over my left key on the top layer. I repeated the process for the 2 key (see Figure 4.3).

Figure 4.3

Adding the text

1 While a two-digit keypad may tell most people that you have an easy shot at guessing the right code, I wanted to really make it clear for those who are slower than most. So I decided to add the text to the bottom of the pad for added humor.

2 I picked a font that looked like one that might appear on this type of device. I typed out one of my two sentences, duplicated the layer by right-clicking the layer in the Layers palette and selecting Duplicate Layer, and then typed the other sentence out on the new layer. I matched the perspective of each line separately because of the slight variation in the angles. I ensured the font was the type and size I wanted and that everything was spelled correctly, because to change the perspective, I would need to rasterize the text layer. Check and double-check on both. We have clearance to proceed to step 3.

3 I right-clicked in the type layer within the Layers palette and selected Rasterize Layer.

4 I chose Edit > Transform > Perspective and set the lines of text to the correct perspective of the keypad.

5 Once the text was at the correct perspective, it was time to add some color. I selected everything in the text layer that was going to be lit by Ctrl + clicking the layer, and then I chose the Lock Transparent Pixels box on the top of the Layers palette. I chose to color the text with a radial gradient of a bright red to a slightly darker red. This gave the lighting a more realistic look. While the gradient may not seem noticeable, it is more noticeable without it.

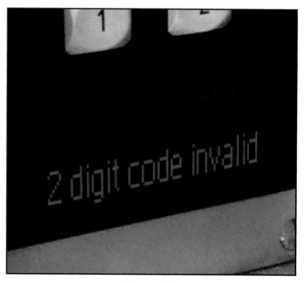

Figure 4.4

6 I chose a dark gray for the other text, so it looked like the text could light up but just wasn't lit at the moment (see Figure 4.4). Often when an item is lit from behind, it has a single light source and does not light the object evenly. The Gradient tool is a great way to emulate this effect. I made this a little lighter than I believe it actually would be in life, but it was important that people be able to see the text to get the joke.

Hint: The actual code we were looking for to gain entry was 2-1. Better luck next time.

Credits

Author: Alex R. Feldman
Source Images: Christian Becker, Morguefile.com

How I made Christmas Bell

Christmas means family time, and family time means getting together, and getting together with family usually is a cause for alarm. This "Christmas Bell" is for the families who like to put the "fun" in dysfunctional—it only rings when everything is going well at the holidays and there are no family problems. We're actually not sure if it's working or not: It's never gone off.

Getting started

This tutorial will work for those at the beginner level of Photoshop.

1 I started with two source images: the fire bell and the Christmas ball decoration.

2 I clicked in the window with the Christmas ball and chose Select > All, then Edit > Copy to bring the image into my clipboard. Next, I pasted the Christmas ball into the same window as the fire bell image. This automatically created a new layer for the ornament image. I closed the other window that contained the Christmas ball so I could work solely in one window moving forward.

3 Next, I resized and positioned the Christmas ball to where the alarm bell would be. I selected Edit > Free Transform and chose the upper-corner handle so my cursor was now a diagonal arrow (see Figure 4.5)

4 I held down the Shift key and made the image smaller by dragging the corner of the image with the mouse until it was approximately the correct size. The Shift key ensured that the image maintained proper proportion by scaling the width and height together.

Figure 4.5

5 I moved the image until it was centered over the bell. When it was the size and placement I wanted, I pressed the Enter key to finalize the Free Transform (see Figure 4.6). If it is not perfect, you can repeat this step as many times as needed.

Figure 4.6

6 To mask the Christmas ball, I chose the Add Layer Mask button at the bottom of the Layers palette, as shown in Figure 4.7.

7 I clicked on the Brush tool on the toolbox. Then I clicked on the bent arrows above the colors at the bottom of the toolbox (see Figure 4.8) to switch the foreground and background colors so that I could paint with black.

Figure 4.7

Figure 4.8

8 I then painted out the background and shadow of the Christmas ball, leaving only the red ball itself (see Figure 4.9). If you mask out too much, click the Switch Background and Foreground Colors button again and paint it back in with white. If you're feeling festive, this may be a good point to stop for an eggnog break. My family made ours with just the right mix of rum and lighter fluid.

9 Next I added the bolt to hold the "all is well" bell in place. Using the technique in step 6, I masked out the bolt head in the center of the bell. To get a nice, smooth transition between the Christmas ball and the fire bell, I lowered the opacity of the brush to 30% by changing the opacity level in the Brush option bar at the top of the screen. With the low opacity, as I painted, I wasn't completely masking out the Christmas bell, just making it translucent. You'll notice that the more you paint over an area, the more it disappears. I finished masking out the center of the Christmas ball to let the bolt head show through.

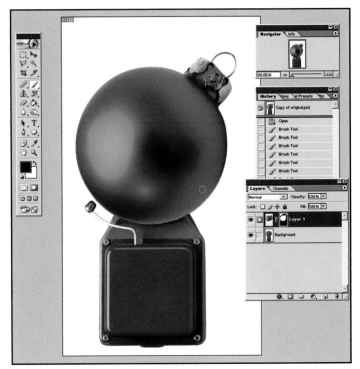

Figure 4.9

Details, details, details

1 The shading and lighting at the bottom of the Christmas ball didn't quite match the fire bell, so using a 30% opacity brush, I masked out the bottom edge of the Christmas ball, trying to make the line between where the Christmas ball stops and where the fire bell starts invisible. You can use white to draw the Christmas ball back in if you need to, and then use black to mask it out again until it looks right. If you turn off all the layers except the Christmas ball, it should look something like Figure 4.10 when you are finished.

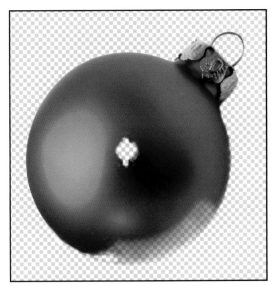

Figure 4.10

2 One of the things people ask when they see this image is, "How did you create the reflection of the bell hammer in the Christmas ball?" The answer is embarrassingly simple: I didn't. Why try to re-create something that is already there? I simply masked out the Christmas ball to let the original reflection show through, exactly the same way as in step 9 for the bolt head. Using a 30% opacity brush, I blended the edges, and then the reflection of the hammer looked real (because it is)—see Figure 4.11. Sometimes the most effective tricks aren't really tricks at all.

If this "all is well" bell ever does go off, it will be a Christmas miracle.

Credits

Author: Kirby Gehman
Source Images: Johanna Goodyear, Sxc.hu, Photospin.com

Figure 4.11

How I made Credit Brick

Just imagine... a riot breaks out, and you hate to miss your chance to loot the local businesses, but at the same time you know the guilt of stealing will weigh heavily on you afterward. The credit brick is the answer to all of your problems. You can hurl this baby through the plate-glass window of the business you wish to loot, and then leave it behind to pay for your merchandise!

Getting started

This tutorial is perfect for beginners.

1. I started by opening the image of my own fair hand holding a brick. For this technique to work, I needed a brick with a fair amount of variety in the texture and color on the surface. Using the Marquee tool, I dragged a roughly credit-card-proportioned shape (see Figure 4.12), then created a new layer by choosing Layer > New > Layer.

2. I pressed the D key to reset the foreground and background colors to black and white, and chose Edit > Fill > Use Background Color to fill the shape with white in order to get an idea of layout.

Figure 4.12

3 I then started creating the text for the card (see Figure 4.13). The "Worth" logo is Edwardian Script ITC and the numerals are OCR A Extended. And no, the numbers aren't my real credit card numbers (they're my ex-girlfriend's). I drew vaguely recognizable logos for the bank and for "LOOSA." It's always a good idea to use separate layers for each element, as you'll always want to adjust them until you're happy.

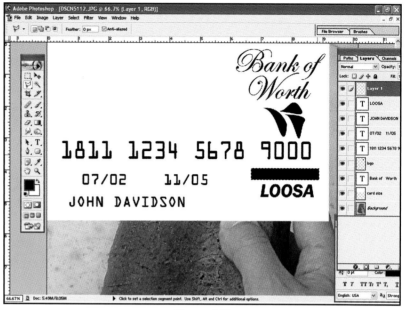

Figure 4.13

4 I then had the text laid out how I wanted it, so I merged the layers into two groups—areas I wanted to appear raised, and those I wanted indented—and I renamed the layers accordingly. I removed the white background layer and then clicked the Link button in the Layers palette to group the two layers together (see Figure 4.14).

5 Next I rotated the grouped layers 90 degrees clockwise by choosing Edit > Transform > Rotate 90° clockwise. To create the right perspective, I then used Edit > Transform > Distort and dragged the corner points to the corner of the brick (see Figure 4.15).

Figure 4.14

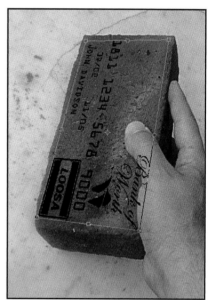

Figure 4.15

6 To create the actual textured effect, I started with the layer I wanted to appear raised. First, I changed the blend mode by right-clicking the layer and selecting Blending Options. Under Blend Mode, I chose Multiply. Then I raised the brightness 100% three times by choosing Image > Adjustments > Brightness / Contrast (see Figure 4.16).

Figure 4.16

7 I opened the Layer Style box again by right-clicking the layer and selecting Blending Options. I clicked Bevel and Emboss and applied the settings shown in Figure 4.17.

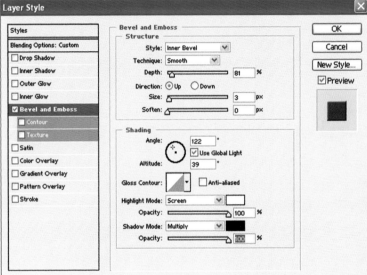

Figure 4.17

8 I repeated step 6 on the layer I wanted to appear indented and then applied the Bevel and Emboss settings shown in Figure 4.18.

Figure 4.18

9 As many (much better) users of Photoshop will tell you, the key to a good image is tweaking for that extra five minutes. I was nearly done, but I decided that the logo would look better on the other side, so I used the Polygonal Lasso tool around the logo, selected the Move tool, and then dragged it over to the other side of the brick (see Figure 4.19).

10 I also decided the Worth logo could use some more definition, as the font is quite thin. I used the Polygonal Lasso tool around it and darkened it slightly by choosing Image > Adjustments > Brightness / Contrast to achieve this result.

The Credit Brick fits in most wallets—and by "wallet," I mean pick-up truck beds.

Credits

Author: Daniel Goodchild
Source Images: Daniel Goodchild

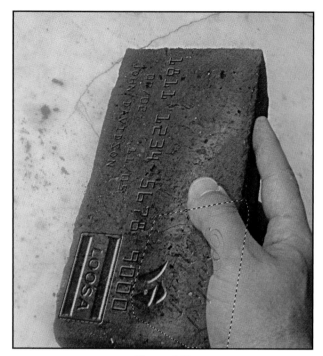

Figure 4.19

How I made Rotocell

You young whipper-snappers, with your fancy PDAs, pagers, P-Diddys, and speed-dialing cell phones. Back in my day, we didn't have speed dial on our cellular phones. If we wanted to dial a number, we had to work for it. We dialed, by gum. And that was good enough for us. And we could drive just fine while dialing, too! Today you kids can't find your own butts with both hands. Where'd I put my teeth?

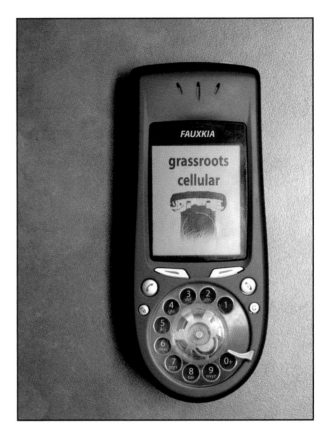

This tutorial assumes you have a basic grasp on how to use Photoshop.

1 I found two good source images of phones (shown in Figures 4.20 and 4.21). One is noticeably older than the other, but one probably pays a noticeably higher long-distance rate.

Figure 4.20

Figure 4.21

2 I adjusted the color balance on the cell phone because I didn't want the greenish tint of the original image. The old, rotary dial phone didn't have any color hue effect, so that was another reason for changing the balance. I chose Image > Adjust Color Balance and changed the midtones to: –34 cyan, –62 magenta, and +34 blue (see Figure 4.22).

3 Using the Magnetic Lasso tool, I circled the rotary dialer and metallic finger stop on the older phone image. I copied the selection to my clipboard using Edit > Copy and pasted the rotary onto the cell phone image by choosing Edit > Paste. The rotary automatically became a new layer on the cell phone image.

Figure 4.22

4 By selecting Edit > Free Transform, I was able to adjust the size of the rotary to fit over the push-button keypad of the cellular phone (see Figure 4.23).

5 Next, I adjusted the color on the rotary dial layer by choosing Image > Adjust Color Balance and changed the midtones to –16 cyan and +32 blue (see Figure 4.24).

Figure 4.23

Figure 4.24

6 Using the Clone Stamp tool, I cloned out the white dots in the center of each finger hole of the rotary dialer (see Figure 4.25). It's important to take a clone sample from the nearest dot you're cloning to match the lighting and texture of each part of the rotary.

7 I duplicated the dial layer by dragging the layer in the Layers palette to the Create a New Layer icon in the bottom-right of the palette. Next, I masked out the finger stop and made it its own layer (see Figure 4.26).

Figure 4.25

Figure 4.26

8 To make the rotary dialer look like it was part of the cellular phone, I embossed the dialing layer using Layer > Layer Properties > Emboss. I embossed down and positioned the lighting source in the same general area as my original light on the cell phone (see Figure 4.27).

9 I made the finger stop layer visible again (see Figure 4.28). The reason for this was so the finger stop appeared above the embossed layer below. Had I not masked out the finger stop, it too would have been embossed and would not have looked right.

Figure 4.27

Figure 4.28

10 It's a shame some careless person scratched the counter. Fortunately, Photoshop has something better than furniture polish. We have the Clone tool. I cloned out the scratch in the counter to the right of the phone (see Figure 4.29).

11 Using the Clone tool again, I cloned out the name brand across the top of the cell phone screen. Then, using the Text tool, I typed out a funnier name brand on a new layer (see Figure 4.30).

Figure 4.29

Figure 4.30

12 Using the Text tool again, I added new numbers and letters for the rotary dial (see Figure 4.31).

13 I created a new layer masking off the whole rotary phone body, not just the dial, and then used the Image > Adjustments > Threshold tool to convert the phone into a simple black-and-white image. Using the slider, I converted the phone into an easy-to-recognize shape (see Figure 4.32).

Figure 4.31

Figure 4.32

14 I inverted the colors by selecting Image > Adjustments > Invert. I then masked out all of the white areas, leaving only the black visible (see Figure 4.33).

15 I set the black image layer to overlay by selecting the Overlay option from the drop-down at the top of the Layers palette. I then duplicated the layer by dragging it to the Create New Layer icon at the bottom of the Layers palette and also set it to overlay, but with an opacity setting of 34% (see Figure 4.34).

Figure 4.33

Figure 4.34

16 Using the Brush tool, I added grass to the bottom of the phone icon (see Figure 4.35).

17 I added the name of my imaginary cellular provider to compliment the logo, using the same overlay and transparency technique on the font layer (see Figure 4.36).

Now that's a cell phone you can set your watch by! If it wasn't for my arthritis, maybe I could actually dial the thing.

Credits

Author: Jeff Birtcher
Source Images: Jeff Birtcher

Figure 4.35

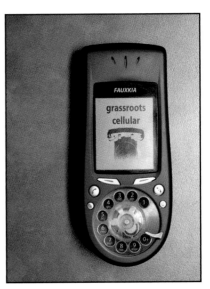

Figure 4.36

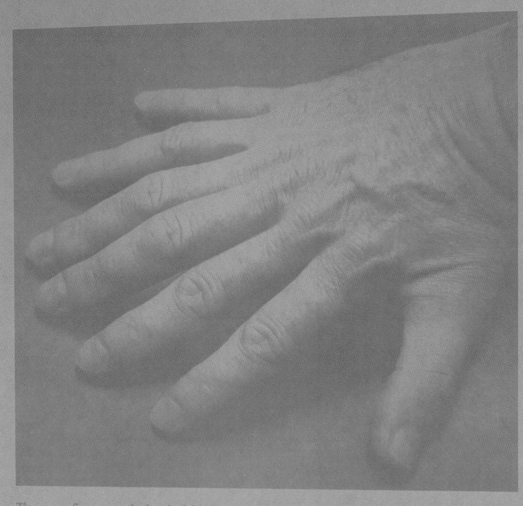

The seven fingers on the hand of this Latvian masonry worker were fully formed and functional. There were none of the abnormalities usually associated with extra digits on the hand.

Photo courtesy of Kulturhistorische Sammlung des Bundesverbandes der Deutschen Zahnärzte, Cologne, 1930.

In Search of Monsters, Ghosts, and Hoaxes

Since Photoshop first debuted, the world began to lose its faith in the simple truth of an image. When Worth1000.com first introduced its hoax image contests, the world threw whatever faith it had right out the window. Never again would anyone believe that Elvis and Bigfoot eloped to Las Vegas in the back of a UFO.

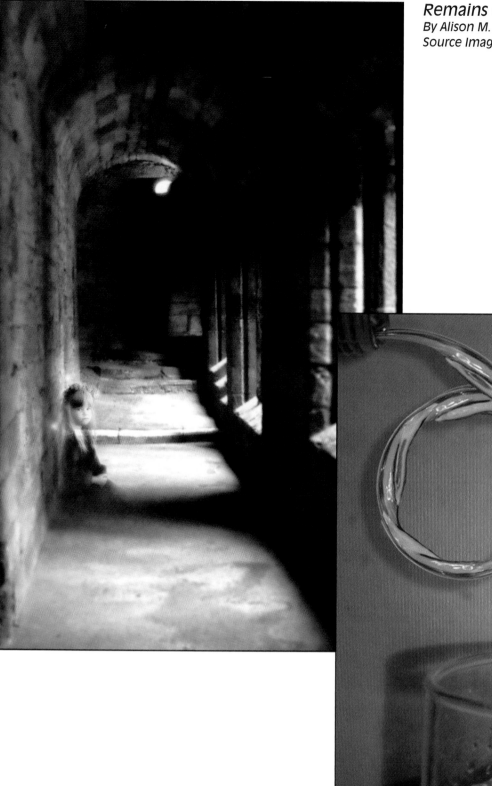

Remains of the Day
By Alison M. Huff
Source Images: Wetcanvas.com

Water with a Twist
By Daniel Goodchild
Source Images: Daniel Goodchild

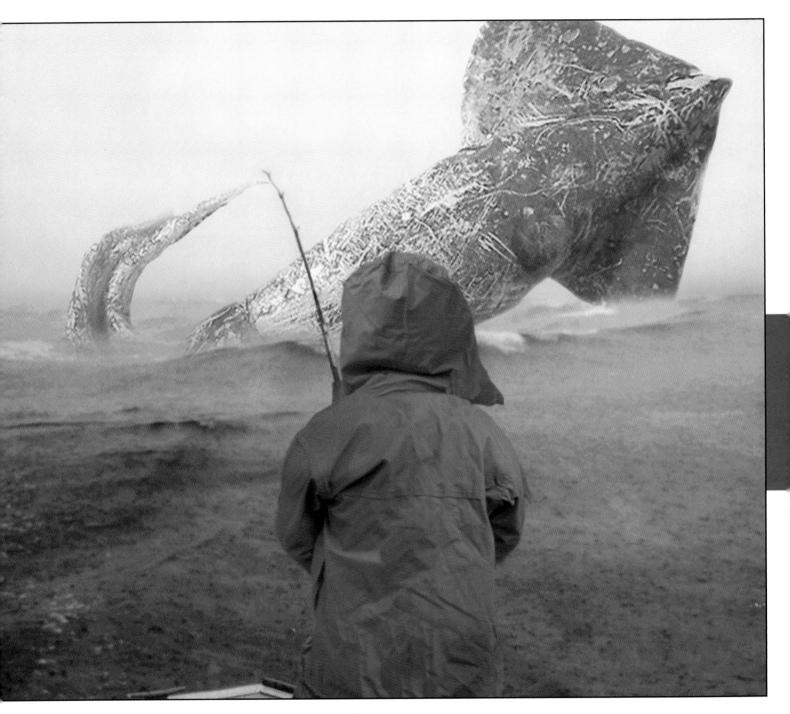

Kraken
By Avi Muchnick
Source Images: Jeff Birtcher

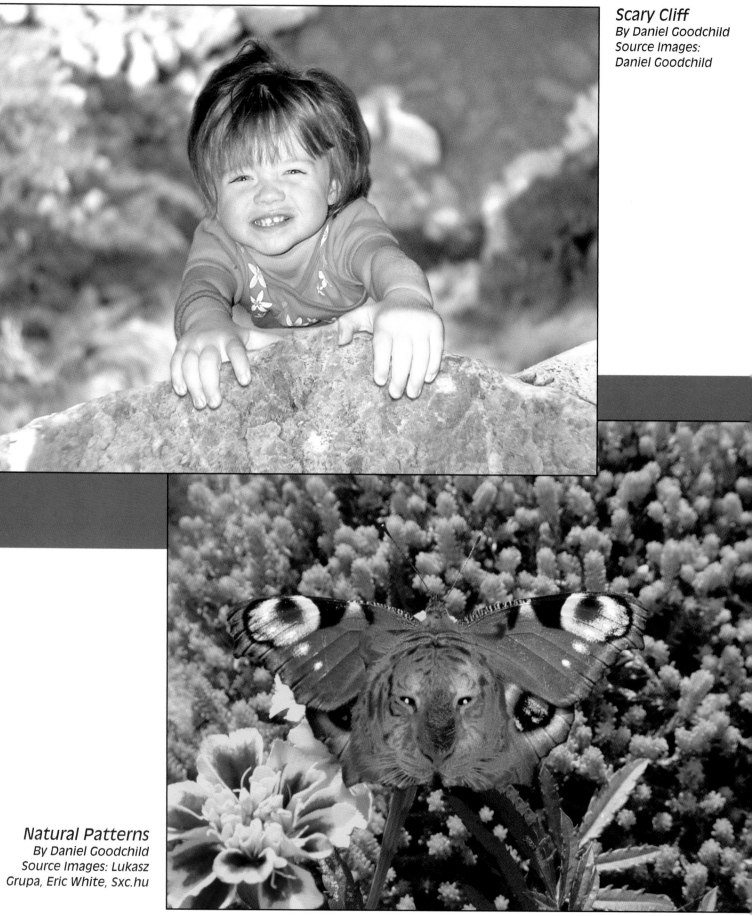

Natural Patterns
By Daniel Goodchild
Source Images: Lukasz
Grupa, Eric White, Sxc.hu

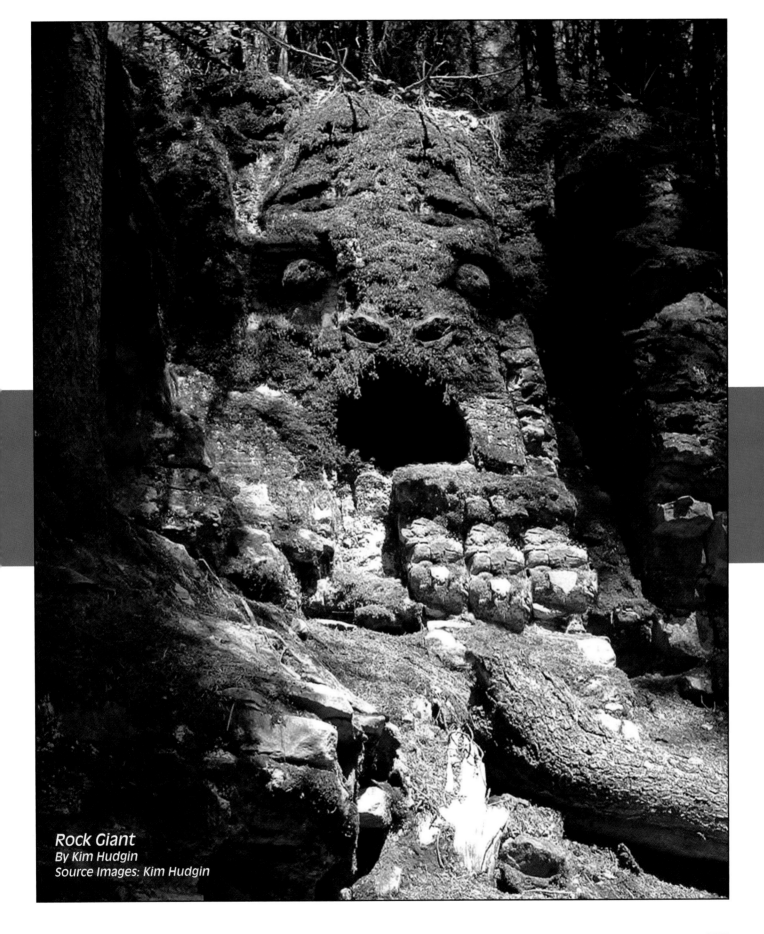

Rock Giant
By Kim Hudgin
Source Images: Kim Hudgin

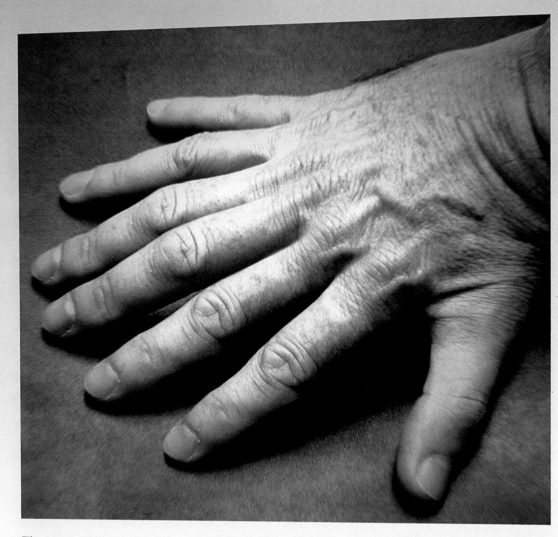

The seven fingers on the hand of this Latvian masonry worker were fully formed and functional. There were none of the abnormalities usually associated with extra digits on the hand.

Photo courtesy of Kulturhistorische Sammlung des Bundesverbandes der Deutschen Zahnarzte, Cologne, 1930.

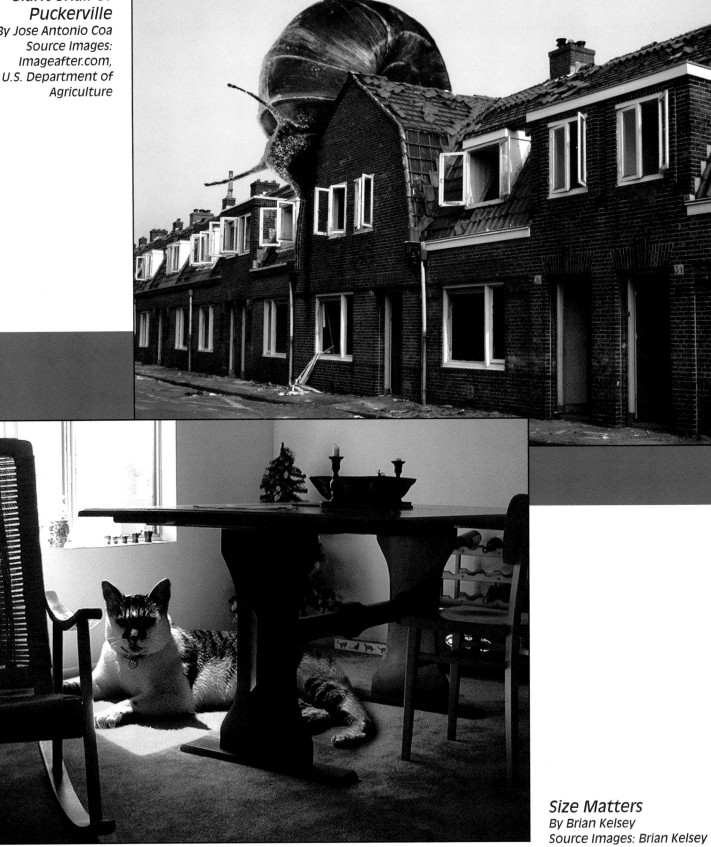

Giant Snail of Puckerville
By Jose Antonio Coa
Source Images:
Imageafter.com,
U.S. Department of
Agriculture

Size Matters
By Brian Kelsey
Source Images: Brian Kelsey

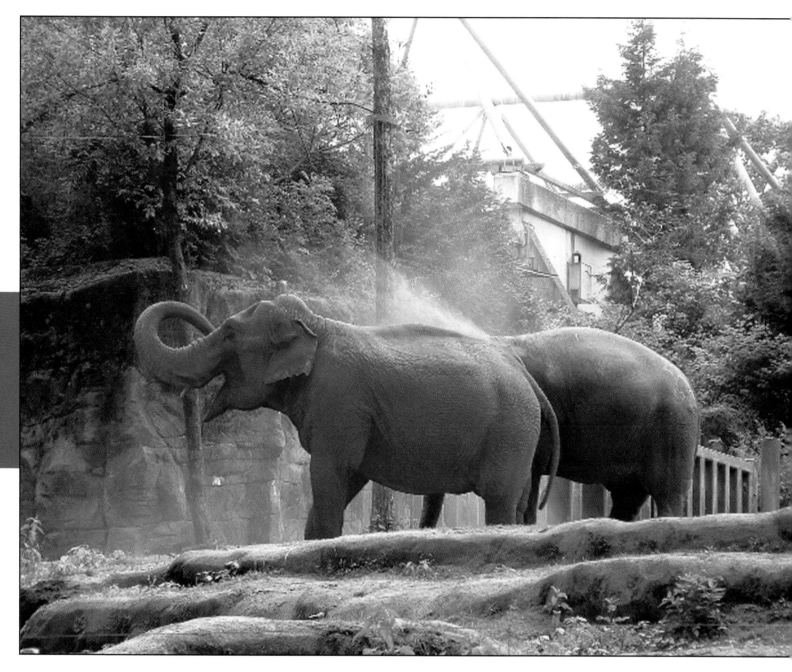

Pink Elephant
By Ellen Vreugdenhil
Source Images: Ellen Vreugdenhil

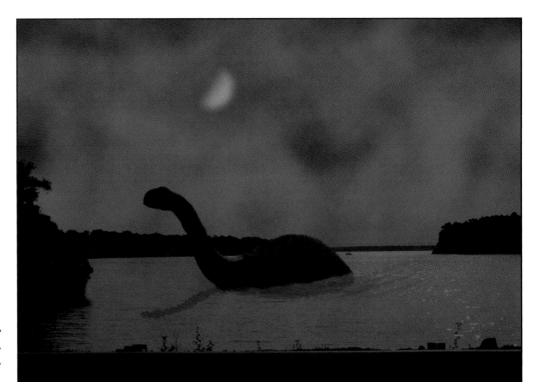

Loch Rend Monster
By Jeff Birtcher
Source Images: Jeff Birtcher

Grab a Wave
By Rebecca O'Banion
Sources: Photospin.com,
Malcolm Brown, Sxc.hu

139

Tutorials

How I made Remains of the Day

Day 7 of our legends, freaks, and folklore hunting expedition brought us to a medieval castle overlooking the north Atlantic. We'd heard the tales of a ghostly girl who wandered the halls, chambers, and porticos of the castle. The girl was rumored to be the illegitimate daughter of the third Duke of Northoverunderroundaboutinghamshire. Locals say she was sealed in a section of wall that would forever be her tomb, and today she's still searching for those who locked her in. Our thorough investigation didn't yield a damn thing. But we promised our publisher a compelling ghost photograph. With Photoshop, we delivered.

This tutorial is going to focus on creating a believable ghostly apparition. Good for a beginner.

1. I started off by using a specialized filter, called the Dreamy filter (shown in Figure 5.1), which is part of the Dream Suite Photoshop plug-in from AutoFX (which must be purchased separately).

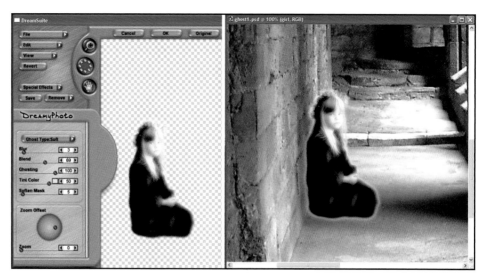

Figure 5.1

2 I wanted to fade the filter a bit, so I chose Edit > Fade DS Bonus and faded it in Overlay mode at 68% opacity (see Figure 5.2).

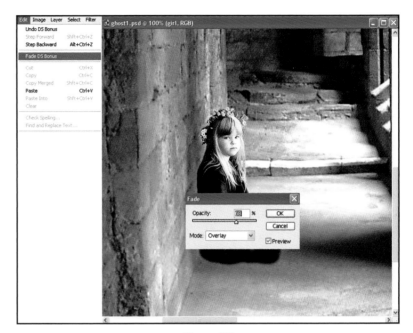

Figure 5.2

3 Switching to the hallway layer, I added a ghostly halo of lights around the little girl's head. I used the Lens Flare filter to achieve this. I selected Filter > Render > Lens Flare and then used a 35mm prime lens type with a brightness of 18%, and I applied this to the hallway layer three times, circling her head (see Figure 5.3).

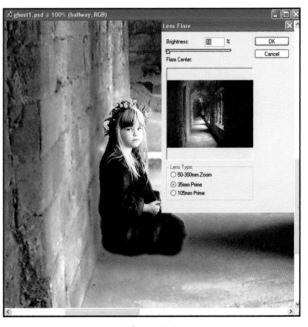

Figure 5.3

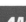

4 Now I needed to make my little girl much more haunting in appearance. Instead of using the blending options to do an all-over transparency, I chose to use a large, soft eraser, set at 5% opacity. This would require several sweeps in various areas, but it gave me the greatest amount of control in keeping specific areas more visible to the eye while making other areas almost non-existent, giving her an ethereal look, as shown in Figure 5.4.

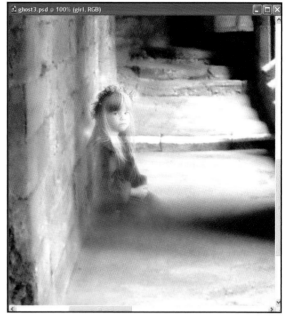

Figure 5.4

5 I decided to crop the image in order to make the details of the ghost more easily viewed. Normally, I would crop in on the main subject of a work, centering on it; this not only allows for a better view of the alterations done to a photo, but adds to the dramatic effect as well. When it comes to "ghostly" photos, however, the ghost is not the intended subject when the "photograph" is taken. The image of the ghost would only materialize once the photograph is developed, so I cropped the entire image in a manner that still left the hallway and architecture as the main subject (see Figure 5.5). It added just a little more realism to the hoax.

The publisher was astounded at the picture of the ghost girl of Northoverunderroundaboutinghamshire. Geraldo called and asked if he could go back with us and try and capture the ghost in a cage; apparently he wants to offer a ghostly world tour. Hmmm… this could get tricky.

Credits

Author: Alison M. Huff
Source Images: Wetcanvas.com

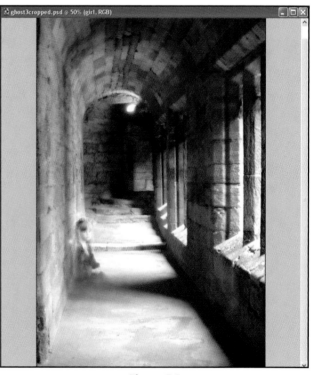

Figure 5.5

How I made Scary Cliff

Running low on funds, our expedition needed some income, and quickly. We had a small child and focused our cameras on her, waiting for her to do something adorable or dangerous so we could submit the image to one of those funny home video television shows and take the grand prize. After 10 minutes, the best we had was her spilling some pudding. Thank goodness for Photoshop. In hindsight, by toying with her photo instead of her psyche and physical well-being, she'll probably turn out better in the long run and not seek some horrible revenge on us when we're too old and feeble to defend ourselves.

First, I'd better thank my daughter for hanging onto the back of my office chair long enough for me to take the photo. The image of the cliff edge was taken in Majorca in the bizarrely named Banyalbufar.

This tutorial is perfect for the warped beginners who want to mess with their children.

1. First, I roughly cut out the image of the girl with the Lasso tool and pasted it onto the cliff photo. This automatically created a new layer, shown in Figure 5.6.

Figure 5.6

2 Next, I added a layer mask by choosing Layer > Add Layer Mask > Reveal All and carefully brushed the excess areas away around her body (see Figure 5.7).

3 I added a little shade under her fingers to make it look more realistic. To do so, I right-clicked the girl layer and selected Blending Options. I then chose a very small Drop Shadow: Distance 2, Spread 0, Size 4, and set the lighting angle from directly above (90°).

Figure 5.7

4 To remove the excess shadow, I right-clicked on the effects layer in the Layers palette and selected Create Layer. Now I could simply erase the majority of this layer, leaving only the shadow under the fingers (see Figure 5.8).

5 As you can see, the top of her head was quite dark, while her fingers were bright. To even this out, I duplicated the layer of the girl by choosing Layer > Duplicate Layer and checked Group with Previous Layer.

6 Next, I raised the brightness using Image > Adjustments > Levels. I checked the Preview box and slid the middle pointer to the left until the brightness looked right.

Figure 5.8

7 I added a layer mask to this duplicated layer by choosing Layer > Add Layer Mask. Next, I used the black-and-white Gradient tool on the layer mask to reveal the fingers and lower portion of the image (see Figure 5.9).

Figure 5.9

8 Finally, I added a final levels adjustment layer to the whole image by choosing Layer > Adjustment Layer > Levels and played with the settings until it looked lighter and better toned, as shown in Figure 5.10.

With a little girl hanging from a high cliff, we're a shoo-in for the "endangering our children" category. Now we wait for the money (and child welfare department) to roll in.

Credits

Author: Daniel Goodchild
Source Images: Daniel Goodchild

Figure 5.10

How I made Loch Rend Monster

Day 12 of our quest for creatures of lore brought us to Loch Ness in Scotland. We've all seen the obscure and dark photo taken in 1934 of a snaky head poking out of the waters of this infamous Scottish lake. We were determined to do better. Is the Loch Ness Monster a dinosaur that somehow survived? Would we be able to capture the beast on camera and still have time to make the early-bird special at the Loch Ness Buffet and Salad Bar? The answer, sadly, was no. Though we did snap a few pictures of Bigfoot, we hit the buffet with no compelling photos of Nessie. To deliver the visual evidence we promised our publisher, we'd need to get creative.

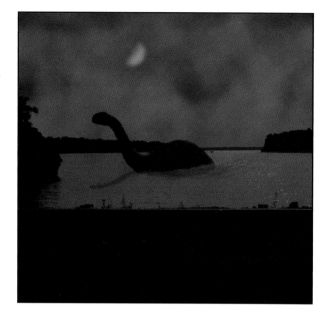

Getting started

This one is good for an intermediate Photoshop user.

1 To create this image, I started with three source photographs: a lake, the moon, and a toy dinosaur (Figures 5.11, 5.12, and 5.13, respectively). It was important to me to get the right colors and angles from the beginning, so I had dozens of different pictures of the same toy dinosaur at different angles and several different pictures of the same lake from different angles as well.

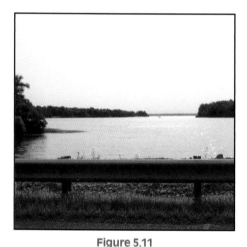

Figure 5.11

Figure 5.12

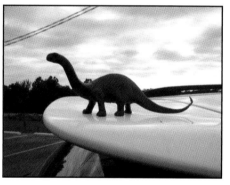

Figure 5.13

2 I wanted this image to appear as though it were taken at night, because Nessie would have wanted it that way, so I adjusted the color balance for the lake by choosing Image > Adjustments > Color Balance. The first step was to adjust the color balance for all three levels by adjusting the blues to +45 on the highlights, midtones, and shadows.

3 The image then had a nice blue hue to it (see Figure 5.14). I adjusted the brightness and contrast by choosing Image > Adjustments > Brightness/Contrast, and I lowered the brightness to –95 and the contrast to –55. I played with the brightness/contrast sliders for a while before I was happy with the exact location (see Figure 5.15). Some people like to say that the brightness/contrast sliders aren't as good as adjusting curve balances, but I think there are merits in using each tool.

Figure 5.14

Figure 5.15

Bring on the monster

1 Now that night has fallen on the lake scene, maybe Nessie won't be so shy. It was time to implement the dinosaur image. I used the Lasso tool to circle the dinosaur and chose Edit > Copy, then Edit > Paste to bring the dinosaur into a new layer on the lake image.

2 I then masked the dinosaur by clicking the Add Layer Mask icon at the bottom of the Layers palette.

3 After masking the dinosaur, I adjusted the color balance in order to have it match up better with the lake (see Figure 5.16). I selected Image > Adjustments > Color Balance, and using the color balance sliders again, I set the highlights to +16 blue, the midtones to +38 blue, and the shadows to +18 blue.

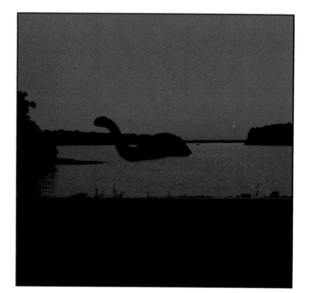

Figure 5.16

4 As with the lake image, I then adjusted the brightness (–24) and contrast (+12) for the dinosaur (see Figure 5.17). You'll note that my values for this change were much less extreme than for the lake. My sources just happened to turn out that way. Playing with these sliders again is a good way to begin "dialing in" the image.

Figure 5.17

5. At that point, the color appeared to be a little too bold, but the hue was exactly what I was looking for, so I desaturated the dinosaur by choosing Image > Adjustments > Hue/Saturation (see Figure 5.18). The value I used was right around –40 on the Saturation slider, and I adjusted the lightness just a touch, to around –5.

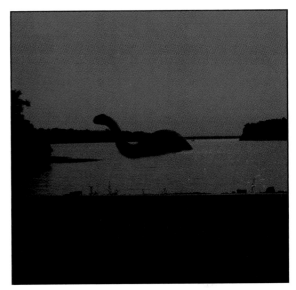

Figure 5.18

Customizing the surroundings

1. Looking back at my lake source image, I realized that there were some funny weeds on the left of the lake, right near where my monster was sitting. In the daytime, they looked fine as green weeds, but at nighttime, they looked like an errant shadow. I cloned out the funny shadow/growth on the lake using the surrounding waters and the Clone Stamp tool (see Figure 5.19).

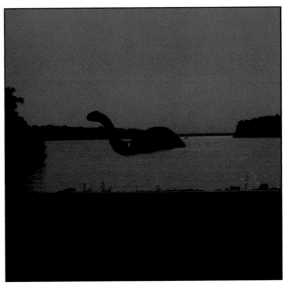

Figure 5.19

2 Then, I created a reflection for my dinosaur so it looked like it was actually sitting in the water. I selected the dinosaur layer, then created a basic drop shadow of the dinosaur layer by choosing Layer > Layer Style > Drop Shadow (see Figure 5.20).

3 I wanted to edit this new shadow, so the first step was to create a new layer from the dropped shadow by right-clicking on its name in the Layers palette and selecting Create Layers. Photoshop will warn you that you might not want to do this, but what does Photoshop know? Once I created the new layer, I flipped it vertically by selecting Edit > Transform > Flip Vertical.

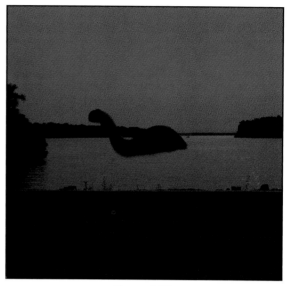

Figure 5.20

4 Next I distorted the shadow using Edit > Transform > Distort. It took me a while to get the shadow exactly where I wanted it. Take your time with this step. Sometimes I will walk away for a few minutes and then come back to it to try to get a fresh perspective. Other times, I'll scream in sheer agony. Do whichever works for you. You can see the results in Figure 5.21.

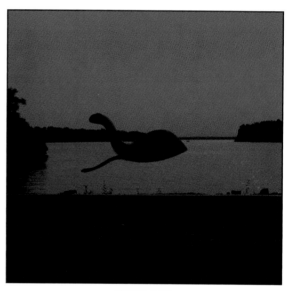

Figure 5.21

5 When the shadow layer was in the right place, from the top of the Layers palette, I changed its layer property to Darken in the drop-down and set its opacity to 28%.

6 I selected Filter > Distort > Ripple and chose 196% on the dropped shadow. Using the ripple filter takes patience. I've found that selecting colors that are close to the surrounding water for my palette can help to get the effect to look just right (see Figure 5.22).

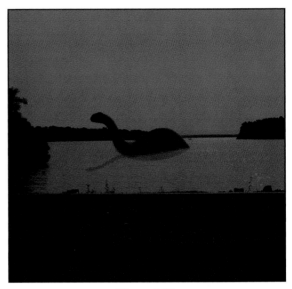

Figure 5.22

7 Next, I needed to create some ripples in the water to give the illusion that the giant Nessie was cruising around slowly and quietly. I selected the dinosaur layer and chose Layer > New > Layer to create a layer above the monster. I used a small, round brush to draw some dark blue wake lines beneath the dinosaur. Once I had the wake lines about where I wanted them, I set the wake layer properties to Soft Light and the opacity to 30% (see Figure 5.23).

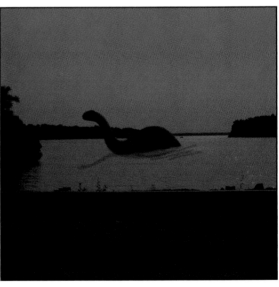

Figure 5.23

8 Using a similar ripple filter as the one I used on the shadow helped to bring the two pieces of the image together (see Figure 5.24). I selected Filter > Distort > Ocean Ripple on the wake layer, and then I set the ripple size to 3 and the ripple magnitude to 15.

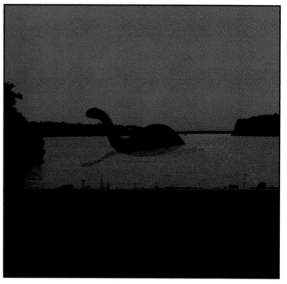

Figure 5.24

Night skies

1 The source picture of the moon was terrible, but it would do. It needed to be foggy and out of focus, and luckily I had captured just such an image. Placement and size came first. I used the Lasso tool to copy the original moon, and I pasted it into a new layer on the monster/lake image. I created a mask to clean up the edges of the moon and allowed it to blend in with my artificial night sky (see Figure 5.25).

2 Then I wanted to add some clouds and fog to the image. I created a new layer above all others and chose colors from the night-lake layer: a dark blue and a light blue. Sampling different areas of the lake layer with the Eyedropper tool to fill the palette is a great way to select these colors, but there's no need to over-think this step.

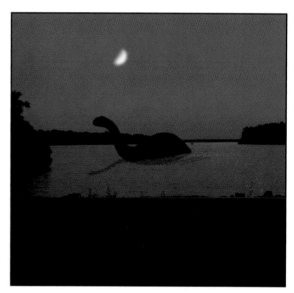

Figure 5.25

3 On the new layer, I painted the entire canvas the darker blue and used the Filter > Render > Clouds option to create some nice, random-looking clouds, as shown in Figure 5.26.

Figure 5.26

4 I set the new layer to 80% opacity, set the properties to Darken, and masked the clouds at varying degrees of opacity. I usually make all of the other layers hidden when I mask off clouds and bring critical layers into view at various points during the masking to see how I'm doing. If I were to re-create this image a dozen times, the clouds would look different for each attempt. Experimenting with different areas and opacities was a good way to find exactly the look and feel I was going for with this image. In the end, my cloud layer, by itself, looked like it was barely going to affect the image, but when I brought everything out of hiding, the clouds popped right out at me. See the final image in Figure 5.27.

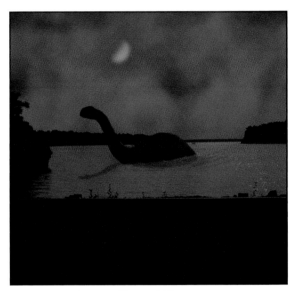

Figure 5.27

Another unbelievable capture of Nessie. Though with enough patience and the right filters, it's not that unbelievable, is it?

Credits

Author: Jeff Birtcher
Source Images: Jeff Birtcher

How I made Natural Patterns

How does a tiger mate with a butterfly? Very, very carefully. The next stop of our expedition brought us to the jungles of Bengal. Maybe it's something in the water, maybe it's the Barry White music being piped in throughout the jungle, but something has caused these two seemingly disparate breeds to mingle. We were determined to photograph the elusive Tiger-Butterfly, or at least fake it if we couldn't find it.

This tutorial is well-suited for a beginner to intermediate user.

1 Using the Elliptical Marquee tool, I copied the roughly cut-out image of the tiger head and pasted it into a new layer of the butterfly image (see Figure 5.28).

Figure 5.28

2 On the Layers palette, I set the blend mode to Multiply to be able to resize the image appropriately over the butterfly. I chose Edit > Free Transform to resize the tiger head over the back of the butterfly (see Figure 5.29). Then I set the blend mode back to Normal.

Figure 5.29

3 Then, I added a layer mask by clicking on the tiger head layer in the Layers palette and clicking the Add Layer Mask icon at the bottom of the palette. Then I removed all areas outside the main head (see Figure 5.30).

Figure 5.30

4 To match some of the butterfly colors, I adjusted the Gradient Map by choosing Image > Adjustments > Gradient Map. I clicked inside the gradient to launch the Gradient options bar and created a new gradient using colors from both the butterfly and the tiger (see Figure 5.31).

Figure 5.31

5 I chose Select > Color Range and clicked an area of tiger stripe. Next, I inverted the selection by selecting the Marquee tool, right-clicking, and choosing Invert Selection (see Figure 5.32). I right-clicked again and chose Feather by 2 pixels.

6 I created another layer mask by selecting the Add Layer Mask icon in the Layers palette, and then I removed the selected area.

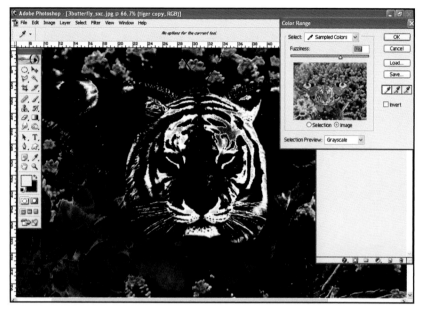

Figure 5.32

7 I added a new layer, named it "purple," and used the same selection technique as discussed in step 5 to select a natural-looking area to recolor. I used the Eyedropper tool to sample a purple spot on the butterfly wing and then used the Brush tool to paint over the selected area (see Figure 5.33).

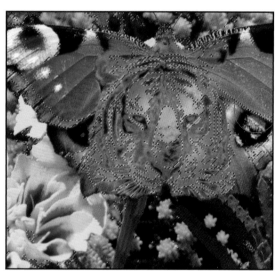

Figure 5.33

8. I added some noise by choosing Filter > Noise > Add Noise and added 4% to the purple layer. Next, I added some blur by selecting Filter > Blur > Gaussian Blur. I gave the blur a radius of 1 pixel and selected OK.

9. Finally, I masked the tiger's nose in line with the butterfly's body (see Figure 5.34).

With our picture in hand, we finally had compelling "proof" of the mating habits between tigers and butterflies. Now, if our butterfly flapped its wings with tiger-like strength in Bengal, would it affect the weather in Newark, New Jersey? The answer is a definite maybe.

Credits

Author: Daniel Goodchild
Source Images: Butterfly—Lukasz Grupa
Tiger—Eric White

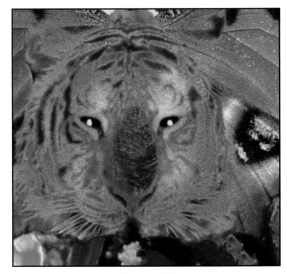

Figure 5.34

How I made Water with a Twist

Our crack(pot) team of investigators heard about a strange place where electromagnetic energy could change the physical world as we know it. Telekinesis, crop circles, and remote viewing can't hold a candle to this supernatural phenomenon. In a secret location in Butte, Montana, we heard about the magic powers of this energy changing the course of mighty rivers. What we heard and what we found were quite different. No mighty rivers changed their course, but we found a humdinger of a strange effect when pouring a glass of water.

I'd like to say I created the spiral with lots of clever filters to produce a beautiful spiraled water effect, but in fact, it was just one handy filter that did most of the work. That, and having plenty of source images.

This tutorial assumes that you have a basic grasp on how to use Photoshop.

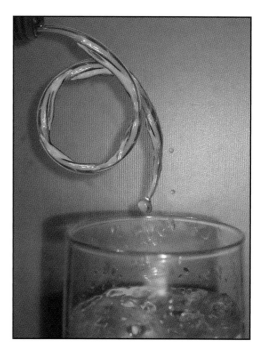

■ This idea came from my feeble attempts at creating that most clichéd of photos, the water droplet. I tried to shoot the picture over and over again until I realized that A) my camera isn't up to the job, and B) it's a boring shot anyway. Three of my closest shots are shown in Figure 5.35.

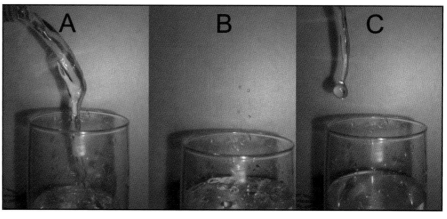

Figure 5.35

2 Using the Lasso tool, I cut out the water section from picture A (the widest of the ones I shot) and pasted it into a new layer of picture B (see Figure 5.36).

3 I then used Filter > Distort > Spherize from a central point on the canvas, so my water object that was placed off-center just distorted it in that direction (see Figure 5.37).

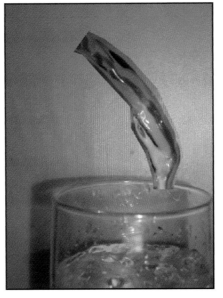

Figure 5.36

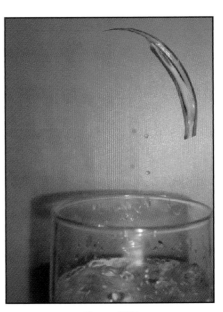

Figure 5.37

4 My next step was a relatively simple matter of removing excess pixels from the water layer, then duplicating the layers and rotating and twisting them accordingly using Edit > Transform > Rotate. Figure 5.38 shows the five identical layers separated and in various stages of rotation.

5 I linked all of the water layers by selecting the top layer, then clicking in the box to the immediate left on the other water layers, bringing up a chain link icon.

6 I merged the water arcs together by clicking the links in the layers palette and choosing Layer > Merge Linked (see Figure 5.39).

Figure 5.38

Figure 5.39

7 I added a drop shadow to the water spiral layer with the settings shown in Figure 5.40.

8 I copied the bottleneck from my original source image and placed it into my working image. Because the angle of the picture and the perspective didn't change between images, the bottleneck fit perfectly into the upper-left corner. Next, I positioned the water spiral layer up to the bottleneck.

9 Finally, using the Lasso tool, I cut out a section of the bottleneck layer so it looked like my spiraling water was pouring directly from the bottle.

Finally, a picture of water as twisted as the people willing to spend $3 for a bottle of "natural spring water."

Credits

Author: Daniel Goodchild
Source Images: Daniel Goodchild

Figure 5.40

How I made Pink Elephant

Though it's arguably one of the smallest politically influential groups in the United States, the Gay Republicans' mascot is the most endangered of all the elephants. Our team of investigators set out to the group's Fire Island headquarters to track down and document the elusive pink elephant.

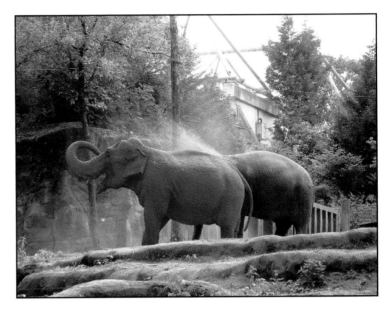

This tutorial is perfect for beginners interested in messing with their narcotics-using friends.

I started with the image shown in Figure 5.41.

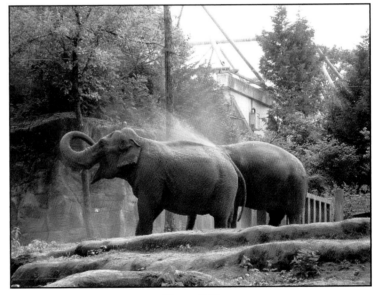

Figure 5.41

1 I copied the background layer by selecting Layer > Duplicate Layer (see Figure 5.42). So now I had two of the same layers.

Figure 5.42

2 I selected the top layer and used the Polygonal Lasso tool to roughly select the elephant, as shown in Figure 5.43. Plus, it's just downright fun to lasso up an elephant. Try doing *that* in real life.

Figure 5.43

3 I chose Select > Inverse and hit the Delete key to cut the surroundings around the elephant (see Figure 5.44).

Figure 5.44

4 I then chose Select > Deselect to drop the marquee. Next, I chose Image > Adjustments > Color Balance and changed the midtones to the settings shown in Figure 5.45.

Figure 5.45

5 I then had an elephant (and some rough edges) that were pink in color. I added a layer mask by selecting Layer > Add Layer Mask > Reveal All. Starting with a large brush, I brushed away the edges of the elephant. As I got closer to the edges of its body, I switched to a small brush (see Figure 5.46).

Figure 5.46

6 With the masking completed, my elephant now looked like Figure 5.47.

Figure 5.47

7 In the Layers palette, I set the opacity to 75% to give the elephant a more realistic look, as shown in Figure 5.48.

Figure 5.48

Because the original elephant is in the exact same position underneath, the natural grays blended well with the pinks (see Figure 5.49).

With the pink elephant "captured," our group of investigators was ready to submit full reports and findings to some of the leading science journals, which can all be found in the checkout aisles of your local supermarkets. Watch for pink elephants, ghosts, and monsters on the front page in the coming months.

Hey, it's a living.

Credits
Author: Ellen Vreugdenhil
Source Images: Ellen Vreugdenhil

Figure 5.49

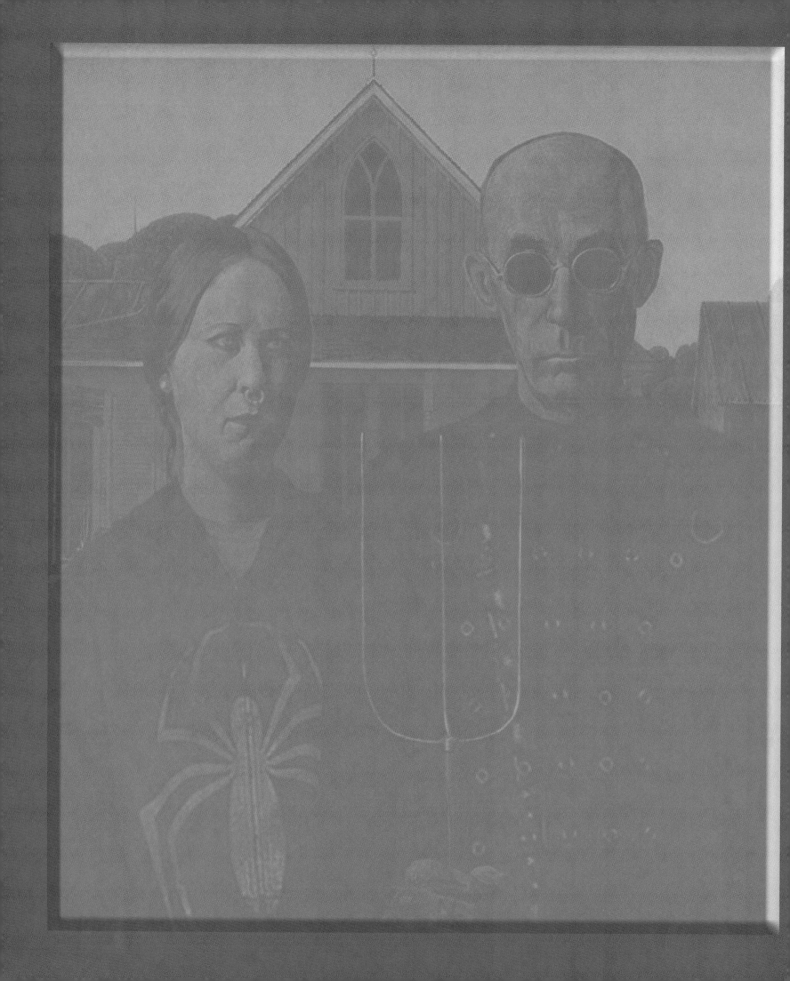

Counterfeit Art

ounterfeiters are getting really lazy lately. There used to be a time when a fake *Mona Lisa* couldn't be detected without a microscope. Nowadays, the mustache and pierced nose is a dead giveaway. At Worth1000.com, we love to befuddle the art world with our counterfeit art. Take a look at the following works and see if you can spot the fake one.

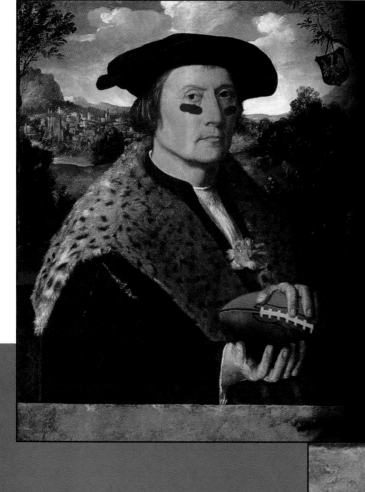

Ancient Football
By Alex Levin
Source Images: Euroweb.hu, PhotoSpin.com

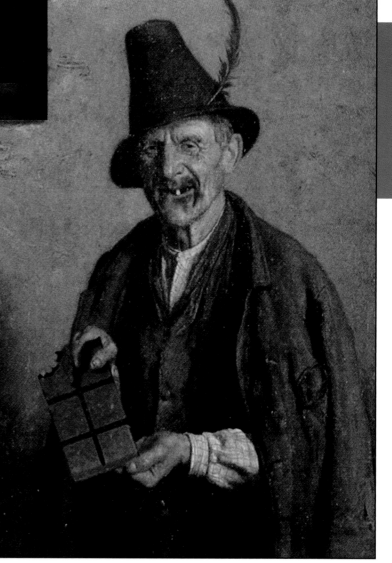

The Candy Dealer
By Adnan Saleem
Source Images: Wetcanvas.com

168

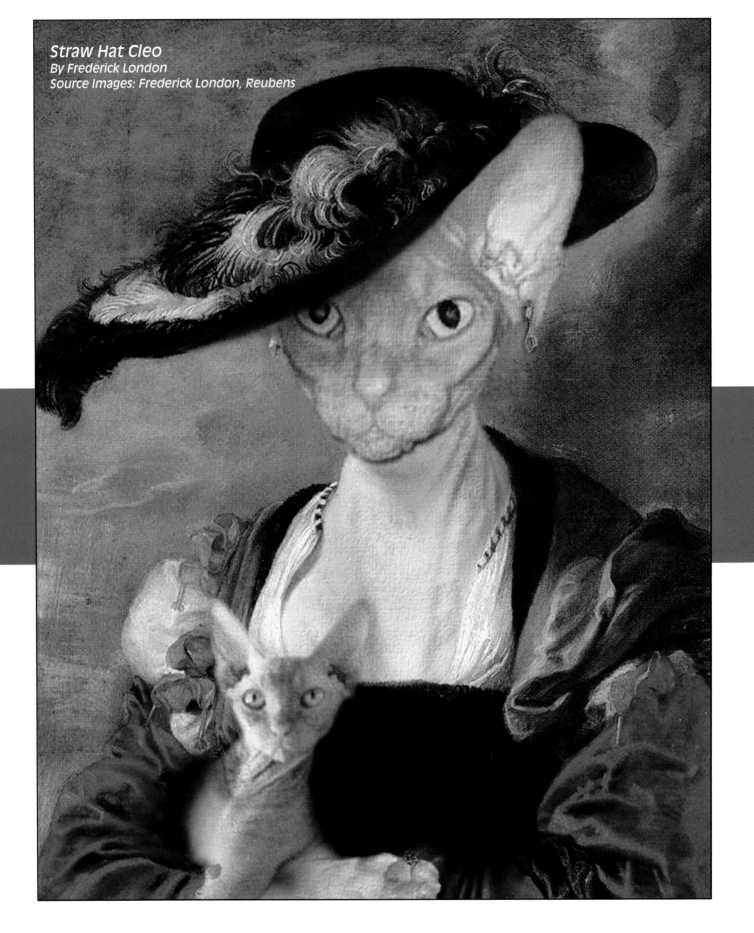

Straw Hat Cleo
By Frederick London
Source Images: Frederick London, Reubens

Cheese!
By Alex Levin
Source Images: Euroweb.hu, Alex Levin

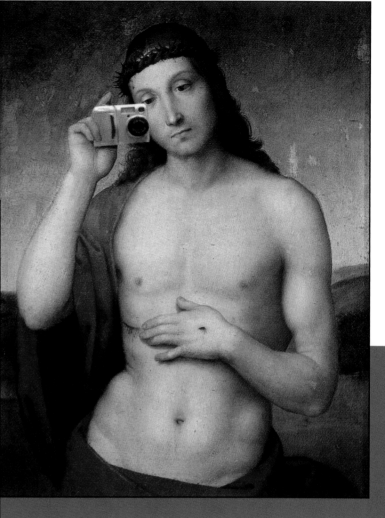

"Twilight" for the Conservative
By Megan Pleuss
Source Images: Megan Pleuss, William Bouguereau

Historical Advertising
By Alex Levin
Source Images: Daniel Goodchild, Euroweb.hu

Charlemagne: All-Star
By Tom Ritchie
Source Images: Durer

Henry VIII in Anne's Clothes
By Alec Ogston
Source Images: Hans Holbien

Michaelangelo for the Conservative
By Renato Dornas de Oliveira Pereira
Source Images: Michaelangelo

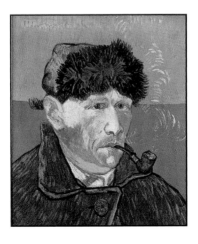

Van Gogh Pre-Ear "Incident"
By Ian Capezzano
Source Images: Van Gogh

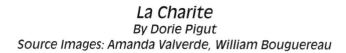

La Charite
By Dorie Pigut
Source Images: Amanda Valverde, William Bouguereau

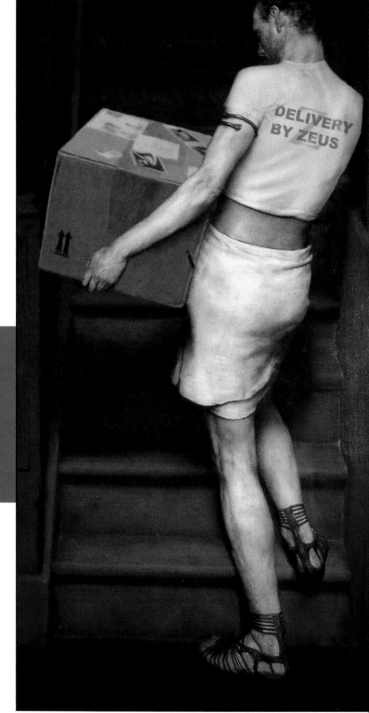

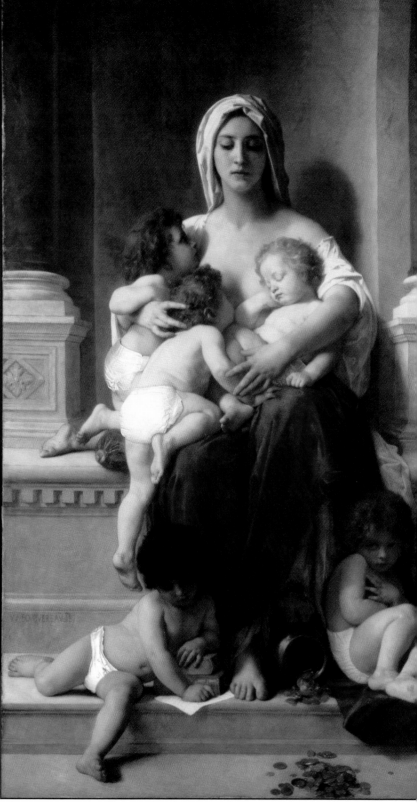

Special Delivery
By Robert Schneider
Source Images: Robert Schneider, Tadema

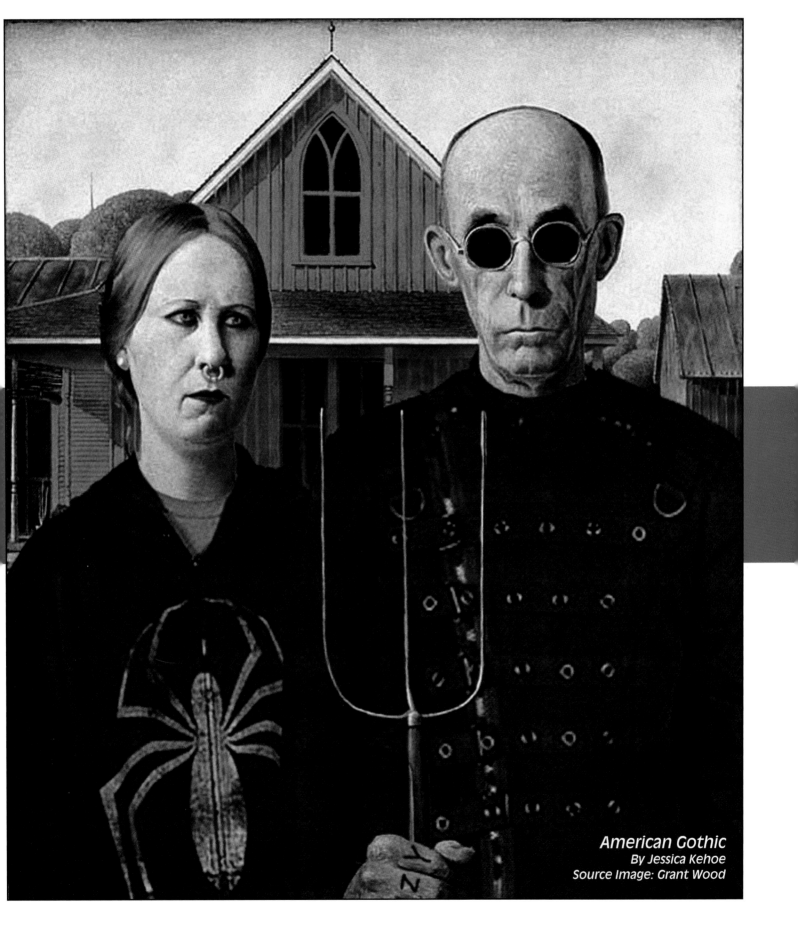

American Gothic
By Jessica Kehoe
Source Image: Grant Wood

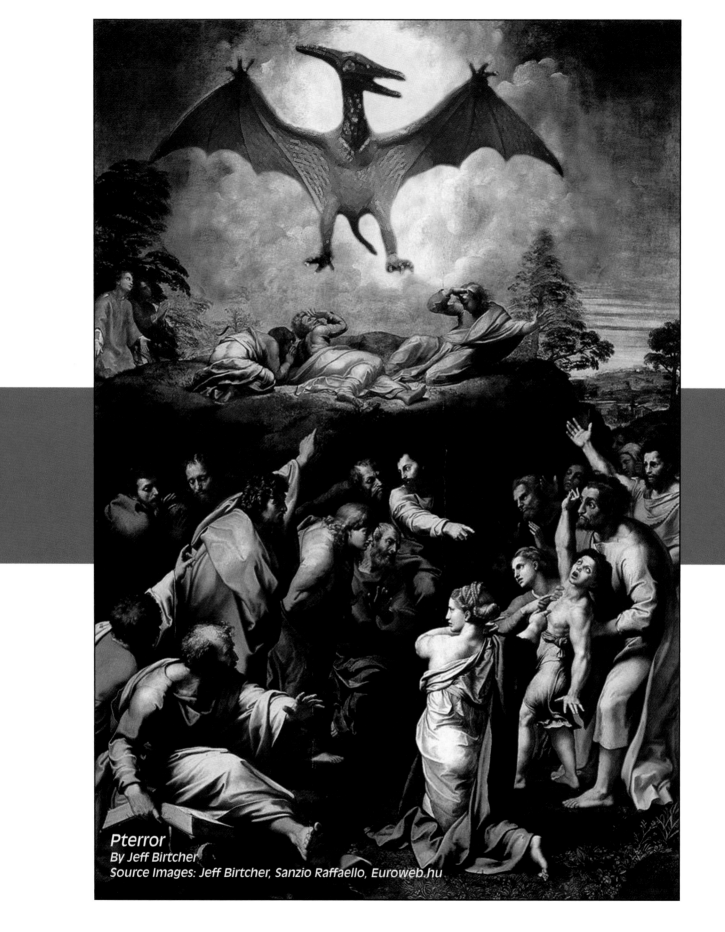

Pterror
By Jeff Birtcher
Source Images: Jeff Birtcher, Sanzio Raffaello, Euroweb.hu

Prince Tuffy
By Jeff Birtcher
Source Images: Jeff Birtcher,
Lucas Cranach, Euroweb.hu

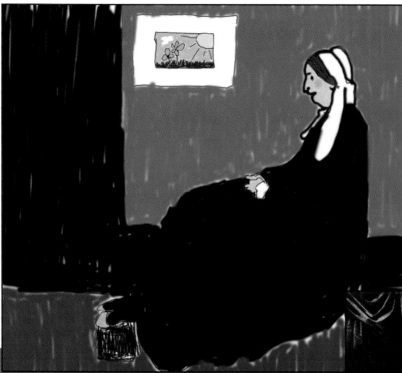

Whistler's Mommy,
By Whistler, age 5
(Actually by Janine Gardner)

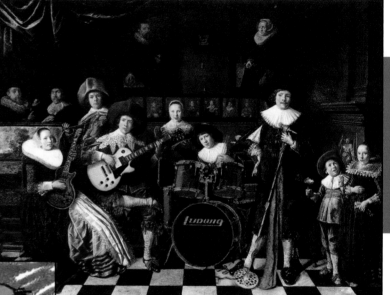

Old-Time Rock and Roll
By Tom Ritchie
Source Images: Molenaer, Tom Ritchie

Ring Around the Rosie
By Matisse, age 5
(Actually by Tracy Lang)
Source Images: Matisse

Modern Music Lesson
By Megan Pleuss
Source Images: Sheila Broumley, Raymond Mclean

*Michaelangelo's
Secret*
By Robert Schneider
Source Images:
Michaelangelo

Waiting
By Alison Huff
Source Images:
Wetcanvas.com

Invisible Gothic
By R.C. Whalen
Source Images: Grant Wood

178

Invisible Pastourelle
By Kris Aring
Source Images: William Bouguereau

Boogieroo's Afro
By Avi Muchnick
Source Images: William
Bouguereau, Hemera.com

179

Tutorials

How I made Invisible Gothic

Creating "invisibles" is much like a teenager going on a date: The overall objective is simply to remove the other person from his or her clothes. Unlike a teenager, though, we're interested in keeping the clothes around, not the person. Actually, that's probably similar to most of the people I dated, too. The trick to creating invisibles is copying from one area of an image to another to hide the person's body.

In this little image, I removed "Jacob" and "Emma" from Grant Wood's famous *American Gothic*. For this tutorial, I'll simply demonstrate the process I used on Emma, because the process for removing Jacob is exactly the same. The original image is shown in Figure 6.1.

Figure 6.1

This tutorial assumes that you have a basic grasp on how to use Photoshop. The major tool used is the Clone Stamp tool.

1 First, I used the Rectangular Marquee tool to select the largest area available on the house that could be used to cover Emma's head (see Figure 6.2).

Figure 6.2

2 I copied this selection onto a new layer by selecting Edit > Copy and Edit > Paste and then used the Move tool to move this new layer over her head. I made sure the lines on the wall aligned with the original (see Figure 6.3).

Figure 6.3

3 I repeated this process until the entire wall was complete. I then used the Clone Stamp tool with a soft brush setting to blend the edges of my copied layers together. The result was that I had cleaned up the seams nicely (see Figure 6.4). The slight blurriness where the edges had been blended didn't matter once the picture was complete, as that area was completely in the background, and everyone was distracted by my invisible people anyway.

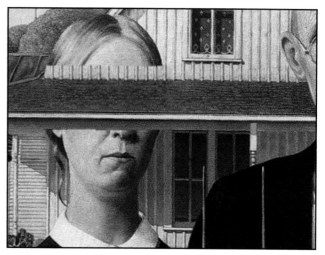

Figure 6.4

4 Next, I used the Polygonal Lasso tool to select an area of the roofline (see Figure 6.5).

Figure 6.5

5 I copied this selection onto a new layer by selecting Edit > Copy and Edit > Paste, and then used the Move tool to move the selection over her head. Again, I made sure that the lines on the selection aligned with the original (see Figure 6.6).

6 And once again, I used the Clone Stamp tool to clean up the seams. I think you're getting the idea here, right?

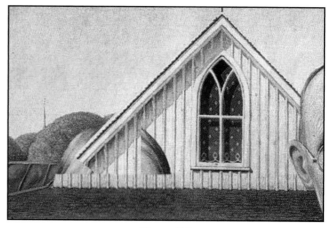

Figure 6.6

7 I also used the Clone Stamp tool to copy the background trees to fill up to the roofline (see Figure 6.7).

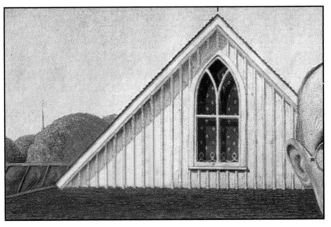

Figure 6.7

8 I used the Polygonal Lasso tool to select an area under the roof. I copied this selection onto a new layer by selecting Edit > Copy and Edit > Paste and then used the Move tool to move the selection over her face. Again, I made sure that the lines on the selection aligned with the original. I used the Clone Stamp tool with a soft brush setting to clean up the seams (see Figure 6.8). You tired of being beaten over the head with this process yet? I thought so.

Figure 6.8

9 Okay, I'll show you how I did something else. I cleaned up my rapidly disorganized Photoshop file by merging all the visible layers (Layers > Merge Visible). I then used the Polygonal Lasso tool to make a selection in the shape of what I thought the inside collar would look like and used the Clone Stamp tool to fill in the inside of her shirt with the same texture as the outside of her shirt. Then I again used the Polygonal Lasso tool to create the shape of the inside of her collar. Again I used the Clone Stamp tool to copy the texture from her existing collar. Finally, I gave the left inner edge a little bit of a shadow using the Burn tool set on Highlights at 20% (see Figure 6.9).

Figure 6.9

10 It was almost time for the finishing touches on Emma. I used the Polygonal Lasso tool to select the roof pillar over Jacob's shoulder. I copied this selection onto a new layer by selecting Edit > Copy and Edit > Paste and then used the Move tool to move the selection behind Emma. I had to guess the location based on the distance between the other columns behind Jacob. I used the Clone Stamp tool with a soft brush setting to clean up the seams (see Figure 6.10).

Figure 6.10

11 I made the column go down to Emma's collar based on the appearance of the column on Emma's left (behind the houseplant). To do this, I used the Rectangular Marquee tool to select the lower portion of the column, copied it into a new layer by selecting Edit > Copy and Edit > Paste, and... well you know the rest (see Figure 6.11).

Figure 6.11

Figure 6.12 is the image with all traces of Emma removed.

Jacob looks happier, doesn't he?

Credits

Author: R.C. Whalen
Source Images: Grant Wood

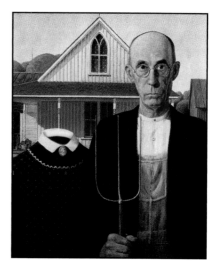

Figure 6.12

How I made Waiting

Have you ever looked at a classic painting and said, "There must be a great back-story there?" In 1879, William Bouguereau painted this classic called "Le Repos" (French for "The Repos"). Clearly the repo men have come and taken away this single mother's pick-up truck. Sadly, Bouguereau is long dead. It will take an act of Photoshop to get this woman her truck back.

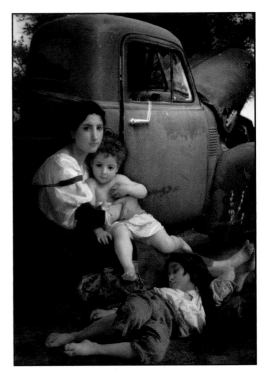

This tutorial assumes that you have a basic grasp on how to use Photoshop.

1. First, I opened my original image of the woman and her kids, shown in Figure 6.13.

2. I then copied and pasted the woman and children in the original painting into their own layer (so I could later move the truck behind them in the image). To do this, I used the Polygonal Lasso tool to carefully select them (it helped to zoom in, via View > Zoom in) and then copied and pasted them into a new layer in its original Photoshop file by choosing Edit > Copy and Edit > Paste.

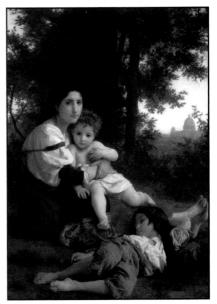

Figure 6.13

3 I then copied the source image of the truck into my Photoshop file as a new layer (see Figure 6.14). To do this, I opened my truck source image as a new Photoshop file (File > Open), chose Select > All, and selected Edit > Copy.

4 Then I clicked back to my painting Photoshop file and pasted the truck in between the layer of the background and the copied children. I know the truck may not be much to look at, but it's got a killer sound system and rims that keep spinning even after the truck stops rolling (though only two of those rims, and they're both on the other side of the truck). To do this, I highlighted the background layer in the Layers palette and chose Edit > Paste. My truck layer then appeared in between them.

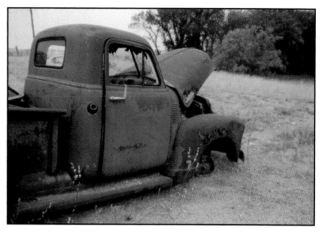

Figure 6.14

5 Finally, I moved the truck layer into position using the Move tool. I turned the art background layers' visibility off to better see what I was doing by selecting the Layer Visibility icon next to the art background thumbnail on the Layers palette. I then used the Eraser tool with a small, hard brush to remove the unwanted background from the truck layer (see Figure 6.15).

6 Next, I resized the truck by choosing Edit > Transform > Scale and dragging the handles to the desired position. By selecting a corner handle and holding down the Shift key, I kept the proportions of the truck intact.

7 I then applied a smart blur to the truck by selecting Filter > Blur > Smart Blur. This gave the truck a more painted feel to better match it to the painting.

8 Finally, I painted the truck's shadows onto the background art layer using the Paintbrush tool. I used a small, soft brush with a dark green color and an opacity of 15%. I then painted under the rim of the truck, alternating the paintbrush modes between Multiply and Color Burn (see Figure 6.16).

Figure 6.15

Figure 6.16

9. Now it was time for finishing touch-ups on the truck layer, to better integrate it with the artwork. I made sure that the truck layer was highlighted on the Layers palette and then adjusted the image levels by choosing Image > Adjust > Selective Color and raised the black levels to +7 (see Figure 6.17).

Figure 6.17

10. I applied a Sharpen filter to the truck layer by selecting Filter > Sharpen > Sharpen. The truck came into a little clearer focus. To give it a more grainy feel, I applied a Film Grain filter by selecting Filter > Artistic > Film Grain. The truck layer was still too blue, so I added red tones to the truck layer by selecting Image > Adjustments > Color Balance and moved the slider to +50 red.

11. To better match the painting, I desaturated it slightly by selecting Image > Adjustments > Hue/Saturation and lowered the Saturation slider by –20. Finally, I merged all of the layers together by selecting Layer > Flatten Image.

12. I then applied a Noise filter to the finished image by choosing Filter > Noise > Add Noise and voila, all done! (See Figure 6.18.)

We beat the repo men at their own game and safely returned the poor woman's truck. If artist William Bouguereau were still around today, we probably would have added a fire-burst paint job, neon underneath, and tinted windows, but we felt it was important to maintain the integrity of the original. One should never mess with a masterpiece.

Credits

Authors: Alison Huff and Avi Muchnick
Source Images: WetCanvas.com

Figure 6.18

How I made Boogieroo's Afro

One thing I've always wondered about famous (but dead) artists is how modern times would have affected their art had they been born now. Or would they have even produced art at all? (Video games sap up a lot of us creative types' free time.) I've always admired William Bouguereau's artwork due to his photographic realism and creepy angels covering every square inch of his canvas. I can't think of anyone who would have fit in better with the '60s-era hippie movement. So I decided to have him paint a nude '60s-era hippie.

I selected a painting of his that had an extra helping of creepy angels for me to work around, and for an extra challenge, I changed the race of the woman from white to black. Well, more like from "painted white" to "painted black," as I've never seen white people as ghostly white as Bouguereau painted them. I figured he probably would have painted black people with the same ethereal tones, and so I got to work.

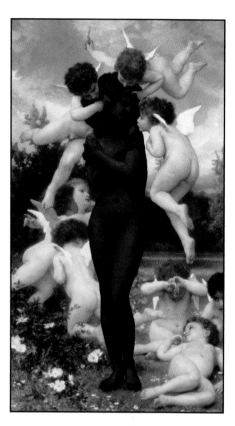

Getting started

This tutorial assumes that you have a somewhat advanced grasp on how to use Photoshop.

1. First, I opened my original image of *Le Printemps* (see Figure 6.19).

2. I then used the Polygonal Lasso tool to select the outline of the woman. This took a bit of time, and I found that by selecting View > Zoom In, I was able to get better control during my selection (see Figure 6.20).

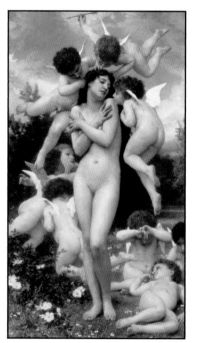

Figure 6.19

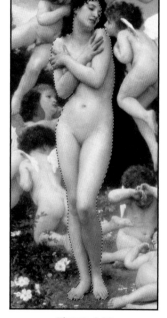

Figure 6.20

3 After making my selection, I realized that I still hadn't done a perfect job. To fix up any areas that weren't quite selected correctly, I entered Quick Mask mode and touched it up by using a small, hard paintbrush to paint over any area I wanted to select. In particular, I looked for dark areas around the woman that might have been just outside of my selection (see Figure 6.21).

4 I exited Quick Mask mode and had a perfect selection of the woman. Knowing that I might need to go back to this selected shape, I saved the selection by choosing Select > Save Selection and gave it a name that was easy to remember.

5 With my selection still visible, I then duplicated the background layer and turned off visibility on the original background layer by selecting the Layer Visibility icon next to the layer thumbnail on the Layers palette. Working with just the duplicate layer now, and my selection still active, I then selected Layer > Add Layer Mask > Reveal Selection. Now only the woman appeared on the duplicate layer (see Figure 6.22).

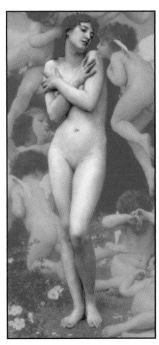

Figure 6.21

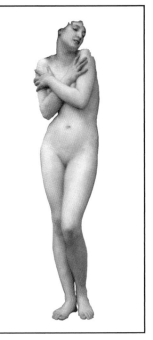

Figure 6.22

6 I then did something similar to the original background layer, only in reverse (with the end goal being that everything *except* the woman would appear in this layer): First, I turned off visibility on the duplicate layer showing just the woman. Then I turned back on visibility for the original background layer and highlighted it in the Layers palette. I then loaded my previous woman-shape selection by choosing Select > Load Selection and choosing the woman shape selection I saved earlier (the selection had disappeared after I applied the mask to the other layer).

7 With the woman shape now loaded, I applied the layer mask to the outside of this selection by choosing Layer > Add Layer Mask > Hide Selection. Then everything except the woman was shown in this layer (see Figure 6.23).

Figure 6.23

8 Still working with my background layer, I applied the layer mask by selecting Layer > Remove Layer Mask > Apply. Now the woman was completely deleted from this layer (and not just hidden by a mask). My next step was to fill in the space where she had been with more background material. I knew that I only needed to blend the outer edges where the woman had been removed from the image, as that's the only place where the outline of the woman would be visible. I filled up the space around her outline by using the Clone Stamp tool to re-create the background where the woman had been. I did this so that when I began blending the woman's outline, I would have paint material to blur together. If I had left it blank instead, blurring the edges would still leave a ghosted outline. Once this was done, I used a soft Smudge tool on 100% pressure to lightly paint the edges of the outline inwards. I did this completely around her outline (see Figure 6.24).

Figure 6.24

9 When I then turned back on the visibility of the woman layer, there was no faint outline anymore. It looked perfect. With the woman successfully split from the original background, but the art otherwise looking the same as when Bouguereau painted it, it was now time for the fun to begin (see Figure 6.25).

Changing the skin tone

1 My first task was to change the woman's skin tones to black. As I needed to work with only the woman, I turned off the visibility of the background layer and activated the woman layer from the Layers palette. I then applied her layer mask by selecting Layer > Remove Layer Mask > Apply. Some of you may be wondering why I bothered using a mask at all, when it would have been much easier to simply cut her out of the original background and paste her into her own layer. The answer is that masking allows you to alter the shape and visibility of your selection even after you have already separated it from the original. Because of this greater flexibility, when working with complex subjects, masking is always preferred to cutting and pasting.

Figure 6.25

2 Getting back to my image… I was then ready to work on the woman. First I adjusted the woman layer's image levels slightly, changing the input levels to 49, 0.62, and 2.34. Then I duplicated the woman layer by selecting Layer > Duplicate layer. On the Layers palette, I changed this duplicate layer's mode to a difference layer and lowered the layer's opacity to 25%. She was beginning to look much darker but still didn't have quite the correct golden tone that Bouguereau would have likely painted a black woman. Returning to the Layers palette, I duplicated this difference layer once and changed the mode to Multiply (opacity at 25%). Then I duplicated this multiply layer and changed the mode to Color Burn (and lowered the opacity to 10%). We now had four layers, and the combined result was that the woman's skin appeared to have a yellowish glow!

3 For finishing touches, I darkened her legs slightly using the Burn tool with a soft brush. I also gave her upper body a more yellowish tint by selecting the area with the Rectangular Marquee tool (with a feather of 30, to soften the change I was about to make), and selected Image > Adjustments > Color Balance. I then raised the yellow highlights by +15 (see Figure 6.26).

Figure 6.26

Note that her skin tones appear more golden than what a realistic black person's skin tones would look like—but then, the cherub's skin tones aren't realistically white either. We're trying to simulate a painted effect—what Bouguereau would have done had he been attempting to paint a black female.

It's all about the hair

With the woman's skin done, it was time to work on her '60s-style afro hairdo.

1 I opened up my source image of a woman's afro, and I used the Rectangular Marquee tool to select a square area of her hair (see Figure 6.27). I then chose Edit > Copy.

2 Next, I created a new Photoshop file by selecting File > New (the size automatically defaulted to the shape of what I had copied). I then pasted my afro selection into this new Photoshop file by selecting Edit > Paste. I converted this into a texture by choosing Edit > Define Pattern. I closed off this new Photoshop file, no longer needing it. The source image of the woman with the afro would be needed later (as I'd use her comb, so I minimized it and forgot about it for now).

Figure 6.27

3 Now it was time to create the afro, using the texture I had just defined. I created a new layer above the woman layer by selecting Layer > New > Layer and used the Elliptical Marquee tool to make a circular selection in the general shape of how her afro would look. Then I used the Paint Bucket tool, with Fill set to Pattern, and selected my afro pattern from the list. It filled up with my afro texture (see Figure 6.28).

Figure 6.28

4 I applied a layer mask to the afro layer by selecting Layer > Add Layer Mask > Reveal All, lowered the layer's opacity to 38% to see through it, and painted away any part of the afro that covered the woman's face and the angels in the background layer behind her (unless I wanted a particular part covered). I turned visibility on for both layers in order to work better with them. I also masked away parts of the top, to simulate the wavy feel of real hair (see Figure 6.29).

5 Once satisfied that the afro shape was now completely defined, I switched to the background layer and chose Layer > New > Layer. Then, with the cherubs visible in the layer below, I began painting shadows from the afro onto this new layer using the Paintbrush tool. I painted with black, using a soft brush, with opacity set to 50%. Then I used the Eyedropper tool to select a

Figure 6.29

rose color from a shadow on the cherub. I then used the paintbrush to paint with this color onto the new shadows with the opacity at 11%. Finally, I used the Blur tool to blend them together. Once satisfied that my shadowing was successful, I merged the shadow layer with the background layer by selecting Layer > Merge Down.

6. For the finishing touches on the hair, I used the Burn tool (with shadows at 6% exposure) to add depth to the hair and to give it a more realistic round shape. Then I sporadically highlighted the hair with the Dodge tool to give it a more realistic look. Finally, I adjusted the brightness and contrast of the afro to better match it to the painting by selecting Image > Adjustments > Brightness/Contrast. I set brightness to +12 and contrast to –5 (see Figure 6.30).

7. With the afro now complete, I still was stuck with the messy task of removing the woman's hair from the original background image. To do this, I used the Polygonal Lasso tool to select the shape of the hair. Then I used the Clone Stamp tool to copy the grassy background and painted it into my selection.

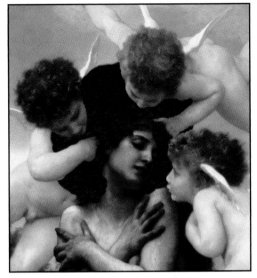

Figure 6.30

Finishing touches

1. I added some finishing effects, such as copying and pasting the comb from my minimized afro source image into my Photoshop file and putting it in one of the cherub's hands. I also replaced the arrow in the top cherub's hands with a pair of scissors from another source (he's apparently the gifted one sculpting the afro). I won't explain what steps I used to select, copy, and paste them into the image, as those steps should be easily understood from reading earlier parts of this tutorial. To better fit, I lowered this cherub's hand by separating it from the image (as I did with the woman and the painting at the beginning of this tutorial) and using the Move tool to lower it down. I also blended the edges of the arm with the cherub's body where I had moved it (see Figure 6.31).

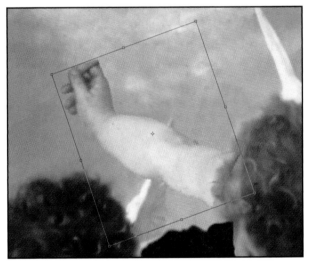

Figure 6.31

2. My final effect on this image was to blend in all the added or altered section with the original background. To do this, I used the Blur tool with pressure set to 17% and a very small, soft brush. I then traced the outlines of everything I had added. The end result was that everything I had changed looked much more like a part of the original painting.

Le Printemps always had angels in it, but now it's got soul.

Credits

Author: Avi Muchnick
Source Images: William Bouguereau, Hemera.com

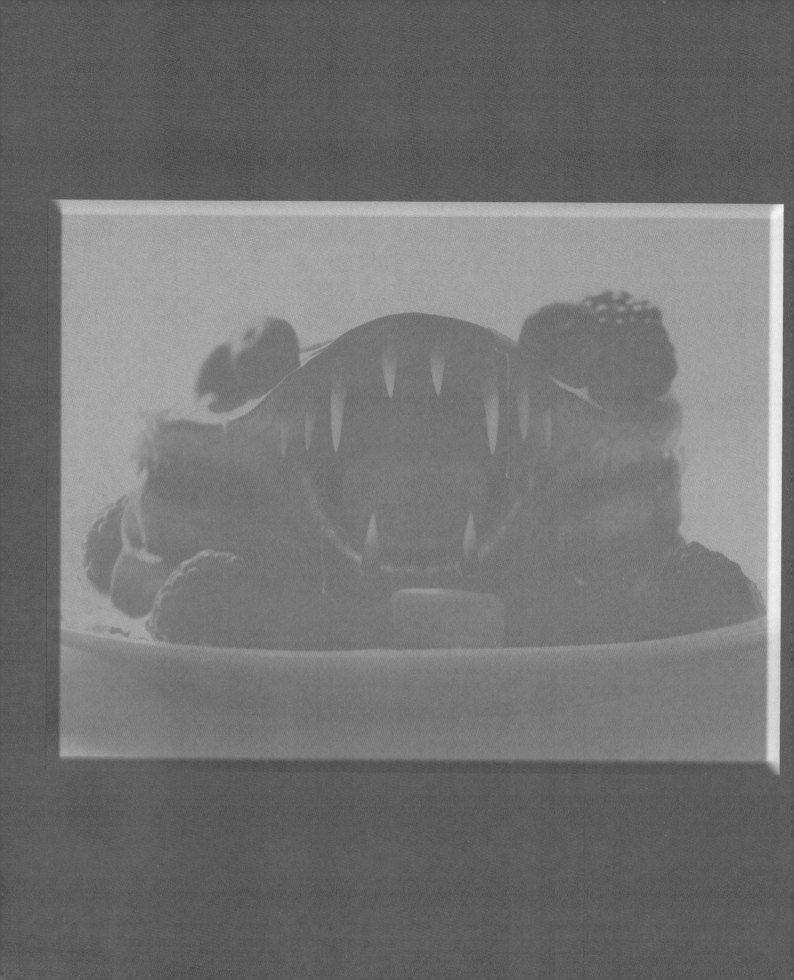

When Pancakes Go Bad

Getting food poisoning is one thing; getting attacked by your food is quite another. This chapter focuses on the darker side of the Worth1000.com food contests. Whether it's a barbecued chicken's revenge, an utterly disgusting snack, or simply a jaw-dropping photo manipulation involving food, you'll never look at your food the same way again. Or eat it.

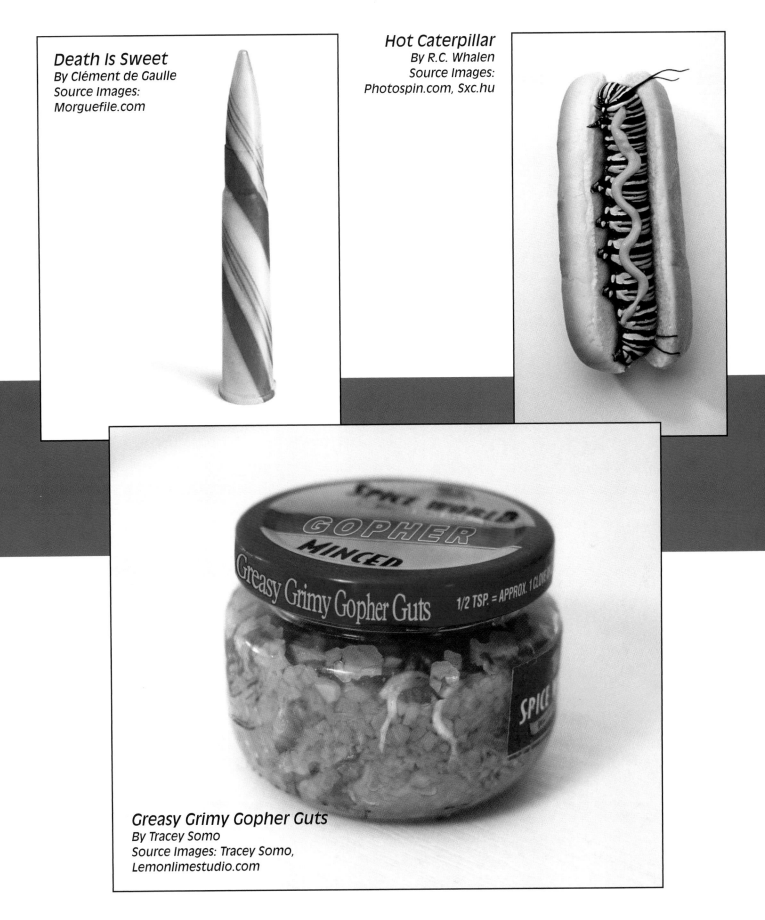

Death Is Sweet
By Clément de Gaulle
Source Images:
Morguefile.com

Hot Caterpillar
By R.C. Whalen
Source Images:
Photospin.com, Sxc.hu

Greasy Grimy Gopher Guts
By Tracey Somo
Source Images: Tracey Somo,
Lemonlimestudio.com

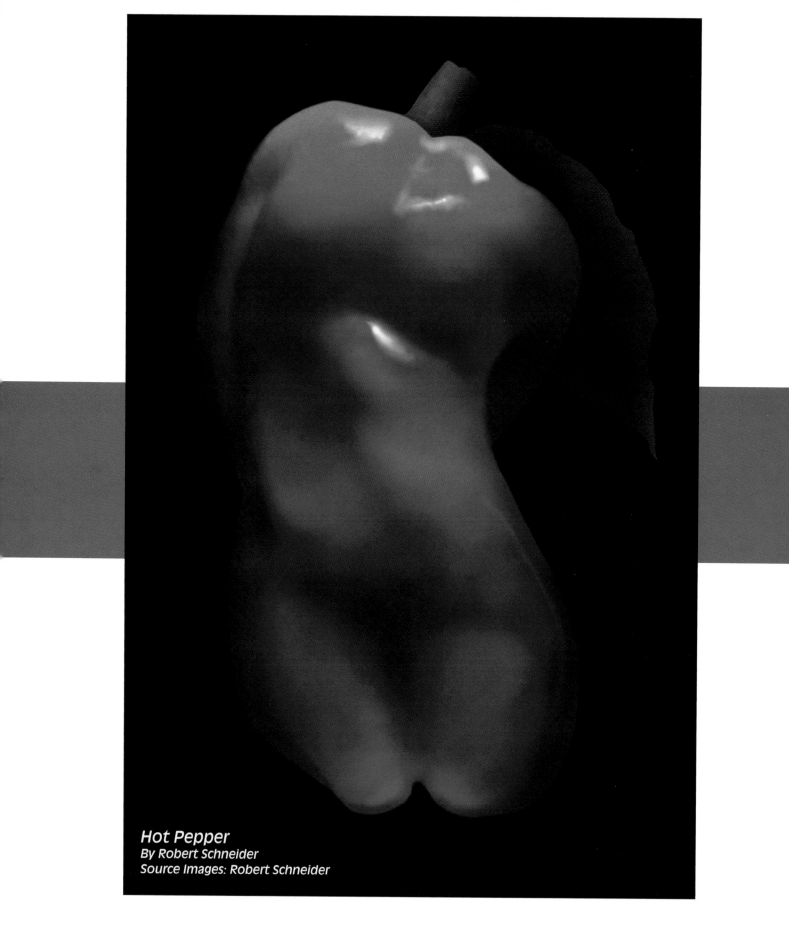

Hot Pepper
By Robert Schneider
Source Images: Robert Schneider

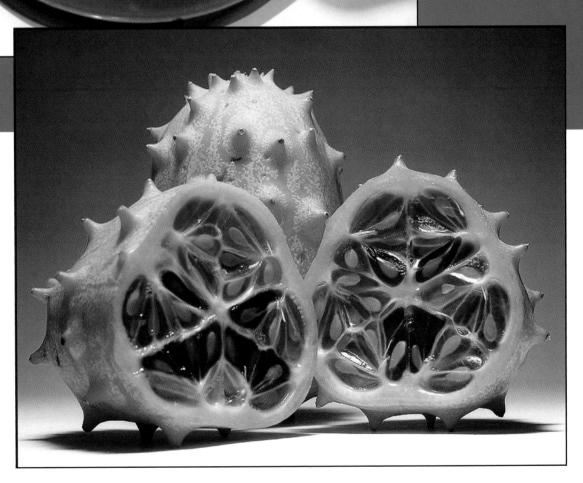

Sole Food
By Daniel Goodchild
Source Images:
Morguefile.com, Sxc.hu

Demon Fruit
By Dorie Pigut
Source Images: Gregg Stricke

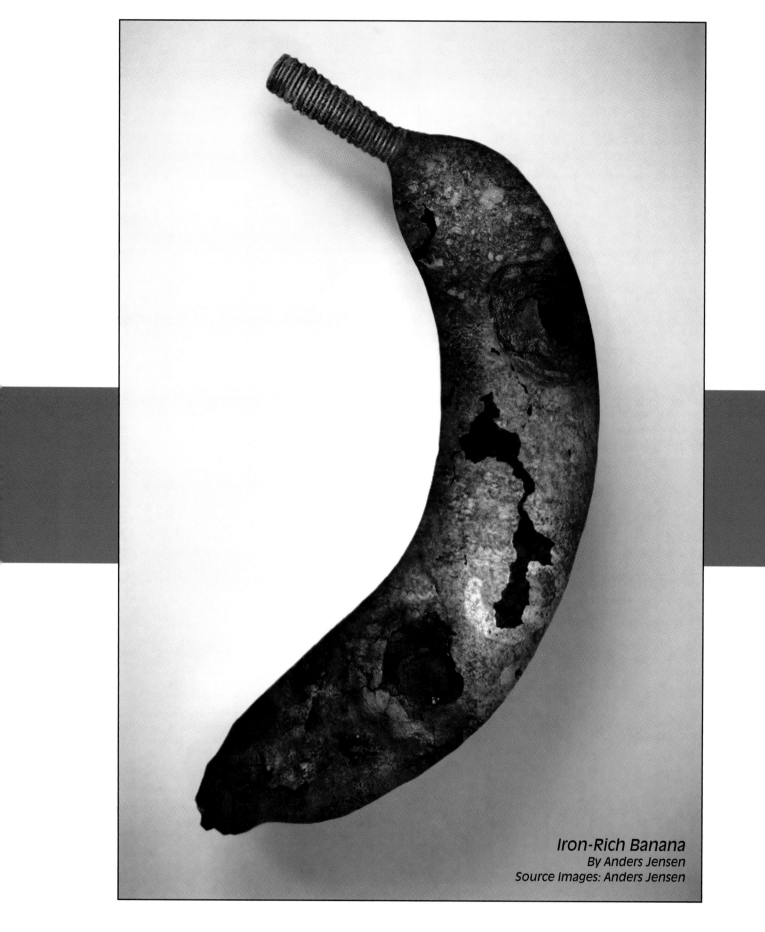

Iron-Rich Banana
By Anders Jensen
Source Images: Anders Jensen

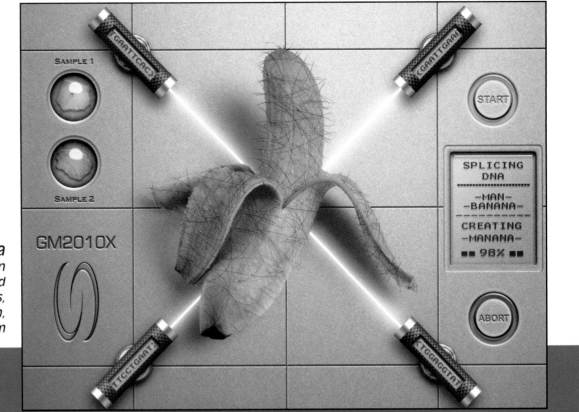

On the device display:

SPLICING
DNA

—MAN—
—BANANA—

CREATING
—MANANA—

██ 98% ██

Labels on device: SAMPLE 1, SAMPLE 2, GM2010X, START, ABORT

Cartridge labels: <GAATTCAC>, <GAATTGAA>, <TTCCTGAAT>, <TGGAGGTAT>

Manana
By Raymond Mclean
Source Images: Raymond
Mclean, Michael Connors,
Morguefile.com,
Mayang.com

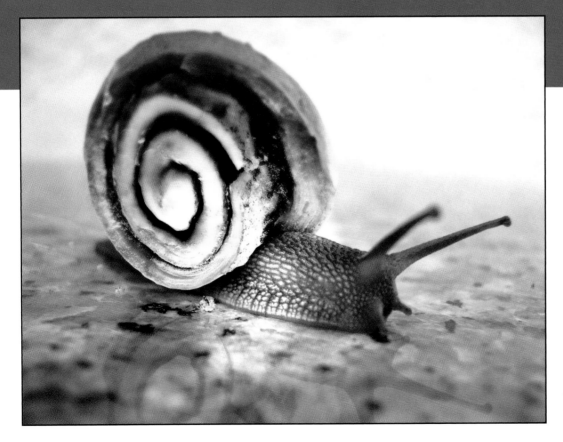

Cinnasnail
By Jack Cheng
Source Images: Kathy
McCallum, Sxc.hu, Jordi
Delgado, Istockphoto.com

201

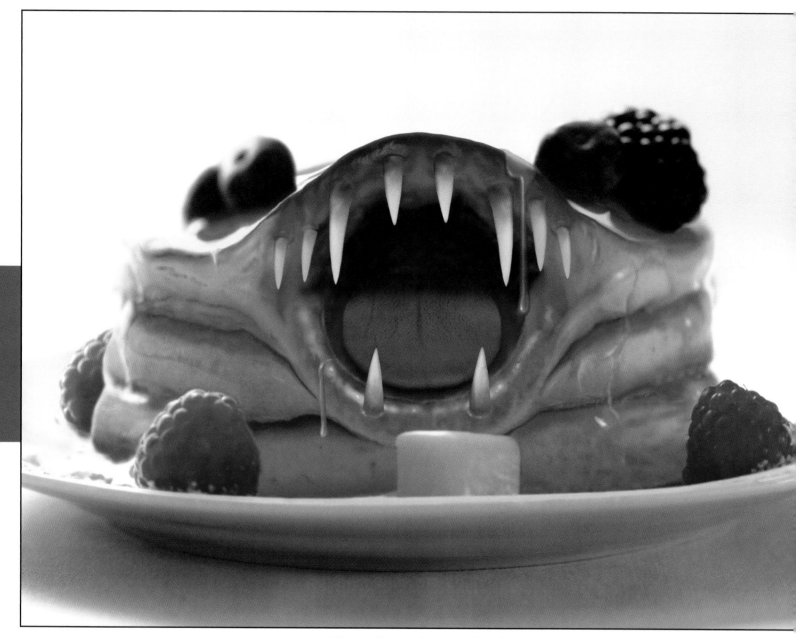

When Pancakes Go Bad
By Robert Schneider
Source Images: Valentina DeGiorgis, Tracey Somo, Lemonlimestudio.com

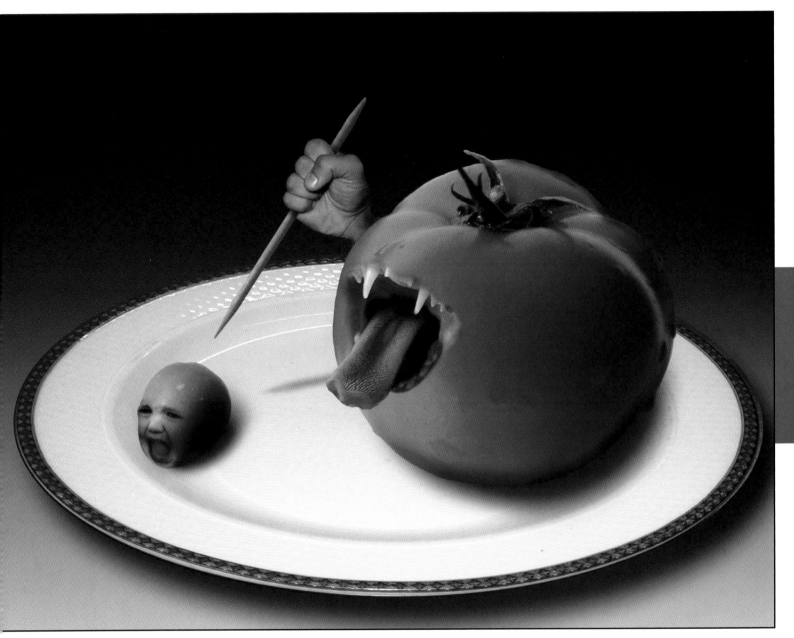

Killer Tomato
By Anders Jensen
Source Images: Anders Jensen

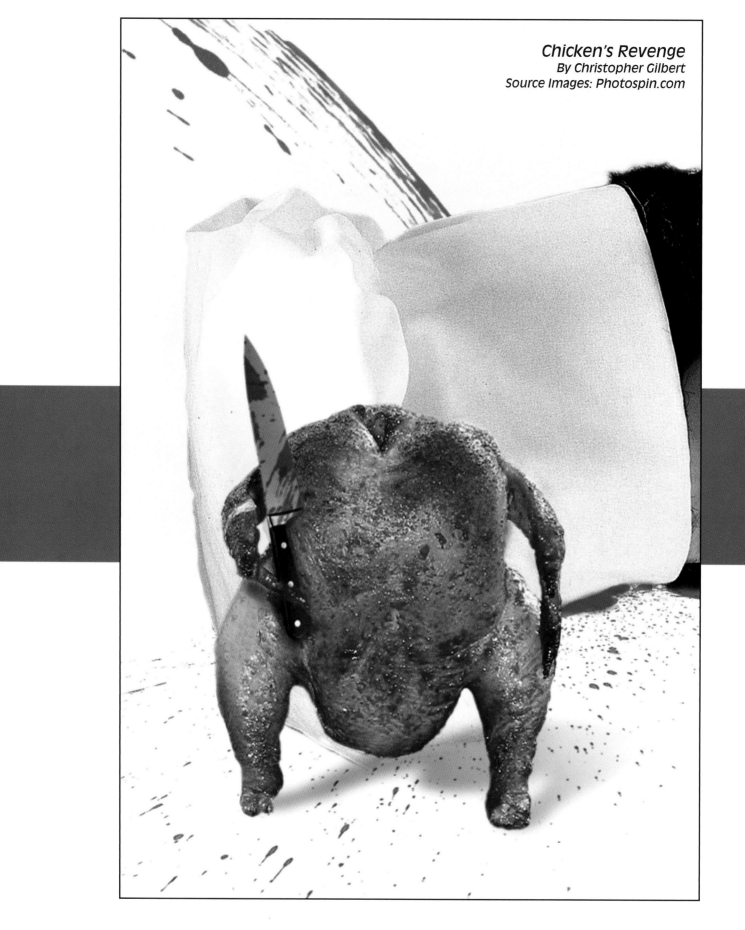

Chicken's Revenge
By Christopher Gilbert
Source Images: Photospin.com

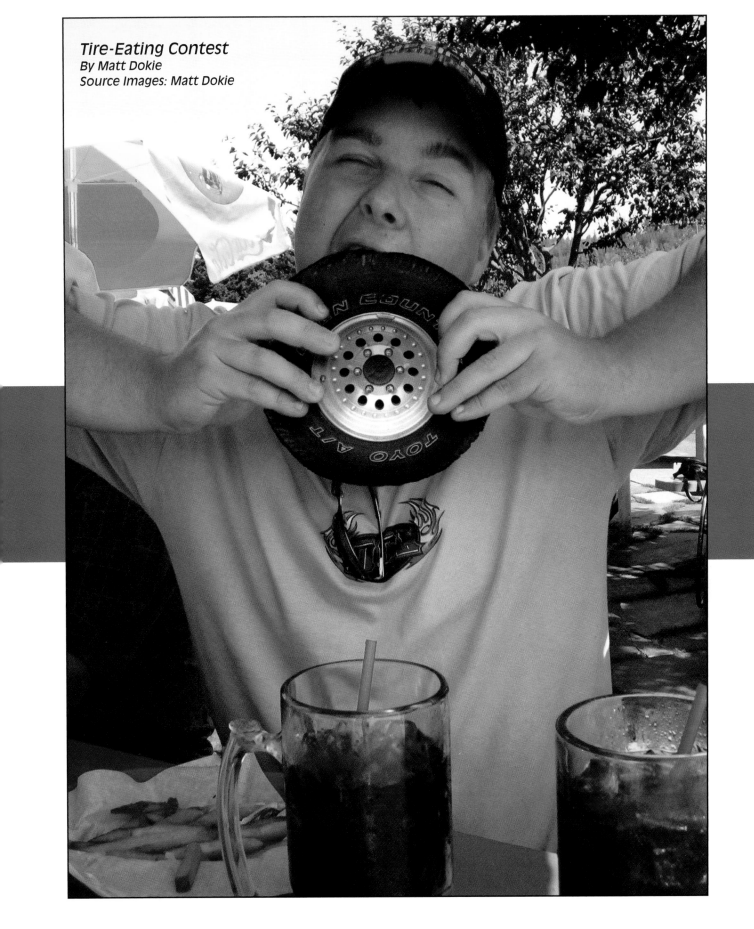

Tire-Eating Contest
By Matt Dokie
Source Images: Matt Dokie

Tutorials

How I made Demon Fruit

We've all done it: Left food out too long or wrapped something up in aluminum foil, tossed it in the fridge, and forgot about it. One day, a waft of rank odor lets us know our food has gone foul. Yes, we all know food can go bad. But sometimes, under the darkest of circumstances, food can go much worse than bad… it can go pure evil. This is the last thing our fruit salad chef ever saw after cutting through this Kiwano horned melon.

This tutorial assumes you have a basic to intermediate grasp on Photoshop.

This transformation is really quite easy—the Overlay mode does all the work for you.

1. My source image was a basic studio shot of a horned melon, shown in Figure 7.1. The seeds and striations of the fruit lent themselves well to forming a demonic face.

2. I chose Layer > New > Layer and named it "faces."

Figure 7.1

3 In the new layer, I used the Paintbrush tool to define the eyes and mouth with a dark brown color (see Figure 7.2).

Figure 7.2

4 At the top of the Layers palette, I set the layer mode to Overlay so I could see the fruit's evil face shine through, as shown in Figure 7.3. I always knew the face was there; the Overlay mode just made it more obvious.

Figure 7.3

5 Our demon now needed teeth and eyes. (What great demon doesn't have those? You can't name one, can you?) I created a new layer by choosing Layer > New > Layer and called it "teeth." I then used the Paintbrush tool and a light brown color to paint the teeth (see Figure 7.4).

Figure 7.4

6 I set the teeth layer mode to Overlay to blend them in (see Figure 7.5).

Figure 7.5

7 Next, I created another new layer by choosing Layer > New > Layer and named it "eyes." I then used the Paintbrush tool to paint in red eyes (see Figure 7.6).

Figure 7.6

8 I set the eyes layer mode to Overlay at the top of the Layers palette (see Figure 7.7).

Figure 7.7

9 I thought the eyes on the fruit on the left were still a bit too dark. To bring out its inner evil, I created a new layer by selecting Layer > New > Layer and called it "lighten eyes." I used the Paintbrush tool to paint them red, as shown in Figure 7.8.

Figure 7.8

10 Finally, I set the lighten eyes layer to Overlay mode and the opacity to 80% (see Figure 7.9).

With our fruit's inner demon out, there's only one way to stop the horror: exorcism. Time to fetch the Holy Food Processor.

Credits

Author: Dorie Pigut
Source Images: Gregg Stricke

Figure 7.9

How I made Greasy Grimy Gopher Guts

The dilemma can be maddening: Do you serve a nice Chianti or a Pinot Noir with Greasy Grimy Gopher Guts?

Minced garlic just looks gross, doesn't it? For this tutorial, I was thinking… what is gross? I mean *really* gross. What could I rename this product? And then it just hit me: the childhood song, "Greasy Grimy Gopher Guts."

Getting started

This tutorial assumes you have an intermediate grasp on how to use Photoshop.

This is a classic exercise in cloning and text manipulation. Looks like it could be simple, but you never know until you get into the darn thing…

1 I needed to clone away the original "GARLIC" text on the edge of the cover and the junk on the label. This actually is a great use for the Patch tool. The Patch tool doesn't quite work intuitively, but it's great for cloning relatively flat, plain areas.

2 I chose the Patch tool, then selected around the area I wanted to be cloned out. In my first example, I used the Patch tool on each letter in "GARLIC." First, I selected a rectangle around the C (see Figure 7.10), and then I dragged that selection to a clean area that I wanted to have replace it. In this case, I dragged it to the right where the plain blue is on the lid (see Figure 7.11). It took the pixels from that clean area and blended them into the original area I selected.

Figure 7.10

Figure 7.11

3 I repeated this step for all of the letters. Once I was done, "GARLIC" was no more, but I still had a few small imperfections (see Figure 7.12).

4 I used the Clone tool at 30% opacity and 50% flow to sample from nearby areas and clone over the small bits with a soft, round brush in a circular motion. I went over them a few times.

5 Obviously, "Greasy Grimy Gopher Guts" is longer text, so I had to get rid of something else as well. I cloned over the little white text on the left so I could have "Greasy Grimy Gopher Guts" wrap around that side. I used the Clone tool again to make more room on the lid.

Figure 7.12

In cloning, I was getting Patch tool contamination—that's what I call it anyway. See how in Figure 7.13 the white text on the left blended with the plain blue target?

6 I used the Clone tool to fix that. I cloned over, and it looked a bit smudgy and soft, so I added Noise by choosing Filter > Noise > Add Noise and selecting and moving the slider until it looked right. Then I added a smidge of Gaussian Blur by choosing Filter > Blur > Gaussian Blur to get it to match more (see Figure 7.14).

7 Next, I used the Text tool and used the font Arial at 24 points. I used yellow like the original text and added a black stroke using the layer style by selecting Layer > Layer Style > Stroke. I changed the stroke color to black.

Figure 7.13

Figure 7.14

8 To make the text look like it was wrapping around the lid, I chose Layer > Type > Warp Text and selected Arch. I changed the arch level to –13 and left the horizontal and vertical warping alone.

9 I selected Edit > Free Transform to change the perspective. By holding the Ctrl key down, I manipulated the corners. I managed to get it pretty close, although not perfect at that point (see Figure 7.15).

10 I selected the Text tool again and experimented with various fonts. I picked Francisco-Regular, but there were several other similar fonts that also would have worked well. I wasn't worried about having to match anything exactly, so I just picked something that was very readable.

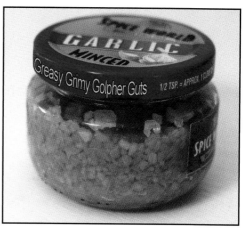

Figure 7.15

11 Now I needed to fine-tune the perspective. I copied the text layer by selecting Layer > Duplicate Layer. I wanted to keep the original in case I needed to start over. I rasterized the text layer by selecting Layer > Rasterize > Type.

12 I turned off the text layer and used the Liquify tool to nudge and squish the text into a more realistic perspective, as shown in Figure 7.16. You may have to do it a few times. Liquify takes some practice. It is also fairly resource-intensive, so it can be a slow process if you've got a big file.

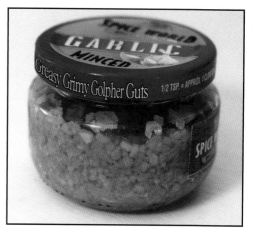

Figure 7.16

13 I duplicated the layer by selecting Layer > Duplicate Layer. Next, I added a bit of noise and then blur to make it look more like the original photo.

14 I changed the layer mode to Normal and then chose Image > Adjustments > Brightness/Contrast and lowered the contrast to –30 to make it look a little more washed out. Even with the lowered contrast, something still seemed a little off, so I selected Image > Adjustments > Color Balance and brought down the midtones just a little bit (see Figure 7.17)—it's something you have to adjust by eye.

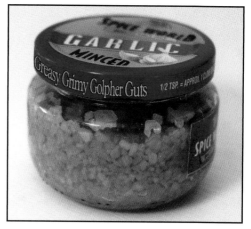

Figure 7.17

15 Now I had to replace the word "GARLIC" on the top with "GOPHER." I cloned away the "GARLIC" using the same kind of combination Patch tool and Clone tool that I used on the lid edge (see Figure 7.18). I realized there was an image of some cloves of garlic on the top of the lid. I dealt with those in a later step.

16 I added the word "GOPHER" with the Text tool. I used the same blue color that I used for the lid. I also added a white stroke around the letters by choosing Layer > Layer Style > Stroke, and chose a white color with a stroke size of 6 pixels.

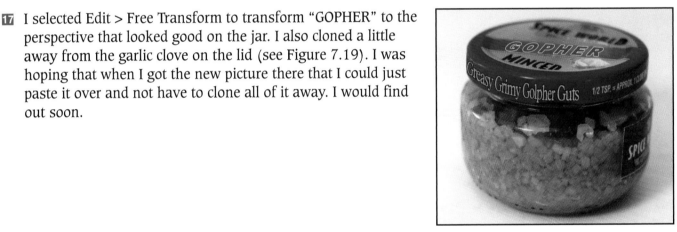

Figure 7.18

17 I selected Edit > Free Transform to transform "GOPHER" to the perspective that looked good on the jar. I also cloned a little away from the garlic clove on the lid (see Figure 7.19). I was hoping that when I got the new picture there that I could just paste it over and not have to clone all of it away. I would find out soon.

Figure 7.19

18 I rasterized the new text layer and then, using the Filters, added some noise and then Gaussian Blur to blend in the text to the lid. After the filters, I thought the white outlines looked chopped and strange and not softly blurred, as you can see in Figure 7.20.

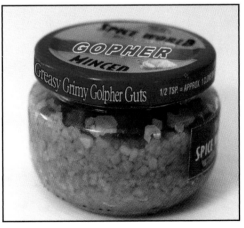

Figure 7.20

19 To fix the "GOPHER" text layer, I Alt + clicked (Option + click on the Mac) on the eye icon on the rasterized text layer so that it was the only layer showing. I created a new layer above it by selecting Layer > New > Layer, then selected Layer > Merge Visible so that it created a layer with just what's showing. This way, I got the layer stroke effect but without the layer stroke itself. I turned the other layers back to visible and turned off the layer with the stroke. Using Filters, I added some noise and then blur and got the look I wanted, shown in Figure 7.21.

20 I needed to add some depth of field to the text. See how the back of the lid is quite blurry? I copied the layer I had just worked on and blurred it even further so that the whole thing looked more like the back of the lid.

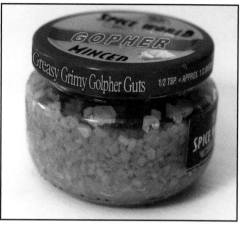

Figure 7.21

21 Next, I added a mask on that layer by selecting Layer > Add Layer Mask > Reveal All. I then selected the mask in the Layers palette. I created a gradient on the mask so it would smoothly go from a slight blur (underneath) to the fuzzy blur. I chose the Gradient tool with black selected as my foreground color. I then used the Gradient options bar at the top to select a gradient that went from black to transparent. I started at the bottom of the text and dragged my mouse up toward the back. I had to undo/redo a few times until I got a good, smooth transition in the blur. I got the best result by going from the bottom-right of the H to the top-left of the H (see Figure 7.22).

22 The text still looked like it was floating slightly. To anchor things, I added a very thin, dark shadow underneath. I used Layer > Layer Styles > Drop Shadow to add a drop shadow at 30% direction, 0px distance, 0px spread, and 5px size.

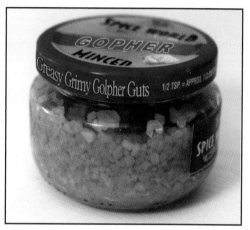

Figure 7.22

From goop to guts

1 My next step was to clone out the garlic cloves—because these are gopher guts! I wouldn't want consumers to be confused and think they might taste like garlic, when in reality they taste like chicken. I used the Clone tool with 75% opacity, sampling various areas of the yellow as I went. It was difficult to keep the line above the yellow area completely straight, so after I finished, I created a new layer and used the Line tool to draw a dark blue and light bluish-white line to re-create it. I used the Gaussian Blur filter to blend it into the lid (see Figure 7.23).

Figure 7.23

2 Now for the fun part—the GUTS! I made chicken one night and took pictures of some of the tendons, entrails, and fat… come to think of it, chicken guts can be pretty greasy and grimy, too. Using the Lasso tool, I copied a selection of chicken guts and pasted them into a new layer of my working window so I could start blending them into the garlic chunks, as shown in Figure 7.24. I repeated this for several different pieces of "chunks" from my source image.

Figure 7.24

3 With the "gunk" in place, I added a mask to each of the gunk layers by selecting Layer > Add Layer Mask > Reveal All. With a soft airbrush, and starting at 100% opacity, I began to remove the edges. As I got closer to the gunk I wanted to keep, I lowered the opacity to lesser levels to blend in.

4 I cloned a little garlic over the top of the gunk to look saucy. Then I used Image > Adjustments > Curves to bring the input down to 253 and the output to 162 (see Figure 7.25). This reduced the brightness of the source gunk and made it look like it was darker in the jar.

5 The top text still didn't look right to me. Using the Burn tool, I burned the highlights on the upper parts of the letters and the cloned stripe underneath to get it just right.

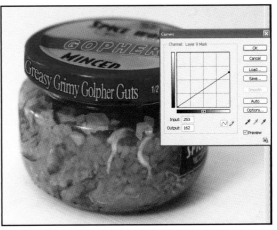

Figure 7.25

6 Oops, I just realized I'd misspelled "Gopher" on the side of the jar lid. I deleted the "l" and selected the letters to the right side with the Lasso tool and moved them over to the left.

With a jar full of great, big gobs of greasy grimy gopher guts, we were ready to hit the kitchen and whip up dinner. But strangely, no one was very hungry when they heard what we were having.

Credits

Author: Tracey Somo
Source Images: Tracey Somo, Lemonlimestudio.com

How I made When Pancakes Go Bad

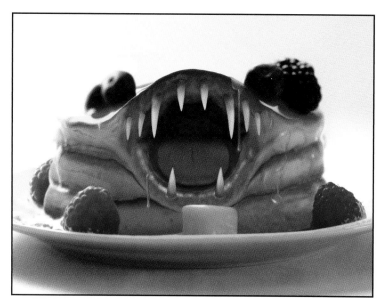

For millennia, humans have been eating breakfast. Sausage, hash browns, eggs, toast, blintzes, cereal—all have gone down without a fight. The best a breakfast food could hope for was to choke our gluttonous yaps during the swallow. That was until the pancakes went bad... very bad. Go ahead, get some maple syrup and take a bite. These pancakes will bite back.

Of course, as you surely realize, having an idea and getting the proper source images are two very different things. I was half-successful. I had an excellent source for the pancakes, as shown in Figure 7.26. A clean, non-cluttered image at a good angle with excellent resolution. The jaw portion was another story.

Getting started

This tutorial assumes you have an advanced grasp on how to use Photoshop.

The pancakes image was a good source image to start with, but it had a few minor flaws. The color was a bit too cool and needed to be warmed up; the pancakes were too thin, and the fruit and butter were a little too symmetrical.

Figure 7.26

The symmetry we'd address later. First, the overall color and pancake thickness:

Color change

1. To create a more appetizing look, the following adjustments were made to the entire image. I selected Image > Adjustments > Brightness / Contrast and changed the brightness to +19 and the contrast to +5.

2. I chose Image > Adjustments > Color Balance and changed cyan/red to +15, magenta/green to –17, and yellow/blue to –63 (see Figure 7.27). I saved a copy of the original by selecting File > Save As with these changes so that all future uses of the image, or pieces of it, would have the same values.

Figure 7.27

Adjusting the pancake stack

1. It's important when working on an image to have a fairly firm idea of what you want the final result to look like. I felt the pancakes were a bit too thin to "split" one into a jaw shape large enough to be the main focal point of the image. If our pancake monster was to have a fighting chance, he'd need some meat on his pancake-y bones. So the first step was to fatten the pancake to an appropriate size. I also decided to simplify the stack into three pancakes instead of four.

2. Beginning with the second pancake from the bottom, I used the Polygonal Lasso tool to select just that pancake. Next, I chose Edit > Copy, then Edit > Paste to paste it into a new layer. I created a mask by selecting Layer > Add Layer Mask > Reveal All.

3. I used the Paintbrush tool to mask out everything around the edges and isolate the pancake. I exited Mask mode and now could work on the pancake. Next, using Edit > Free Transform, I fattened it to be approximately 1/3 of the final height of the stack. I then used the Move tool to center the new pancake and line it up so the bottom of the pancake was a bit below the plate rim, as shown in Figure 7.28.

Figure 7.28

4 I returned to my pancakes source image layer and used the Polygonal Lasso tool again to copy and paste another layer for the next pancake up. I masked, isolated, and fattened the next pancake using the same technique as in steps 2-3. Then I positioned it on top of the other fattened pancake using the Move tool. I trimmed away any unwanted pixels from my original pancake image by changing the opacity of the layers in the Layers palette and using the Erase tool with a slightly soft edge (see Figure 7.29).

Figure 7.29

5 Finally, I repeated steps 2-3 again to create my top fat pancake. I again positioned it and erased it as described in step 4. (see Figure 7.30).

Figure 7.30

6 When the upper pancake was fattened, it obviously distorted the top surface texture of the pancake as well. To fix this, I returned to my original pancakes source image layer, used the Polygonal Lasso tool to select the top surface of the top pancake (including enough upper background to cover the distorted portion in the previous step), and chose Edit > Copy, Edit > Paste to copy it into a new layer. I used the Move tool to move this surface layer into position at the top of the stack, as shown in Figure 7.31.

Figure 7.31

Adding the jaws

1 I then made some adjustments to the base image for the jaws. Since I knew I would have to do quite a bit of manipulating to create the jaws I envisioned in my mind, I needed to make a jaws template that would help guide me. To begin, I created a new layer by selecting Layer > New > Layer.

2 On the this new layer, I used the Paintbrush tool to draw two ovals that would designate the outer and inner mouth. I also drew an arc to line out the bottom jaw. I used a bright green color so my guidelines would clearly stand out from the image under them. I could now follow through all of the next steps.

3 When doing a lot of cloning and brush work, it's very easy to go astray with size and shape. Having a guide to follow makes it considerably easier and saves a lot of grief later. First I made sure that my guide layer was in the very top position on the Layers palette.

4 I then merged my fattened pancake layers together by turning off visibility on my original pancakes source image layer and the guideline layer and selected Layer > Merge Visible. I then reenabled visibility for the guide layer.

5 I used the Liquify tool to push the pancakes into the shape of the jaws template, as illustrated in Figure 7.32. Obviously, the center portion of the pancakes, which would be covered later, was not important. The ends were then close in shape to the eventual curve of the mouth.

Figure 7.32

6 The cat's mouth, in the left-hand image of Figure 7.33, was the closest image I found to what I was looking for. My goal was to distort it close to the jaw shape I visualized: rounder and not resembling any commonly recognized animal's jaw.

7 Using the same tools in steps 1 and 2 of the "Color change" section, I color-corrected the jaws and made them compatible with the pancake image (see Figure 7.33, second image).

Figure 7.33

8 I used the same colors and textures within the cat's mouth as a base for the pancake's mouth. I used the Clone Stamp tool to retain whatever I could of the existing mouth texture. Then I created a new layer by selecting Layer > New > Layer. I then used the Clone Stamp tool to paint in the general shape of the inside of the pancake's mouth onto the new layer. I used my jaws template as a guideline for where that would be (see Figure 7.34).

Figure 7.34

9 Now that I had a separate layer for the jaws, I needed to add some teeth. I selected one of the cat's teeth using the Polygonal Lasso tool and used Edit > Copy and Edit > Paste to copy it into a new layer. Then I gave it a slight silhouette by selecting Layer > Layer Style > Drop Shadow. Finally I used Edit > Free Transform to elongate the tooth. I used the Erase tool to trim it to more of a fang-like point and used the Clone Stamp tool to add some of the pancake texture onto the upper portion of the tooth to help blend it into the gums. I also painted down the sides of the tooth with the Paintbrush tool using the same colors as the gums. (I used the Eyedropper tool to select the color.) This gave the tooth a more rounded feel (see Figure 7.35).

Figure 7.35

10 Using the process described in step 9, I made two slightly different teeth in new layers, colored them a bit differently so they didn't feel like duplicates of each other, and chose Edit > Free Transform to manipulate them into the sizes I needed. I then copied them (alternating which one I copied at random) by choosing Layer > Duplicate Layer. I then placed the different teeth copies around the mouth using the Move tool, guided by the template. Some of them I flipped horizontally by selecting Edit > Transform > Flip Horizontal. I removed the template for clarity in Figure 7.36.

Figure 7.36

11 My next step was to create and add a tongue. I selected and opened a photo of my dog, Obi, as the source image. I used the Lasso tool to select his tongue, and then I copied and pasted it into a new layer on my pancakes image by choosing Edit > Copy, Edit > Paste. Using Edit > Free Transform, I enlarged his tongue and made it wider to fit well within my jaws template and then used the Eraser tool to trim it to be flatter and rounder. I color-corrected the tongue to be compatible with the mouth colors using Image > Adjustments > Color Balance and Image > Adjustments > Brightness/Contrast controls (see Figure 7.37).

12 With the teeth and tongue in place, it was easier to visualize what was needed to create a more believable mouth. I added a shadow beneath the tongue with a soft paintbrush at 15% opacity, with black selected as my foreground color.

Figure 7.37

13 On the roof of the mouth, I used the Paintbrush tool to paint on some dark and light color variations to give an illusion of depth and to suggest a normal mouth structure. I added a darker edge to the top surface using the Burn tool to make it look more like a pancake edge.

14 Medium dark browns were painted onto the upper area of the mouth and behind the teeth, using the Paintbrush tool at about 40% opacity. This blended the teeth and suggested a softer fleshy surface. It's important that I did this in a random fashion to suggest mouth structure rather than trying to render something specific. A lighter pancake color was then painted using the Paintbrush tool, to enlarge the lower lip of the mouth.

15 Finally, I disabled layer visibility on every layer except for those that made up the mouth and chose Layer > Merge Visible. My mouth was now merged into the new pancake stack.

16 I used the Polygonal Lasso tool and selected all areas that had been brushed in, with a feather setting of 20. I chose Filter > Noise > Add Noise to add some Noise (1-3% amount), as shown in Figure 7.38. It's necessary to add this texture whenever adding color with the Paintbrush or Airbrush to help create a photographic look and grain.

17 Using the Paintbrush tool on a soft setting, I added some darker and lighter brown colors to the lower jaw. The goal was to set the teeth into the jaw and create the illusion of a more rigid, but still soft structure. When our pancakes attack, we can't have them crumble! The Smudge tool, at about 35% opacity, was used to soften the edges between the various colors.

Figure 7.38

Highlights

1 I used the Dodge tool (on a soft setting at 50% exposure) to add a slight saliva line to the inside of the lower jaw. I also used the Dodge tool (with a much lower exposure—8%) to create soft highlights. This provided dimension and a suggestion of "wetness" to the jaw itself, as shown in Figure 7.39.

2 Finally, I merged the mouth with my new pancakes layer. To do this, I reenabled visibility on the new pancakes layer and selected Layer > Merge Visible. There were minor adjustments made to make the mouth blend into the pancake.

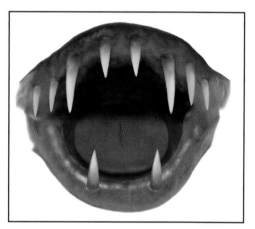

Figure 7.39

3 A combination of the Blur tool and the Smudge tool worked well to blend in the corner of the mouth with the pancake stack. Additionally, I used the Smudge tool to enlarge the pancake's edges in order to meet the lines of the mouth, as shown in Figure 7.40. I also applied a Noise filter after using either tool (see step 16, in the "Adding the jaws" section for more information on how I used the Noise filter).

4 The berries atop the stack became discolored and faded during the color correction on the original. I reenabled visibility on my original pancakes source image and selected all of the original berries using the Lasso tool. I then copied and pasted them onto my new pancakes layer and positioned them with the Move tool to cover the discolored ones. I moved the blueberries on the left further down for a more balanced look.

5 I used the Dodge tool to paint a syrup highlight below the blackberry and on some of the pancake details.

6 I added some minor detail to the upper-left portion of the pancake stacks by using the Paintbrush tool to paint in some dark brown burn streaks on the white, fluffy surface (see Figure 7.41).

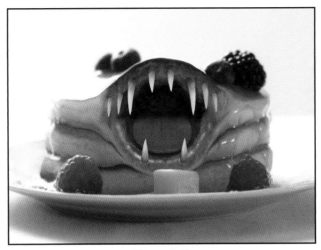

Figure 7.40

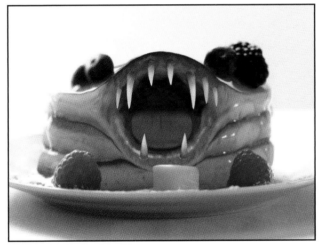

Figure 7.41

No self-respecting pancake monster is complete without some mouth drool and drips. The simplest way to add them, aside from locating some photographic ones that will work with your image, is to render them.

7 I created a new layer by selecting Layer > New > Layer and then entered Quick Mask mode. I painted the dripping shape that I thought was how syrup should look and exited Quick Mask mode. Then I used the Paintbrush to fill the dripping shape (which was now selected) with a color picked off the existing syrup in the photo using the Eyedropper tool.

8 I created another new layer by selecting Layer > New > Layer. I changed the foreground color to a slightly darker setting and used the Paintbrush tool with a soft setting to paint on a light, soft shadow around most of the edge, except where the highlight would be placed. Then, I added a smaller and darker shadow around the same areas using the same techniques.

9 Adding another new layer and adjusting the color slightly lighter than what the Eyedropper tool in step 7 had selected, I used a soft paintbrush at about 15% opacity and added a few light, soft highlights to the drip (see Figure 7.42).

Figure 7.42

10 I finished it off with some stronger, brighter highlights using a smaller brush size and finally used the Smudge tool to push the highlights into the proper shape. When I was satisfied with the result, I merged the drip layers by selecting Layer > Merge.

11 I duplicated the drip layers and lowered their opacity to 50% to give them the translucent look. I positioned them separately onto the pancake using the Move tool. Then I used Edit > Free Transform to elongate them and the Smudge tool to push the drool drips into place (see Figure 7.43). I then merged all of the new pancake layers together using Layer > Merge until my pancake monster was composed of a single layer. (My jaws template layer and the original pancakes source image layer were still separate layers.)

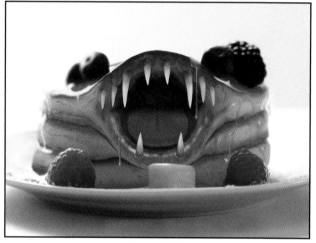

Figure 7.43

12 It was time for the finishing touches. First I selected the raspberry on the right side using the Lasso tool and dragged it with the Move tool a bit to the right, just for balance in the image. I used the Clone Stamp tool to replace the pancake where the berry had been. It seemed like another berry would help the overall look by making it less symmetrical, so I selected the berry on the left side using the Lasso tool, copied and pasted it using Edit > Copy, Edit > Paste. Then I turned it on its side using Edit > Transform > Rotate and placed it on the left side of the image behind the pancakes. I then used the Eraser tool to erase parts of the berry to make it appear as if it was behind the pancakes (see Figure 7.44).

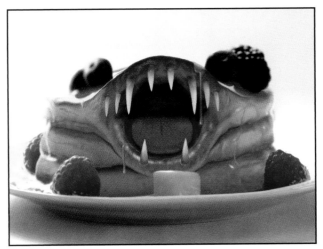

Figure 7.44

Okay, the breakfast buffet is open. Bring your fork and bring your knife—you'll need them to defend yourself. Cover yourself in butter and whipped cream, as it's your best hope to camouflage yourself from these killer pancakes. If you need reinforcements, there's only one human this breakfast food fears, and that's your aunt... Jemima.

Credits
Author: Robert Schneider
Source Images: Valentina DeGiorgis, Tracey Somo, Lemonlimestudios.com

CHAPTER 8

Swap

This final chapter sums up the underlying basis for all the images of Worth1000.com: Take an image and swap out some elements with something bizarre to make it fun. Ever see a pair of headphones made out of a sliced orange? Or a rose made out of money? But even better than viewing the swapped results is creating them. Just don't go to a party and tell people you "swap"—they may get the wrong idea.

Butternut
By Jeff Minkevics
Source Images: Jeff Minkevics

Cordless Cordial
By Heather Flyte
Source Images: Pawel Wizimirski,
Allahverdi Sefihanov, Sxc.hu

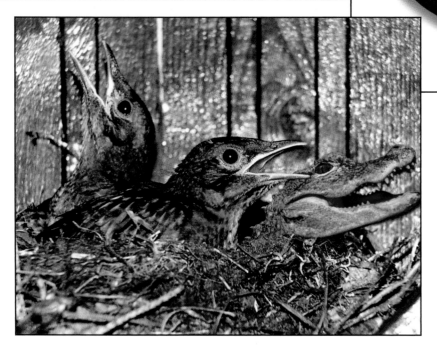

Sibling Rivalry
By Scott Baker
Source Images: U.S. Dept of the Interior, National Park
Service, Edison National Historic Site

Candy Candle
By Robert Schneider
Source Images: Robert Schneider

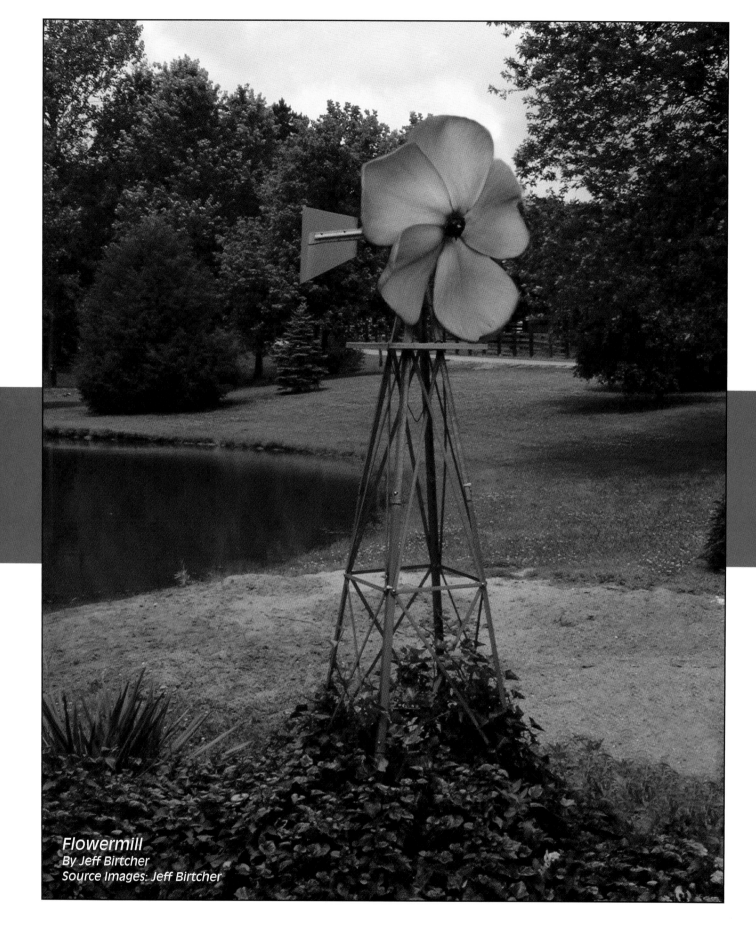

Flowermill
By Jeff Birtcher
Source Images: Jeff Birtcher

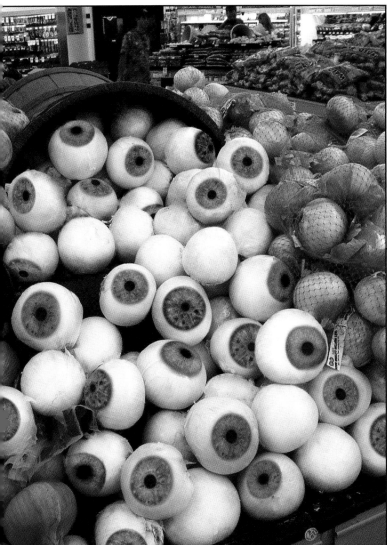

Eyeballs: $0.99/lb
By Jeff Minkevics
Source Images: Jeff Minkevics

Licorice Laces
By Wendy Biss
Source Images: Istockphoto.com

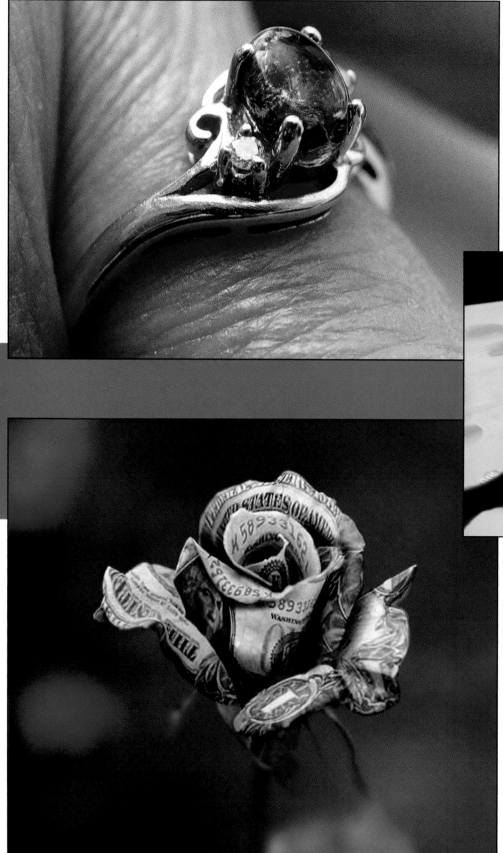

Give Her the World
By Dorie Pigut
Source Images: Bigfoto.com, NASA

Yes, It Is Made of Cheese
By Ian Capezzano
Source Images: NASA

Money Doesn't Grow on…Flowers?
By Brooks Summerlin
Source Images: Brooks Summerlin, Zeedaam.com

Omelet
By Robert Layton
Source Images: Tracey Somo,
Lemonlimestudio.com, U.S. Air Force

Chocolate Snail
By Alex Levin
Source Images: BigFoto.com

Orange Headphones
By Ivo van der Ent
Source Images: Sxc.hu, Morguefile.com

Ye Olde Spinning Cookie
By Renato Dornas de Oliveira Pereira
Source Images: Library of Congress,
Michael Connors, Morguefile.com

Syrup Toothpaste
By Rob Loukotka
Source Images: Rob Loukotka

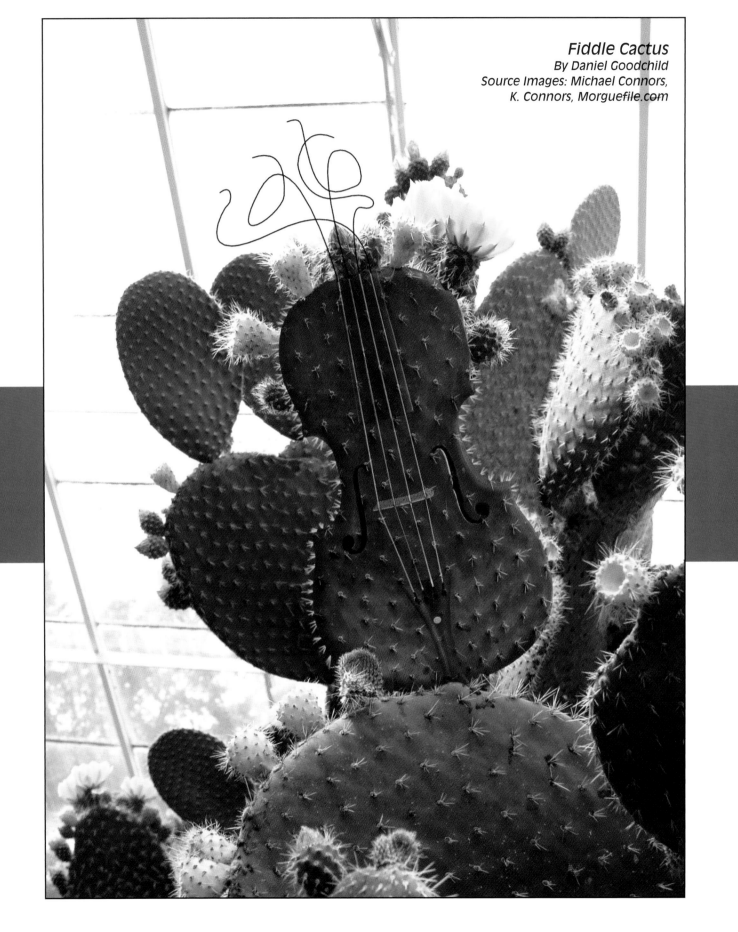

Fiddle Cactus
By Daniel Goodchild
Source Images: Michael Connors,
K. Connors, Morguefile.com

Tutorials

How I made Eyeballs: $0.99/lb

We all know that various vital organs are sold on the black market, and it has gotten so bad that the government has had to step in. However, I'm pretty sure this isn't what they had in mind. I mean, they're not even in a cooler for crying out loud!

Times change, though, and who knows… maybe in a few years we'll see something like this in a supermarket. For the moment, I'm perfectly content to believe that the only way we're going to see giant eyeballs staring at us from a table in a grocer's produce department is through the miracle that is digital editing.

This tutorial assumes you have an intermediate grasp on how to use Photoshop.

Here are the source pictures I used (see Figures 8.1 through 8.4).

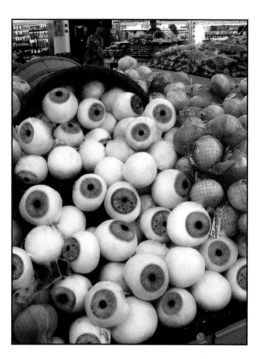

Figure 8.1

Figure 8.2

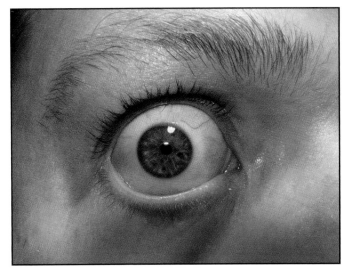

Figure 8.3

Figure 8.4

What is this: Lasik surgery or source images? Freaky, isn't it? I won't tell you who the eyeballs belong to, but I can tell you that those things sitting on the produce counter are onions. Well, for the moment, at least.

1. One of the reasons I chose onions is because they are already white, which eliminates all of the work involved in removing color from grapes or tomatoes or other produce. If you can pick up a source picture that has done half of your job for you, do so. All that I needed to do to make these onions prime for pupils was to add a new layer by selecting Layer > New > Layer and then set the mode to Overlay in the Layers palette. I used the Airbrush tool (to access this, choose the Brush tool from the toolbox and select Airbrush from the Brush options bar) to add some white in strategic places on the onions. Okay, let's poke some of the eye samples out and paste them into the image, just to get started.

2. I used the Lasso tool on the portion of the third eye I wanted. I chose Edit > Cut and Edit > Paste to place it in the produce picture. Using Edit > Free Transform, I rotated and distorted the iris to the shape I wanted in order to make it look like it was part of the onion.

3. I created a layer mask on my pupil by selecting Layer > Add Layer Mask > Reveal All. Using the Airbrush tool, I masked out the whites of the eye sample I didn't want in the picture, so that the iris and onion blended together somewhat believably. With those things done, it looked like... well... like an onion with an iris pasted on it, as shown in Figure 8.5.

Figure 8.5

4 To fix that, I created a new layer underneath the layer the iris was on and set the layer's mode to Overlay. This is located in the pull-down menu under the word "Layers" in the Layers palette, and is shown in Figure 8.6.

Figure 8.6

5 I then changed the new layer's opacity to about 30% or so and used a large, fuzzy paintbrush to add some white. I used a circular stroke in the center of the onion beneath the iris. Next, I applied a second stroke that was more centered, still at 30% opacity, and not only did I get the kind of white I was looking for, but I was able to keep the gray around the edges, which reinforced the illusion of spherical volume. As you can see in Figure 8.7, the difference before and after is rather striking.

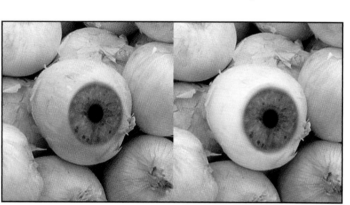

Figure 8.7

6 Eye think (Ha! Get it?) that looks half-decent, even with the onion skin poking its way out of the edges. So, one down, and several dozen to go! Instead of going through all of the trouble of pasting another brand-new iris into the picture, distorting, and erasing portions until I got it just right, I simply copied the one I had and moved it to a different position on a different onion. The easiest way to do this was to select the iris layer in the Layers palette and select Layer > Duplicate Layer. I now had a carbon copy of that particular layer, which I could move and rotate until it looked like it was situated where I wanted it on another onion.

7 Due to the fact that I'm using the exact same eye sample in the same picture, I wanted to make a couple of subtle changes so that there are noticeable differences between the eyeballs. If someone were to see the same iris characteristics in exactly the same color for all of the eyeballs in the picture, they would probably catch on immediately that the picture was a fake. (Of course, we should worry just as much about the people who believe a basket full of eyeballs could be found in the produce department.) Since color is the most noticeable characteristic if left the same, I adjusted the color of the new iris layer by selecting Image > Adjustments > Hue/Saturation (see Figure 8.8).

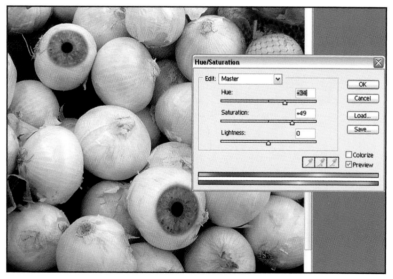

Figure 8.8

The hue slide bar changes the actual color of the entire selection you're working with, while saturation increases or decreases the intensity of the selection. In the pull-down menu at the top, you can specify these changes to be applied to all colors at once or make changes specific to the individual colors of red, yellow, green, blue, cyan, and magenta.

8. I played with the different colors until I ended up with a believable green with some hazel around the pupil. If you look carefully, you'll notice that they're exactly the same iris, and the only differences are position and color.

9. I repeated this process several times with new iris layers to give the impression of several *different* eyeballs using the exact same eye sample, which saved me bundles of time and energy (see Figure 8.9).

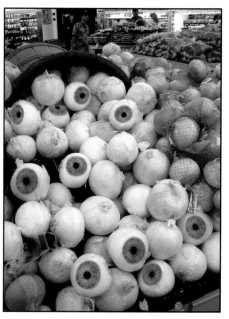

10. Now, because I had a few different eye samples to choose from, I repeated the above process with a completely new sample in order to create some actual variance among all the different eyeballs. In addition, I left a few of the onions as they were, because the law of averages would suggest that not all eyeballs would have the iris visible, and leaving some white space in the display gave it a somewhat haphazard and natural look.

To make eyeball soup, add 4 eyeballs, 1 chopped onion, a pinch of garlic, and salt and pepper to taste. The eyeballs may tear up when the onions are added. Double-check your ingredients before adding them, as you'd hate to hear a dinner guest proclaim, "There's a contact lens in my soup!"

Figure 8.9

Credits

Author: Jeff Minkevics
Source Images: Jeff Minkevics

8

How I made Give Her the World

Two month's salary? Ha! You'd better save up a little longer than that if you're going to give her the world. This Earth stone is the most precious there is, and you're going to need Trump-like wealth to be lord of this ring.

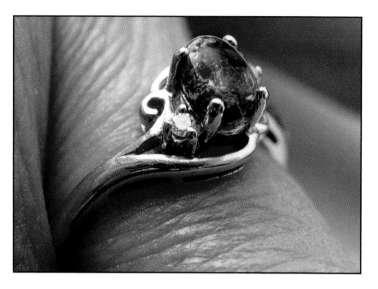

This tutorial assumes you have a basic grasp on how to use Photoshop.

1. I chose this close-up (see Figure 8.10) of a ring as my source image. The blue of the gemstone instantly made me think of the Earth... and how badly I want to rule it.

Figure 8.10

2. From NASA, I found a great image of my home planet of Earth. I copied the image and pasted it into a new layer on the ring image and then selected Edit > Free Transform to resize the Earth until it was roughly the same size as the gemstone (see Figure 8.11). You may want to set the opacity of the earth layer to 50% so you can see the stone beneath as you resize.

Figure 8.11

3 In the Earth layer, I created a mask by selecting Layer > Add Layer Mask > Reveal All. I then used the Brush tool to mask out everything that didn't fit in the ring, as shown in Figure 8.12.

Figure 8.12

4 Next, I copied the background layer by selecting Layer > Duplicate Layer. I named this layer "hard light." Make sure this is now the top layer. In the Layers palette, I set its mode to Hard Light and its opacity to 87% (see Figure 8.13).

5 In the hard light layer, I created another mask by choosing Layer > Add Layer Mask > Reveal All. Starting with a large brush and moving to finer brush sizes as I got closer to the Earth, I masked out everything but the world. The hard light layer mode made the original highlights of the ring show on the world layer, making it look round and shiny, as shown in Figure 8.14.

Figure 8.13

The Earth ring also doubles as a mood ring. After you give her this world, be careful; you may just get a little global warming.

Credits

Author: Dorie Pigut
Source Images: Bigfoto.com, NASA

Figure 8.14

How I made Fiddle Cactus

Have you ever wondered what the difference is between a violin and a fiddle? Violins are made by skilled craftsmen and can trace their roots to sixteenth-century Italy. Fiddles, on the other hand, grow wild in the old Southwest. Yep, partner, they grow in the desert on what them horticulturalists call *Cactus Stradivarius*. Please be careful, though. If you pick 'em too early and hold one up to your chin to play it... *yeeeooowww!*

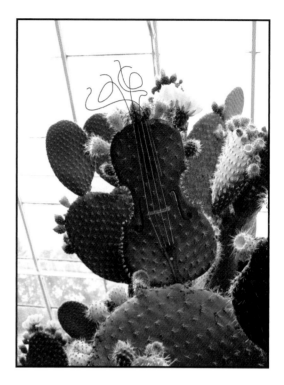

This one's good for the intermediate Photoshop user.

1. Using the Marquee tool, I roughly circled the fiddle from my source image and chose Edit > Copy to copy the image into my clipboard. Next, I used Edit > Paste to paste it onto the cactus image (see Figure 8.15).

2. To line up the layers, I added a layer mask to the fiddle by going to Layer > Add Layer Mask > Reveal All and used a black brush to remove the area outside of the fiddle that I didn't need.

3. I used Edit > Free Transform to resize and rotate the fiddle into the right place over the branch of the cactus, as shown in Figure 8.16.

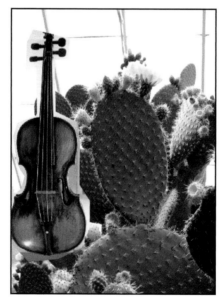

Figure 8.15

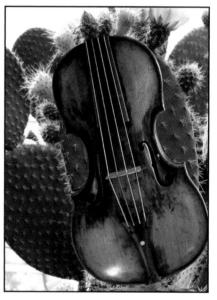

Figure 8.16

4 To create a background texture that would work well with the fiddle, I right-clicked the fiddle's layer mask and selected Intersect Layer Mask With Selection. This selected the visible pixels (see Figure 8.17).

5 This next step was one of the main keys to this image. I switched off the fiddle layer's visibility and added an additional layer below it by choosing Layer > New > Layer. If your new layer isn't in the position you want, you can always click, drag, and move it within the Layers palette.

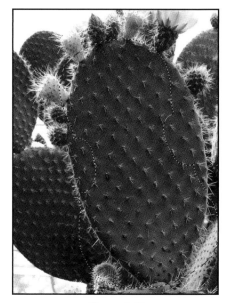

Figure 8.17

6 I selected the Clone tool and made sure the Use All Layers checkbox was selected in the Clone options bar. I then filled in the pattern of the cactus inside the fiddle area, then I inverted the selection by selecting the Marquee tool, right-clicking the area, and choosing Invert Selection. I repeated the process outside of the fiddle area (see Figure 8.18). There's no easy way to teach use of the Clone tool; it's much the same way one gets to Carnegie Hall… practice, practice, practice!

7 To give some shape to the fiddle, I switched the visibility of the fiddle layer back on and changed the Blend mode to Soft Light in the Layers palette. Finally, I lowered the opacity to 41% (see Figure 8.19).

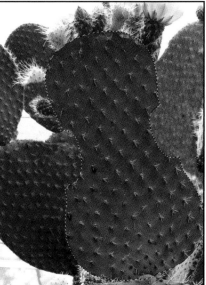

Figure 8.18

Figure 8.19

8 This worked quite well for the body of the fiddle, but the edges needed more definition. I adjusted the edges by selecting Layer > Layer Style > Blending Options. I added Bevel and Emboss with the settings shown in Figure 8.20.

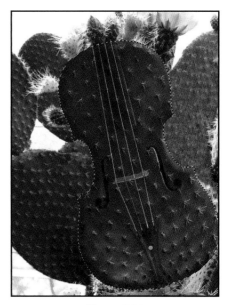

Figure 8.20

9 Next, I wanted to define the detail on the fiddle, so I duplicated the fiddle layer by selecting Layer > Duplicate Layer. Then, I added a layer mask to my new layer and exposed only the details I was looking for, such as the holes, fret board, and so on. I set the Blend mode to Normal and lowered the opacity to 64%. The fiddle was now starting to take a more recognizable and three-dimensional shape, which you can see in Figure 8.21.

Figure 8.21

10 The beauty of using an additional layer for cloning (steps 5 and 6) is that your original background layer stays intact. I copied all the small, knobby branches of cactus from the original layer and pasted them into more new layers, then positioned them around and in front of the bottom of the new cactus shape to make the scene look more natural (well, natural for a cactus anyway). Obviously, I used layer masks on each one (see Figure 8.22).

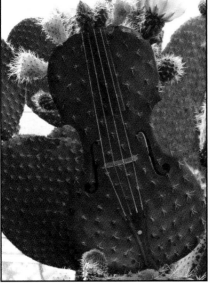

Figure 8.22

11 To replace all the fluffy little spines around the cactus, I added a new layer and simply drew them using the smallest brush possible in a light color sampled from the existing spines with the Eyedropper tool. Then, I used Filters > Blur > Gaussian Blur to add a little bit of Gaussian Blur to my sketched needles to make them look more blended and realistic (see Figure 8.23).

12 Finally, in another new layer, I used the Pen tool to draw individual strings growing from the top. I created each string with the Paintbrush tool, using the smallest brush size. Again, I added a little Gaussian Blur to blend them in.

When this baby ripens, you're bound to hear it cryin' in the background of some song about momma, drivin' trucks, and drinkin'. *Yeeeeee haawww!*

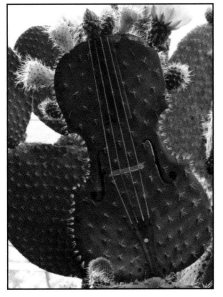

Figure 8.23

Credits

Author: Daniel Goodchild
Source Images: Michael Connors, K. Connors, Morguefile.com

How I made Omelet

We admit it: we're not in the best of health anymore. The doctor said we needed to cut down on our cholesterol intake. We asked if that meant giving up the beer-battered, deep-fried egg, cheese, and butter sandwiches. The doctor sighed and shook his head. He tried to explain to us how eggs are like bombs just waiting to go off in our hearts. Eh, we've had a good run.

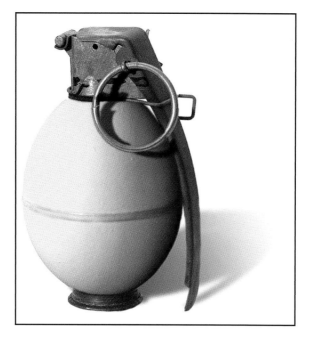

This tutorial assumes you have an intermediate grasp on Photoshop.

1 So, I had this grenade lying around in my basement. Ha! Just kidding. I created a new layer by selecting Layer > New > Layer, then made a mask by selecting Layer > Add Layer Mask > Reveal All. I used the Paintbrush tool to mask out the parts of the grenade I wouldn't need from my source image. Then I turned the original grenade layer invisible in the Layers palette (see Figure 8.24).

2 In my egg source image, I duplicated the layer by selecting Layer > Duplicate Layer, and then I created a mask by selecting Layer > Add Layer Mask > Reveal All. Using the Paintbrush tool, I masked out everything around the egg, as shown in Figure 8.25.

Figure 8.24

Figure 8.25

▣ Using the Elliptical Marquee, I copied the egg by selecting Edit > Copy, Edit > Paste to paste the egg into a new layer on the grenade image. Using Edit > Free Transform, I resized the egg to the right "grenade" size.

▣ I created another duplicate layer of the egg by choosing Layer > Duplicate Layer. I find it's a good idea to save the elements in an intact state, because chances are, you'll need them later. Once I had a duplicate layer, I turned off the visibility of the original egg layer in the Layers palette.

▣ In my new egg layer, I changed the opacity to 80% so I could see the grenade through it. Next, I created a layer mask on the egg and used the Paintbrush tool to mask away the parts of the egg that would be hidden by other grenade parts. I used a finer-sized brush to get close to the ring and also where the handle meets the egg. When I was done, I brought the opacity back up to 100% (see Figure 8.26).

▣ I duplicated the original grenade layer by selecting Layer > Duplicate Layer and then created a layer mask. Using the Brush tool, I masked out the grenade ring's shadow and filled it in with black using the Paint Bucket tool, as shown in Figure 8.27.

▣ I created another copy of the grenade, using the method discussed in the previous step, added another layer mask to this new duplicate, and masked out the base of the grenade to fit on the bottom of the egg (see Figure 8.28).

▣ I repeated the same process to show the central ridge around the middle of the grenade. On this new grenade layer, I selected Image > Adjustments > Desaturate to desaturate it (see Figure 8.29).

Figure 8.26

Figure 8.27

Figure 8.28

Figure 8.29

9 I went back to my original, intact egg layer and turned it back to visible. I duplicated the layer again so I could create a mask of the ridge from step 8. Next, I set the blending mode of the layer to Color in the Layers palette (see Figure 8.30).

10 I continued to mask my egg layer around the ridge until everything looked clean and blended in. Finally, I selected Image > Adjustments > Levels and tweaked the levels through trial and error until the egg looked right (see Figure 8.31).

Figure 8.30 Figure 8.31

11 To create the shadow behind the grenade, I flattened the whole image by selecting Layer > Flatten Image. Next, I chose Select > All, and Edit > Copy to copy the image into my clipboard. Then I used Edit > Paste to paste the image into a new document that was the same height, but twice the width of my original (see Figure 8.32). You'll probably want to undo the Flatten Image command on your working document in case you want to go back later and tweak any of the elements.

Figure 8.32

12 I created a new layer in my new document and masked out the egg grenade. Using the Eyedropper tool, I selected a color from the darkest part of the image. I created a duplicate layer and used the Paint Bucket tool to fill the layer with that dark color, as shown in Figure 8.33.

Figure 8.33

13 By using Edit > Free Transform, I altered the dark shadow into the right angle and perspective. Lastly, I reduced the opacity of the shadow layer slightly to give it more of a shadowy look (see Figure 8.34).

The nice thing about dangerously high cholesterol is that we won't be one of those elderly people who linger on for years drooling because though our bodies are strong, the mind is mush. No, not for us. With high cholesterol, one day we pull the pin and BOOM! Massive coronary… no lingering.

Figure 8.34

Credits

Author: Bob Mogal
Source Images: Tracey Somo, Lemonlimestudio.com, U.S. Air Force

AL YANKOVIC

CATCHER - NEW YORK

Index

Index